Mantegna

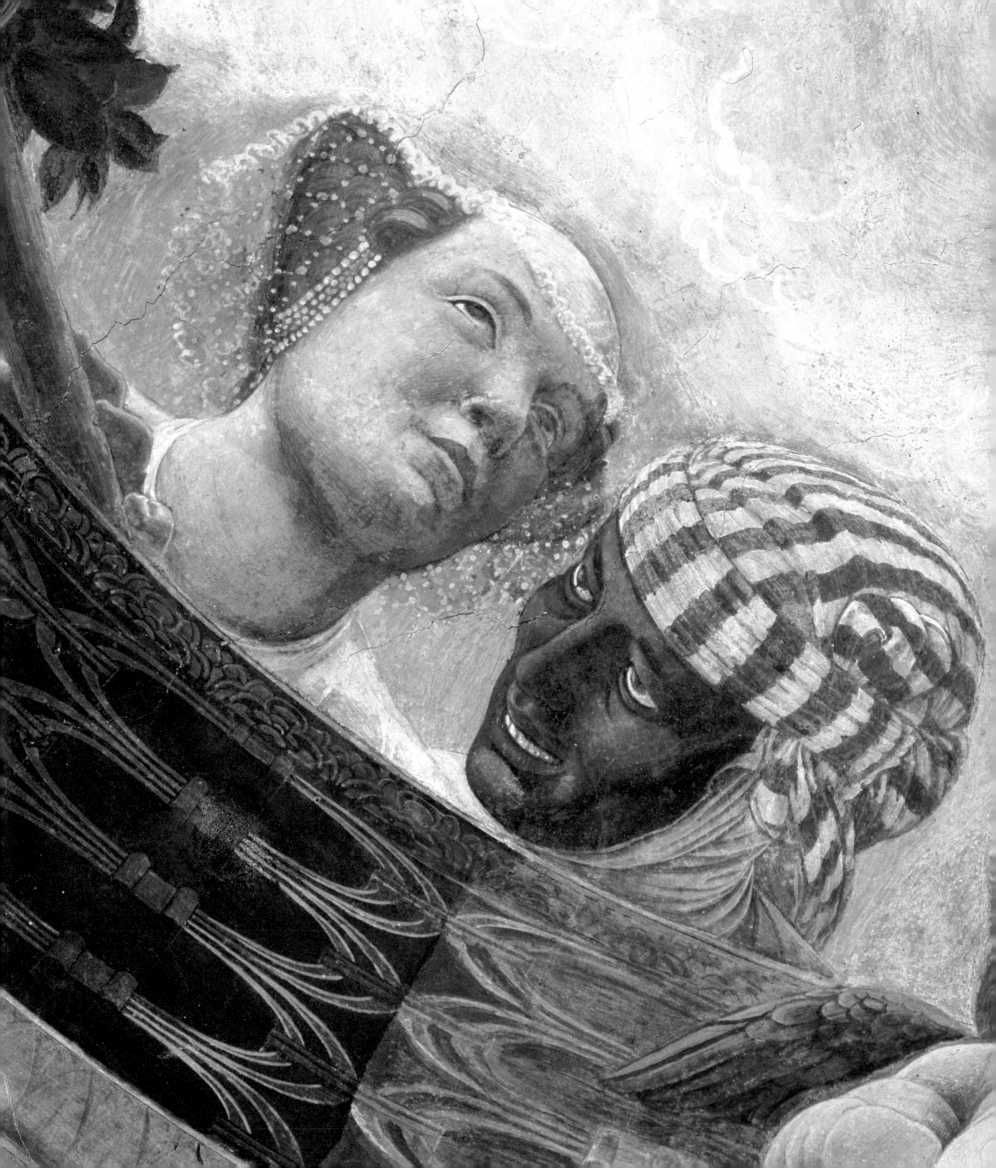

Nike Bätzner

Andrea

Mantegna

1430/31–1506

KÖNEMANN

1 (frontispiece)
Camera degli Sposi, detail of the ceiling fresco (cf. ill. 63)

© 1998 Könemann Verlagsgesellschaft mbH
Bonner Str. 126, D-50968 Köln

Art Director: Peter Feierabend
Project Manager and Editor: Sally Bald
Assistant: Susanne Hergarden
German Editor: Ute E. Hammer
Assistant: Jeannette Fentroß
Translation from the German: Phyll Greenhead
Contributing Editor: Chris Murray
Production Director: Detlev Schaper
Assistant: Nicola Leurs
Layout: Claudia Faber
Typesetting: Greiner & Reichel, Cologne
Reproductions: Omniascanners, Milan
Printing and Binding: Neue Stalling, Oldenburg
Printed in Germany

ISBN 3-8290-0252-1
10 9 8 7 6 5 4 3 2 1

Contents

MANTEGNA'S EARLY CAREER IN PADUA

Andrea Mantegna was probably born in Isola di Carturo, a village between Vicenza and Padua, in 1430 or 1431. In northern Italy during the 14th and 15th centuries, Padua was a cultural center second only to the politically and economically more powerful city of Venice. Padua had a long history, and isolated traces of the ancient Roman town of Patavium are still visible today. The university, already in existence by the early 13th century, had a reputation for excellence that went far beyond the city itself.

It was in this enlightened and humanist city that Mantegna grew up. At the age of about eleven he was accepted into the workshop of Francesco Squarcione (1394/97–1468), a painter of only moderate significance. In contemporary reports, Squarcione was described as a tailor and embroiderer, though he had clearly also turned to art – one of his few surviving works is the altarpiece *Mary with Child* (ca. 1460, now in the Gemäldegalerie in Berlin). Squarcione's real significance lies in the fact that he owned a large number of classical sculptures and casts, as well as an extensive collection of copies and sketches of works by the major artists of the age. At this time the study of the works of the masters was an essential part of an artist's training, and on the basis of his collection Squarcione built up a busy training workshop that was enormously popular – over the years 137 students came to him. However, he made it his practice to adopt his students so that he could put them to work without paying wages, and once trained most of them escaped from this exploitative dependency as quickly as they could. Mantegna was no exception. He was soon sufficiently self-assured to make the break, and his "apprenticeship" ended in a lawsuit that won him his freedom in 1448. Just seventeen years of age, he completed his first independent work in the same year: an altarpiece (now lost) for the church of Santa Sofia in Padua. Though the work of a very young artist, it was greatly admired and his gifts were extolled in poems of praise.

His earliest surviving works are his frescoes in a chapel belonging to the Ovetari family in the Chiesa degli Eremitani in Padua (ills. 3–15, 18–20). This church – in English, the Church of the Hermits of St Augustine – was built in the 13th century and is adjacent to the Arena Chapel whose interior is the masterwork of Giotto (ca. 1267–1337). The greater part of the Church of the Hermits was destroyed during the Second World War, so today we can gain an impression of the Ovetari Chapel only with the help of photographs and old descriptions. There are also, however, a few fragments of the frescoes that were preserved after being removed in the 19th century to prevent deterioration on the damp walls.

The patron for the frescoes was the notary Antonio Ovetari, who, in a will dated 5 January 1443, provided that immediately after his death 700 gold ducats was to be spent on decorating his family's funerary chapel, which was to the right of the main choir. The exact date of the notary's death is not known, but he must have died before 16 May 1448 as this is the date heirs drew up the initial contracts for a series of frescoes. There were two contracts. The first commissioned works from the artists Giovanni d'Alemagna (died 1450) and Antonio da Murano, known as Vivarini (1415–1476/84). These two artists were to be responsible for the wall on the right hand side of the chapel, the main vault, and the front wall. The second contract, also dated 16 May 1448, commissioned Mantegna and Niccolò Pizzolo (died 1453) to execute the frescoes for the second half of the chapel. According to the art writer Giorgio Vasari (1511–1574) in his famous "Lives", the abilities of Pizzolo, a little-known former assistant of the sculptor Donatello (1386–1466), were already equalled by that of the young Mantegna. In addition to his work on the frescoes, Pizzolo was also responsible for painting the altar reliefs sculpted by Giovanni da Pisa (died ca. 1460). As Giovanni d'Alemagna died in 1450 and Vivarini worked on the frescoes till 1451, the painters Bono da Ferrara (died 1452) and Ansuino da Forlì (active in 1450s) were brought in for the as yet untouched right hand wall in 1451. All the frescoes were completed by 1457.

Because so many artists were involved, one of them must have developed an integrated overall concept for the cycle of frescoes, and there is some indication that Mantegna (young as he was) may have been the

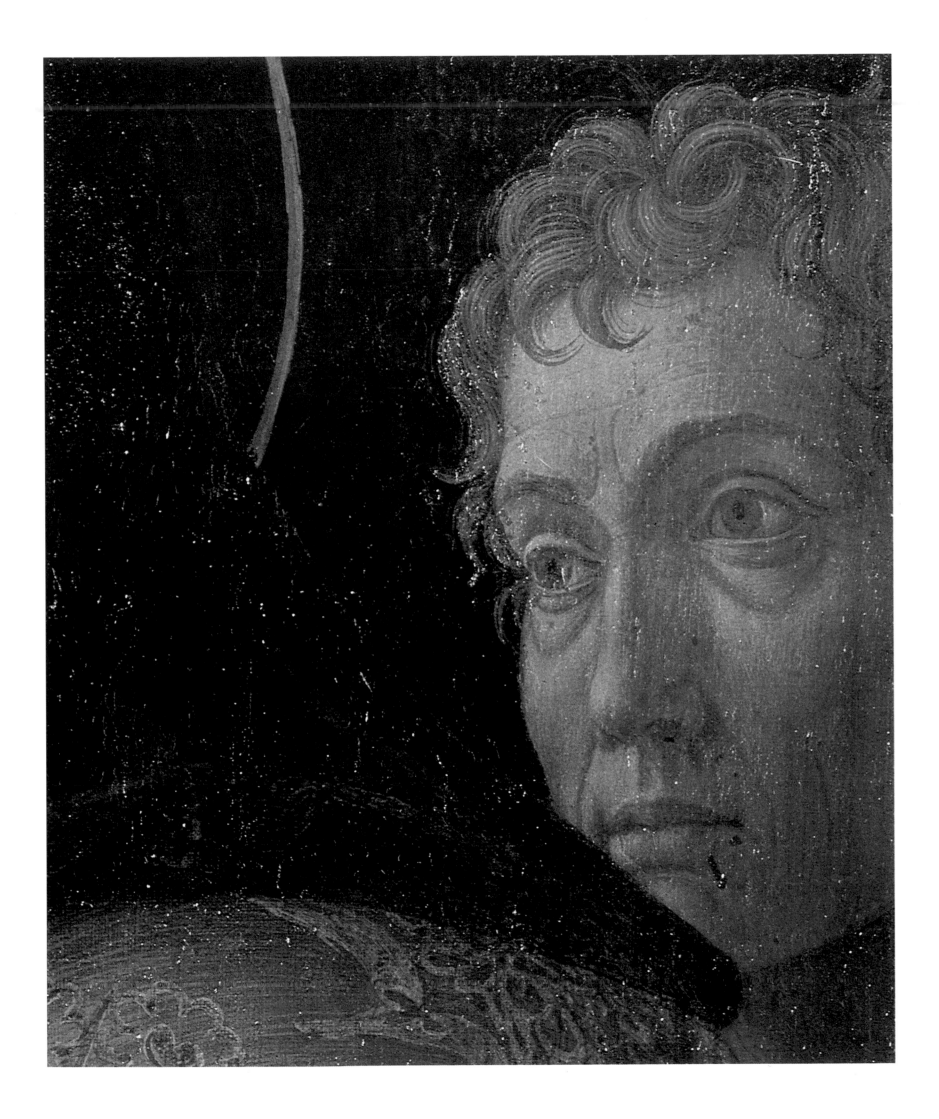

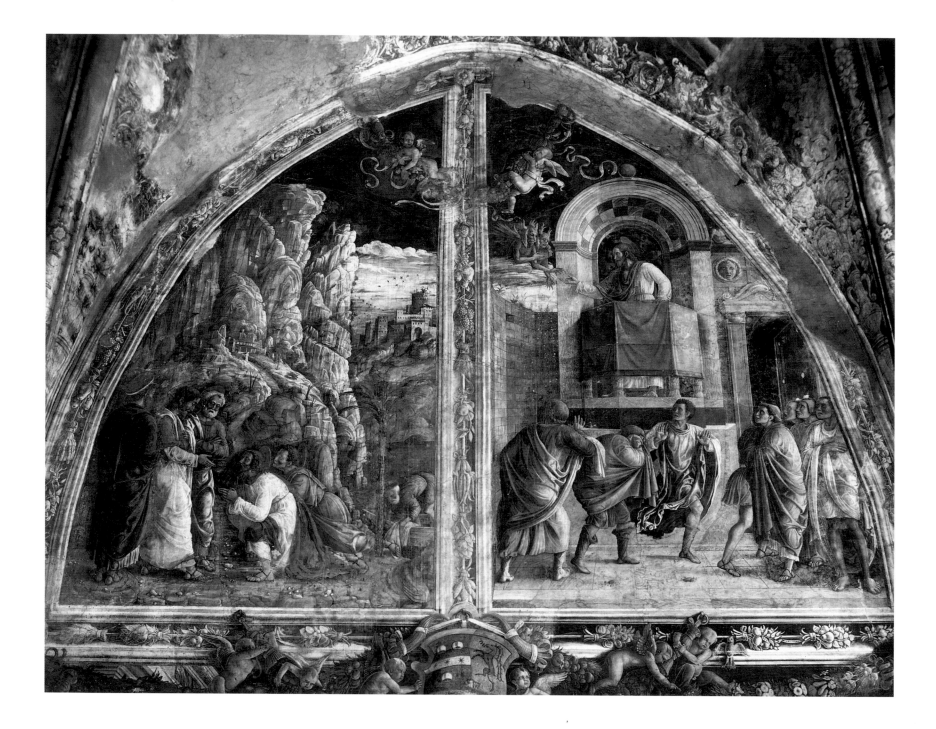

originator of both the overall formal composition, and also the structural device of painted frames. The co-ordinated composition of the scenes also looks like his work.

In his will, Antonio Ovetari had provided an outline for the content of the pictures. The side walls of the chapel area were dedicated to scenes from the lives of St James and St Christopher, and the apse wall, with its window apertures, was to depict the Assumption of the Virgin, in the center behind the altar. In the now destroyed vaults there were portrayals of the four Evangelists, and the four Fathers of the Church and other saints, with God the Father enthroned in the center, above Mary. As dictated by custom, the ceiling frescoes were the first to be painted. Mantegna and Pizzolo painted the frescoes in the apse vault, and Vivarini and Giovanni d'Alemagna were responsible for the vault over the body of the chapel. The "Legenda

Aurea", a collection of saints' lives by Jacobus de Voragine (1230–1298), was used as the source for the stories of the saints depicted on the side walls of the chapel. Mantegna probably painted the left wall, which has been almost completely lost (ills. 3–7). The surface is divided by means of a painted ornamental frame on which a realistic garland of fruit is hanging, giving the impression that it is standing out from the wall. In the center, two of the acrobatic putti inside the frame are holding up the patron's coat of arms. The scenes from the legend of St James are set within this painted architectural framework dividing up the wall, which is now no longer treated as a uniform whole but as several independent units for self-contained episodes. At first it seems that in each scene the unities of time, place and action have been respected.

In the top register, the left-hand scene depicts the calling of the brothers James and John to be disciples of

3–7 *Scenes from the Life of St James,* 1448–1457
Fresco, dimensions of the wall unknown,
chapel area 8.75 x 7.00 m
Chiesa degli Eremitani, Cappella Ovetari, Padua

The photographs were taken before the chapel was destroyed on 11 March 1944; today only fragments of the lower wall area remain. The left-hand wall showed scenes from the story of the Apostle James. They were, from the upper left to the lower right: the *Calling of Saints James and John* and the *Preaching of St James*; *St James Baptizing Hermogenes* and the *Trial of St James*; *St James Led to Execution* and the *Martyrdom of St James.*

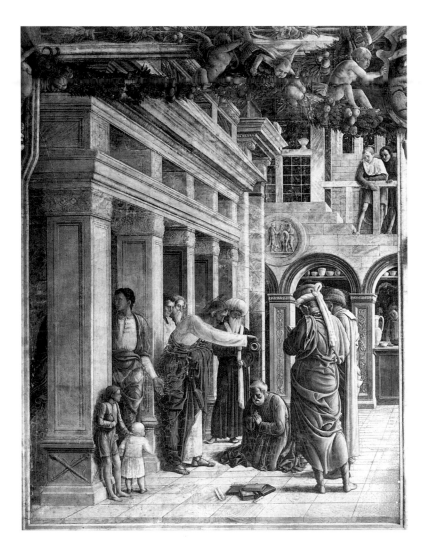

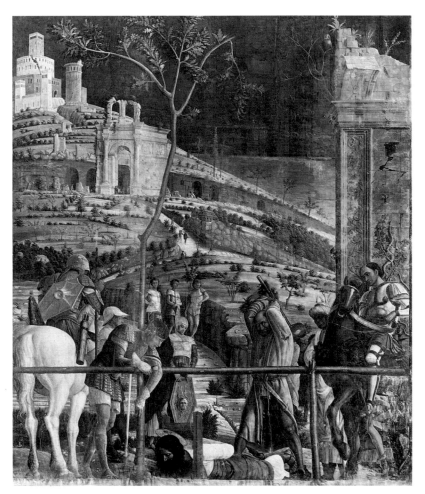

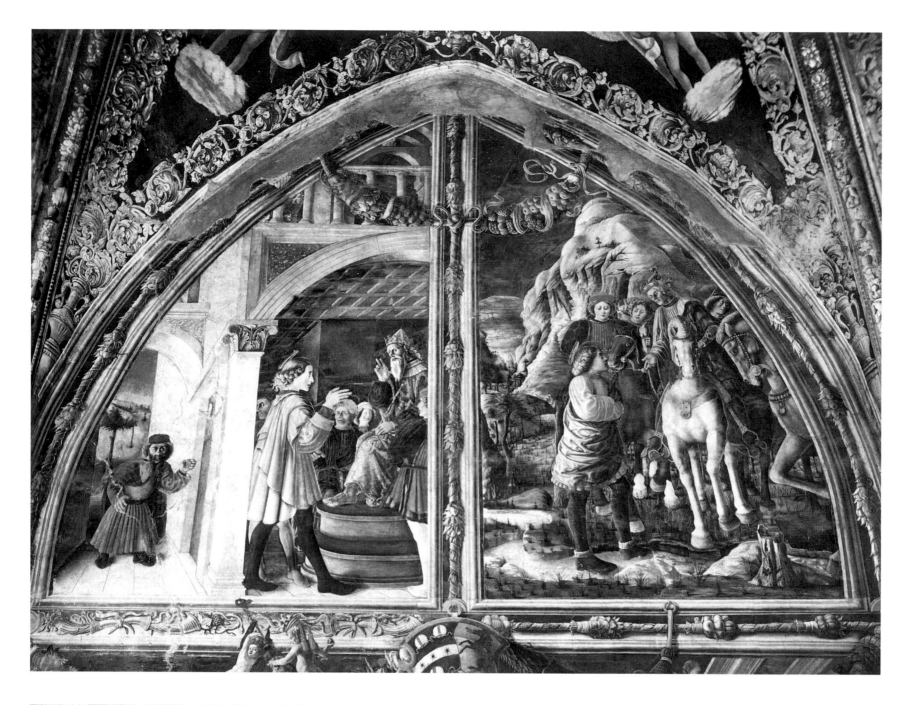

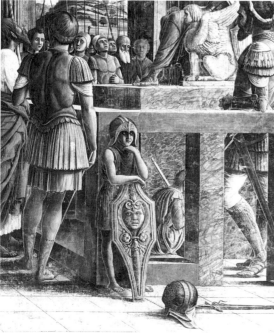

8, 10–13 (above and opposite) *Scenes from the Life of St Christopher,* 1448–1457
Fresco, dimensions unknown
Chiesa degli Eremitani, Cappella Ovetari, Padua

The right-hand wall of the chapel was dedicated to St Christopher. From the upper left to the lower right, the scenes were: *St Christopher before the King* and *Confrontation with the Devil*; *St Christopher Carrying Christ across the River* and *St Christopher and the Soldiers of the King of Samos in Lycia*; the *Martyrdom of St Christopher* and the *Removal of his Body*. The composition of the whole wall was Mantegna's work, but only the two bottom pictures were painted by him.

9 (left) *Trial of St James,* left-hand wall in the Ovetari Chapel (detail ill. 5), 1450–1457

The amusing figure of the little shield bearer, looking out from under a helmet too large for him, demonstrates the imaginative and playful quality of Mantegna's composition. The head on the shield could be a self-portrait of the artist. Mantegna left a permanent memorial of himself in the decorative detail of several of his works, as for instance, later, in the Camera degli Sposi (ill. 83).

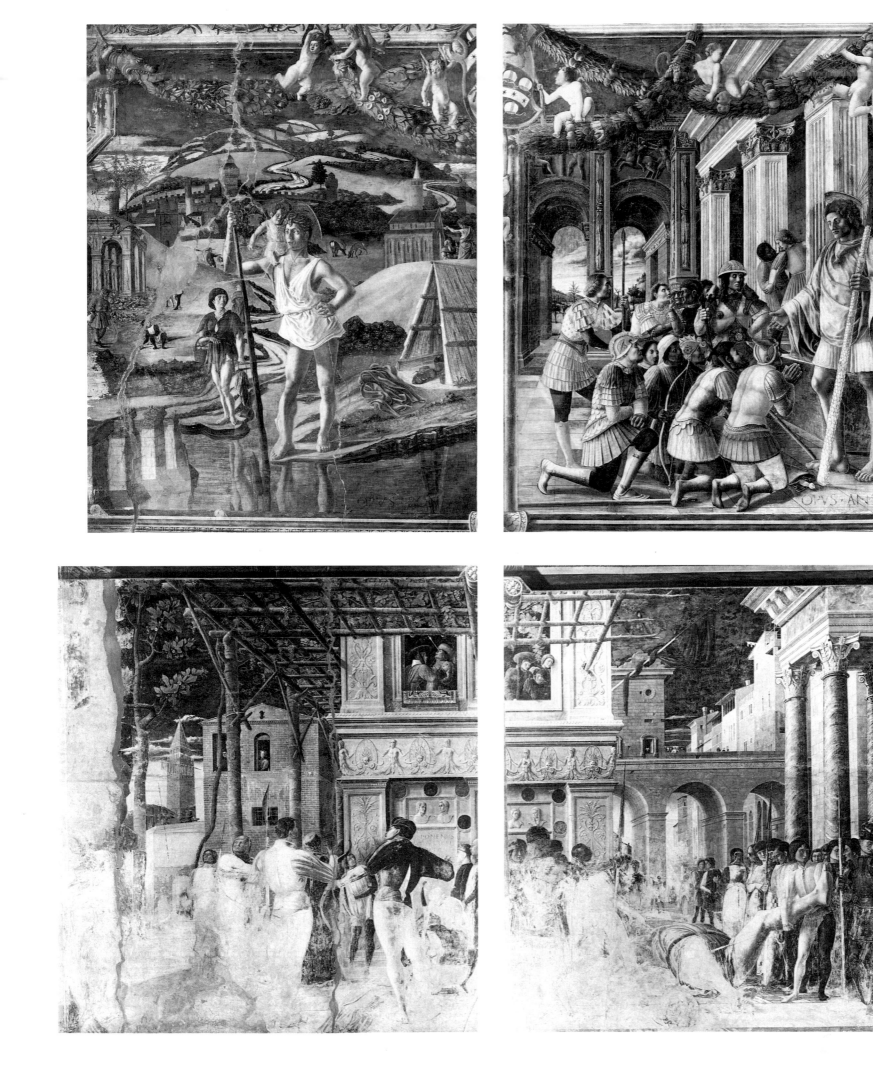

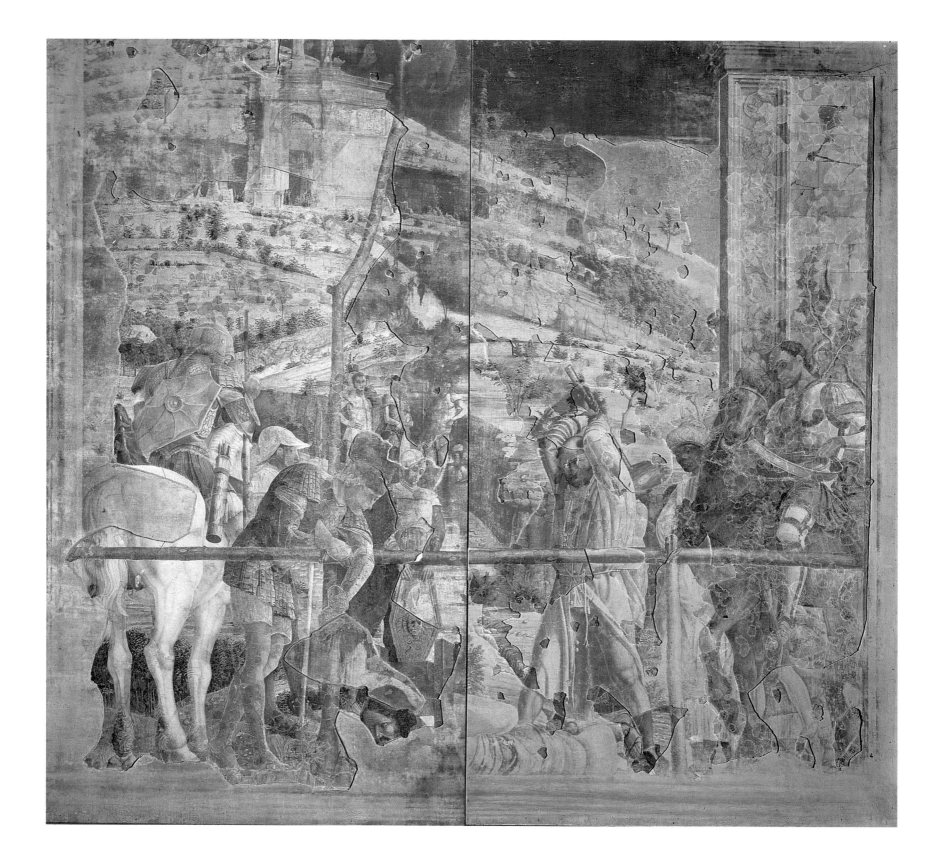

14 (above) *Martyrdom of St James,* left-hand wall in the Ovetari Chapel (detail ill. 7), 1448–1457

This badly damaged fresco was transferred to canvas in 1886–1891, and thus combined with a copy of the original. The Apostle James is seen lying along the bottom edge of the painting, a device to draw us into the scenes unfolding immediately before us. The moment depicted is the instant before the martyrdom takes place.

15 (opposite, top) *Martyrdom of St Christopher* and *Removal of his Body,* right-hand wall in the Ovetari Chapel (cf. ills. 12, 13), 1448–1457

This section of the fresco was detached from the wall in about 1880 because of its deteriorating condition, and is therefore still preserved, though only in a fragmentary state. According to the legend, the giant Christopher wanted to serve only the most powerful of kings, and so finally came to Jesus. He was called upon to carry an infant across a river, and as he almost drowned under this burden, he recognized the child as the Infant Jesus. Christopher was martyred during the Roman persecution of the Christians.

16, 17 (opposite, bottom) *Martyrdom of St Christopher* and *Removal of his Body,* 1457–1500
Distemper on wood, transferred to canvas, each 51 x 51 cm
Musée Jacquemart-André, Paris

This copy of the lower section of the story of St Christopher was probably made shortly after the frescoes were completed. To the left can be seen the huge figure of St Christopher, almost completely lost in the original. He and the small boy to the right are standing partially outside the decorative framework of the fresco, intermediaries between the viewer's space and the narrative of the fresco.

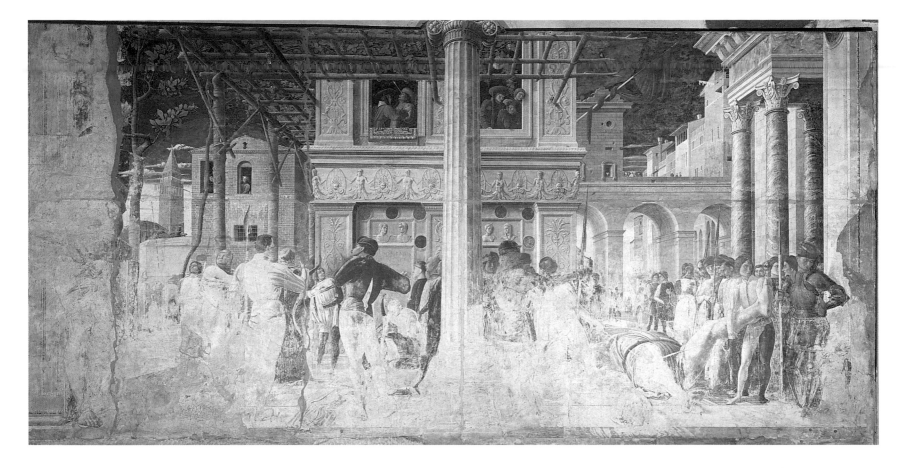

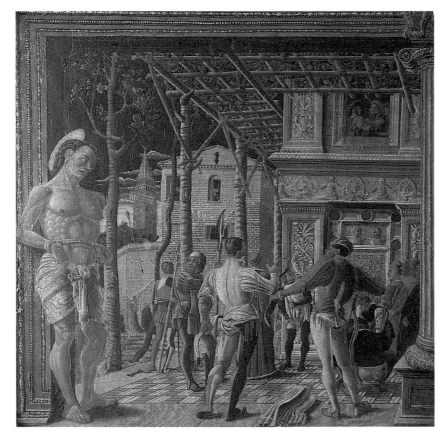

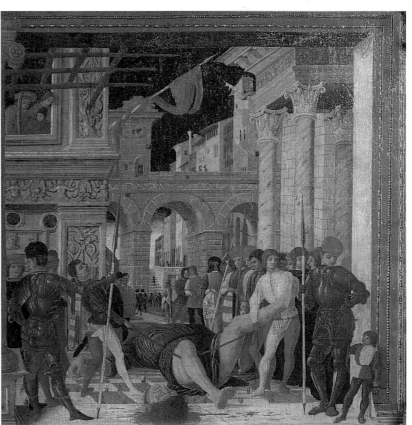

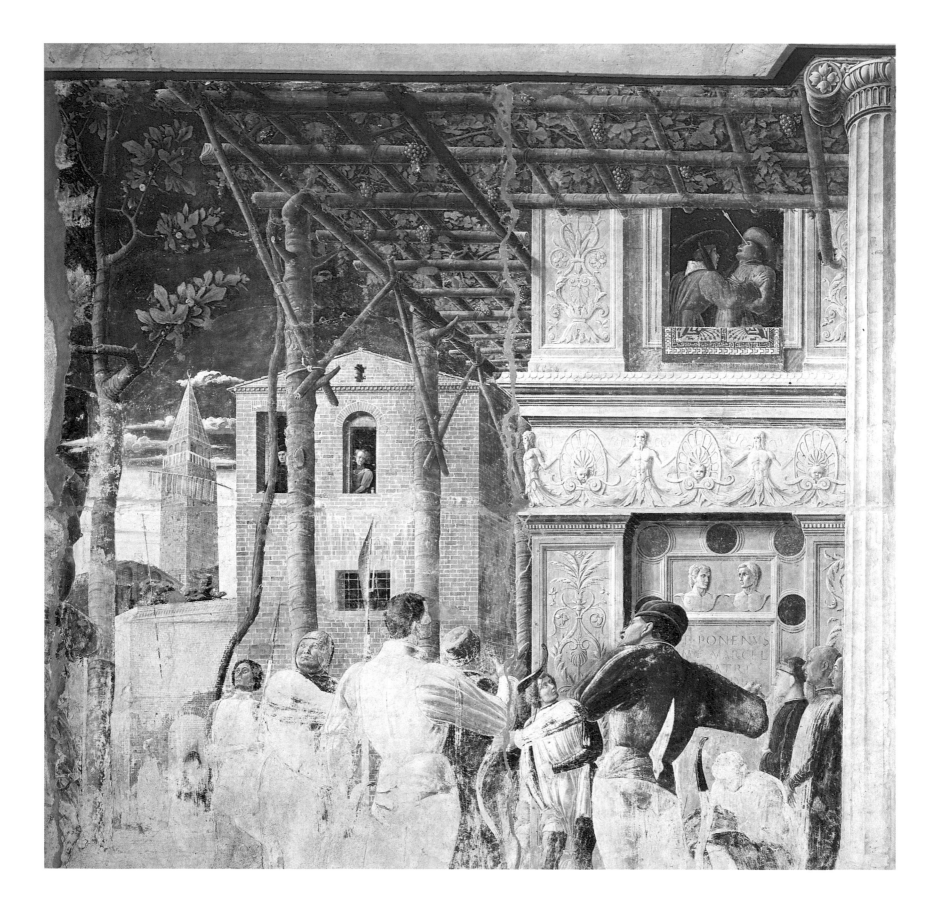

18 *Martyrdom of St Christopher,* right-hand wall in the Ovetari Chapel (cf. ill. 12), 1450–1457

The arrows shot at the saint were miraculously deflected. The tyrant responsible for the saint's martyrdom was struck in the eye by one of them, at which Christopher said to him, "Tomorrow, when I'm dead, take some of my blood, mix it with some earth, put it on your eye, and you will be healed." When the king followed this advice and found he could see again, he converted to Christianity.

Christ (ill. 3, left-hand side). The background shows a craggy cliff face, a landscape typical of Mantegna. To the right, next to this, James is preaching from a pulpit. The walled square on which the pulpit stands bears no relation at all to the previous landscape.

In the left-hand scene of the central register, the baptism of the magician Hermogenes is depicted (ill. 4): St James is freeing him from demons and converting

him to Christianity. In the adjacent scene, the trial (ill. 5), Herod Agrippa is condemning St James to death. These two scenes are depicted at the same level, as shown by the floor paving, the lines of which converge on a single point, and also a common horizon, which is at about the eye-level of someone standing in front of the fresco. However, the architectural setting does not represent a single, unified space. The row of arches in

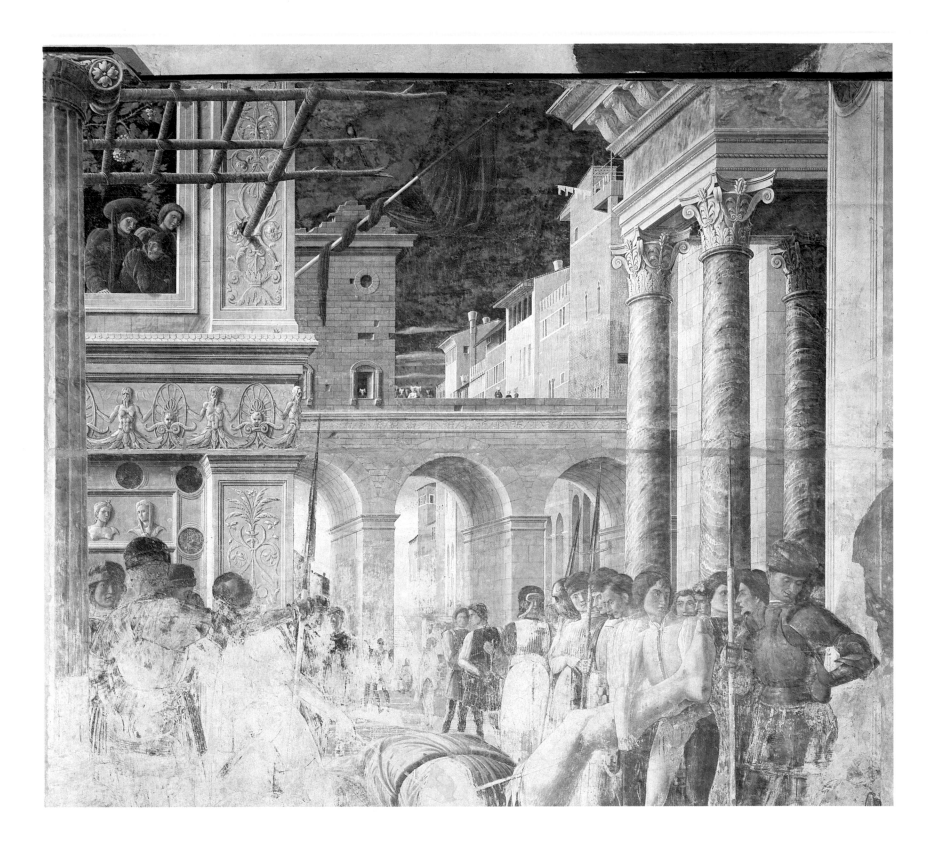

the baptism scene breaks off abruptly at the edge of the painting and its line is not continued into the right-hand scene. These events occurred in two different places, and in both scenes the action and attention focus on the central figures: Hermogenes, being baptized, and St James in conversation with Herod Agrippa. The two scenes are separated by an empty space where an isolated soldier stands looking sceptically out of the frame.

In the bottom register, the scene to the left (ill. 6) is dominated by a lively crowd. The procession that was supposed to be leading St James to his execution has come to a standstill. A lame man is kneeling in front of James, who is healing him. Beside St James, the soldier who is still leading the saint with a rope stands by unperturbed; facing St James, another soldier raises his arms in amazement. The figures behind do not seem to

19 *Removal of the Body of St Christopher,* right-hand wall in the Ovetari Chapel (detail ill. 13), 1450–1457

In this scene the architecture combines set pieces from classical reliefs and buildings with city palaces of the Quattrocento to create a setting that in no way resembles an actual city. Vasari thought he could identify some of the people in the picture, who were therefore contemporaries from the 15th century rather than figures taken from the classical world.

21 (above) *Monogram of Christ with Saint Anthony and Saint Bernard,* dated 22 July 1452
Fresco mounted on wood, base 316 cm
Museo Antoniano, Padua

The fresco was originally a decoration for the lunette over the central entrance to the Santo in Padua, which is why the emblem is supported on the left by one of the saint most revered in that city, St Anthony. On the right, St Bernard is portrayed: it was from his Latin description *Iesus Hominum Salvator* that the central abbreviation for the name of Christ originated: IHS. As the fresco was heavily restored in the 18th century, it is now barely possible to discern Mantegna's picture.

20 (opposite) *Assumption of the Virgin (Assunta),* 1454–1457
Fresco, base 238 cm
Chiesa degli Eremitani, Cappella Ovetari, Padua

Surrounded by angels, Mary floats towards God the Father, who was originally sitting above her in an oval picture. Presumably the empty space surrounded by the Apostles was intended for Mary's sarcophagus, which Mantegna probably left out because the shape of the apse wall meant that the space available was too narrow.

have noticed the miracle. At the lower edge of the scene, as a compositional counterbalance to the miraculous cure, a soldier repulses a standard bearer driven by his curiosity to see what is happening. The last scene depicts St James' execution. These two bottom scenes also share a common perspective, though it is quite different to the one shared by the two pictures in the middle register. The action is pushed forward right up to the front edge of the painting, with a toe and a heel even protruding beyond the boundary of the scene. A range of different emotional reactions is depicted, particularly through stance and gestures, though, as is typical of Mantegna, without exaggerated dramatics – the drama of the narrative is underlined by the enormous depth of the setting. The vanishing point for both of these episodes is situated beneath the base line of the picture, so that the main figures are seen from immediately below and the feet of the characters standing further back are not visible. The scenes are in effect shown from the viewpoint of an observer inside the chapel and appear to extend the viewer's space. In the bottom right-hand landscape scene (ill. 7), Mantegna depicts a rising terrain and in this way circumvents the disappearance of the ground level. Here the action is closed off from the front by the use of a solid-seeming *trompe-l'œil* barrier that appears to be

secured out of frame at the left. One of the soldiers is leaning over the barrier into the chapel.

Of the paintings on the opposite wall, dedicated to scenes from the life of St Christopher (ills. 8, 10–13), the four upper scenes are presumably by Bono da Ferrara and Ansuino da Forlì, since the two in the center are signed by them. The two scenes at the bottom, however, are by Mantegna (ills. 12, 13). Here he was able to create a synthesis of his artistic experience so far. The vanishing point seems to lie in the middle ground of the opposite wall, at the eye level of the figures depicted at the very front of the scene. The ornamental system of painted frames structuring the wall space is interrupted here: a column separates the two scenes of narrative, though they are, nevertheless, played out in the same place and are therefore closely linked. This link is indicated by the soldier standing to the right of the column looking towards the earlier events in the left-hand scene. In this left-hand scene, Mantegna depicts the unsuccessful attempt to martyr the saint. The arrows have failed to strike the saint (one of them striking the man shown in the upper window), and the executioner has resorted to his sword. In the right-hand scenes, the beheaded corpse of the giant is carried from the town.

Finally, between the walls portraying the legends of the saints, the altar wall of the chapel illustrates the

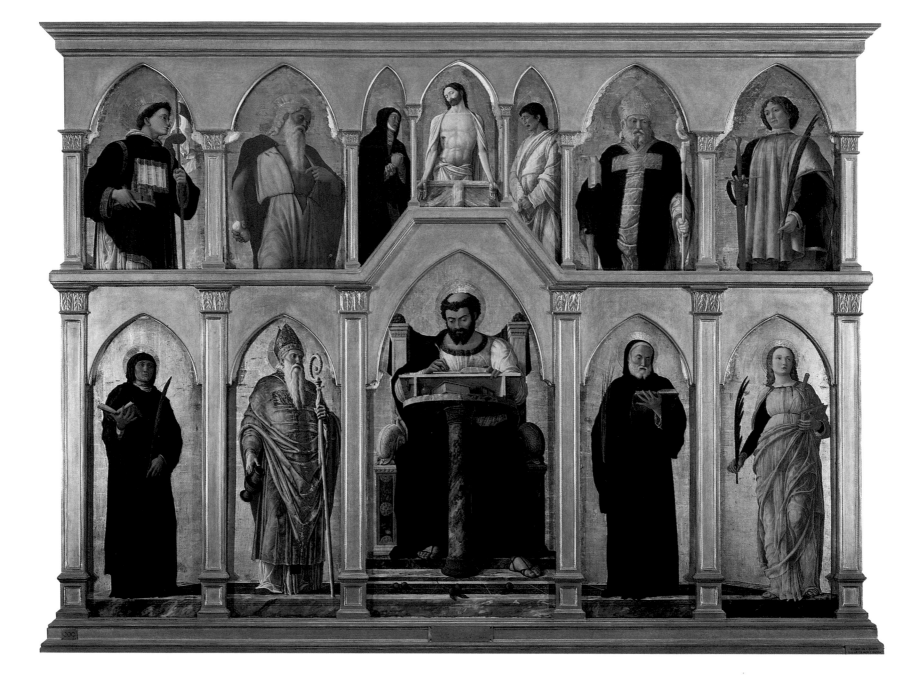

Assumption of the Virgin (ill. 20). This is for the most part the work of Mantegna. Here the synthesis of the actual architectural setting and illusory architectural effects is completely successful. On the left, one of the Apostles is holding on to one of the pillars that frames the scene. The Apostles are standing between and even in front of this architectural framework, close to and on a level with visitors to the chapel, who gaze up at Mary with them. In 1457 the *Assumption of the Virgin* became the subject of a dispute. The widow of the patron complained that four of the Apostles were missing. The judge in the case challenged this purely numerical argument by referring her to the exceptional artistic result. But Mantegna's former master, Squarcione, who had taken sides with the widow, replied that Mantegna should have made the Apostles smaller in order to fit in all twelve of them.

In the Eremitani frescoes, Mantegna was trying out the different possibilities for constructing space through perspective. In doing so, he was not following any one

dogmatic concept: for Mantegna, practice was far more important than theory. The upper scenes in the legend of St James, depicted as if seen from slightly above, seem to be turned towards the viewer; the frescoes of the middle register, which give a direct, frontal view of the scenes, draw the viewer into the action; while the lower scenes, depicted with a low viewpoint, give the viewer a sense of confronting real space.

These novel experiments with space, allied with their almost sculptural visualization of antiquity, meant that the frescoes had a great impact on later artists. Nevertheless, Mantegna received some criticism for his "all too classical" style – a charge made by Squarcione, for instance, who envied the success of his former student and who (according to Vasari) observed that Mantegna could have just left the color out, since his figures were more like the marble statues of antiquity than living people. It is true that few buildings or details in Mantegna's work can be connected with concrete models: for Mantegna classical antiquity provided a

22 (above) *St Luke Polyptych*, 1453–1455
Distemper on wood, 230 x 177 cm
Pinacoteca di Brera, Milan

The original frame for these paintings has been lost, but a reasonable reconstruction of the format was possible. St Luke and the group with Christ were almost without exception flanked by saints local to the city of Padua. Here, in the top left-hand corner we can see St Daniel, with a model of the city, and next to him the penitent St Jerome. The half-length figures in the upper section appear to be standing behind a balustrade and fill the space in the narrow field available with their monumental dimensions.

23 (opposite) *St Luke Polyptych* (detail ill. 22), 1453–1455

St Luke the Evangelist is enthroned behind a scribe's desk in such a way that his physical presence almost threatens to break the boundaries of the old-fashioned panel. Above him is a *pietà*, a close-knit group representing Christ in His suffering: His narrow, finely proportioned body, still bound by the Gothic concept of physicality, lies between Mary and John, who are tending him.

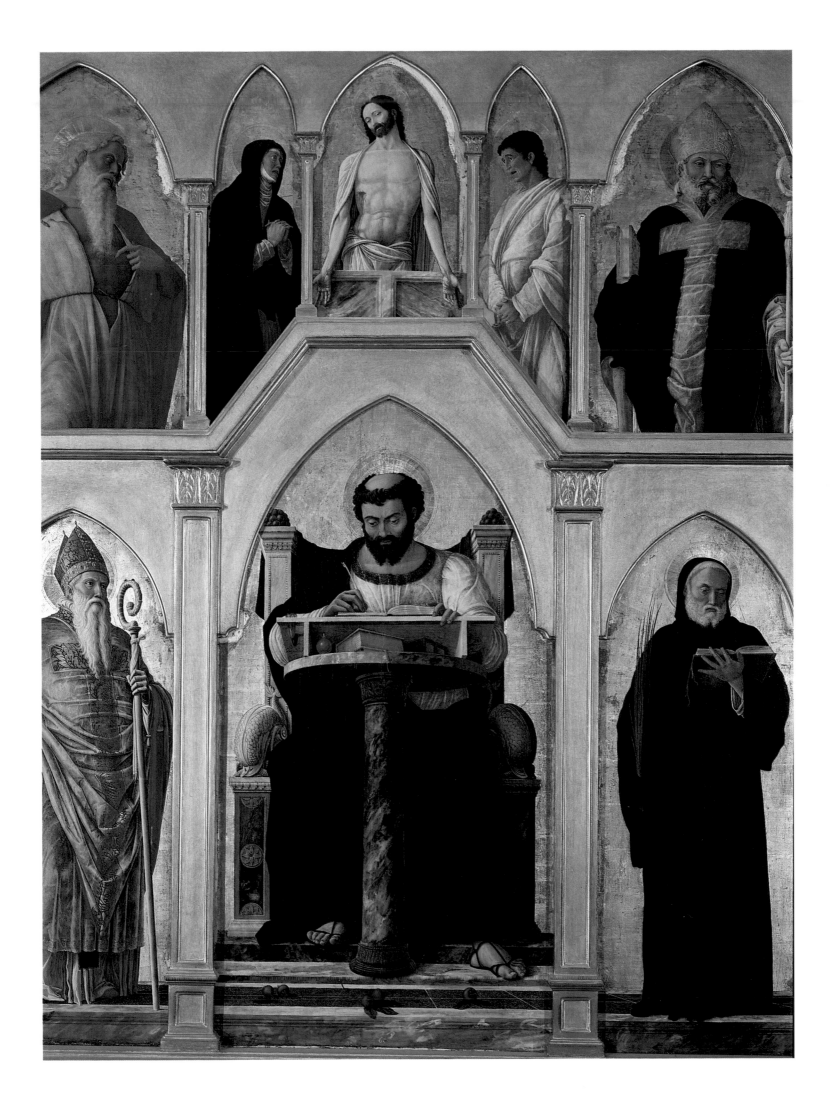

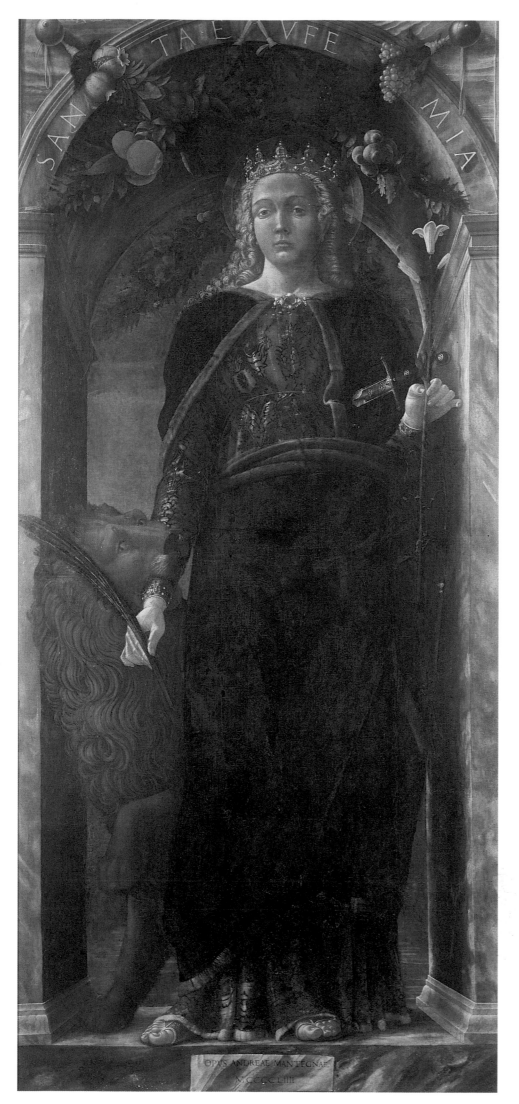

24 (left) *St Euphemia,* 1454
Distemper on canvas, 171 x 78 cm
Museo e Gallerie Nazionali di Capodimonte, Naples

St Euphemia was subjected to various forms of torture
during the persecution of the Christians under Emperor
Diocletian. These are symbolized by a sword that has
pierced her side and a lion biting her arm. The painting
was damaged by fire in the late 18th century, so that the
detail of the folds of her robe are no longer apparent.

25 (opposite) *St Mark,* ca. 1448/49
Casein (?) on canvas, 82 x 63.5 cm
Städelsches Kunstinstitut, Frankfurt

Mantegna's first painting on canvas is a key work in his
development. For the first time, the artist tried out the
effect of the painted frame here, representing Mark in a
thoughtful mood. This work was long considered to be
from his studio, since there was some doubt about the
genuineness of the signature and also, therefore the early
date. The doubts are reinforced by the fact that neither
the patron nor the place it was painted are known.

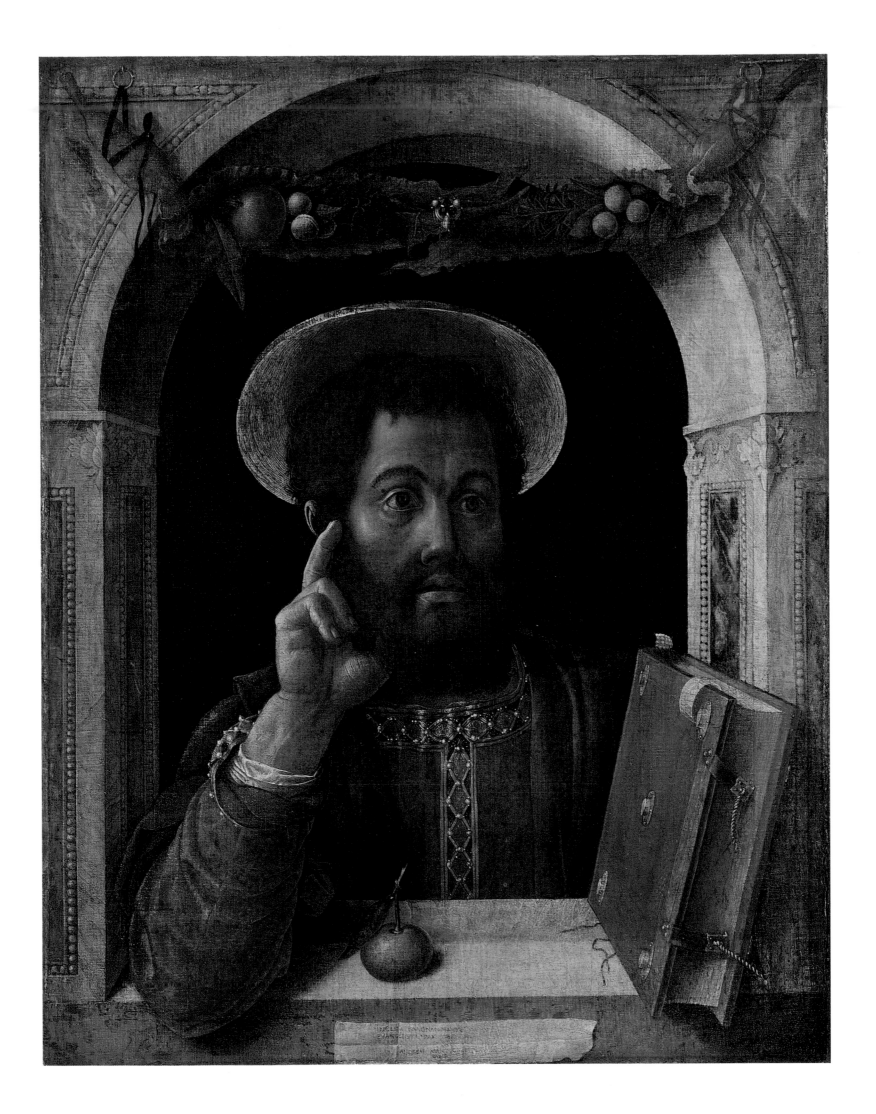

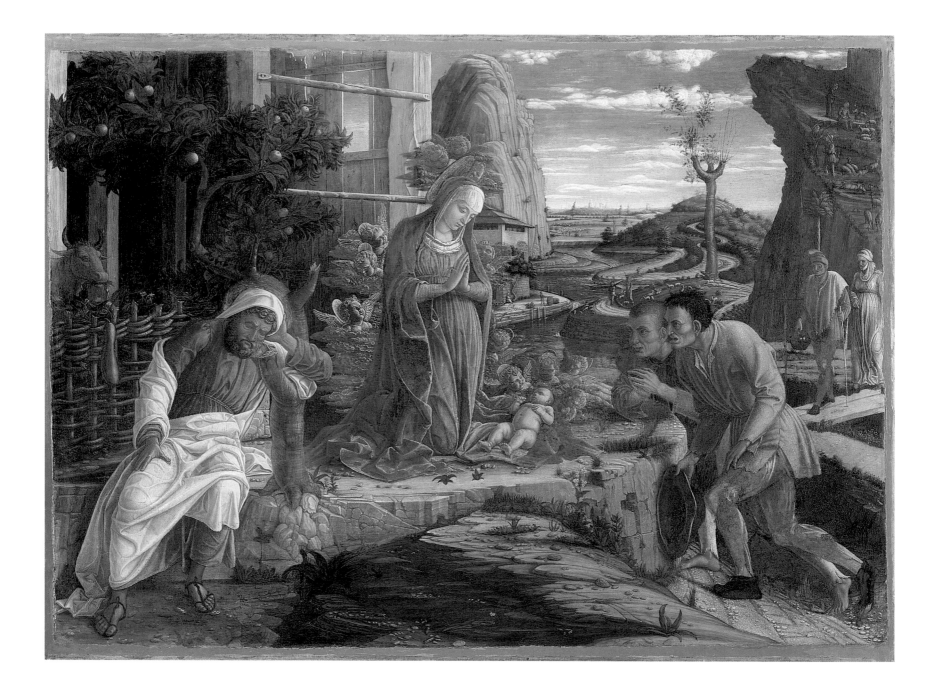

26 *Adoration of the Shepherds,* ca. 1450/51
Distemper, transferred from wood to canvas,
40 x 55.5 cm
The Metropolitan Museum of Art, New York

In this scene the realistic portrayal of the two shepherds in
ragged clothing betrays Flemish influences. Mantegna was
able to study the work of Rogier van der Weyden at the
Ferrara court, for which this painting was created. This
transposition of literary interpretations of the holy story
to a pictorial representation – with the degree of detail
favored by miniaturists – was very popular. Mary is
surrounded by little angels, their colors representing the
fire of divine love (red) and the light of eternity (gold).

general rather than specific inspiration. However, he had
been educated in classical literature and archeology and
had an accurate eye for detail. He had gained a
knowledge of Greek art through coins, jewelry and small
bronzes, and of Roman architecture mainly from nearby
Verona, where the classical remains included a
renowned arena, among other things. Although not an
exact representation of the arch in Verona, the triumphal
arch shown in the fresco *St James Led to Execution* (ill. 6)
bears the inscription: L.VITRUVIUS [IL] CERDO
ARCHITE[C]TUS, taken from the Arco dei Gavi,
which names the famous Roman architect Vitruvius as
its creator.

Classical buildings, particularly triumphal arches,
appear often in Mantegna's works and are endowed with

a much greater significance than simple background
features would normally merit. Except for the lower area
of the St Christopher frescoes, where the figures appear
in contemporary dress, Mantegna prefers costumes in a
classical style. Like Donatello, Mantegna had studied
Roman reliefs in detail and could portray Roman armor
with great precision. In 1443, Donatello had gone to
Padua to complete reliefs for the altar in the church of
St Anthony, known as the Santo (ill. 32). Donatello's
work there provided an impetus for the artists of Padua,
Mantegna too being inspired by the sculptor's creative
energy. Several aspects of Mantegna's work clearly show
a direct influence on the statuesque attitudes of
Mantegna's figures, the chiselled appearance of the folds
in their clothes, and his experimentation with the

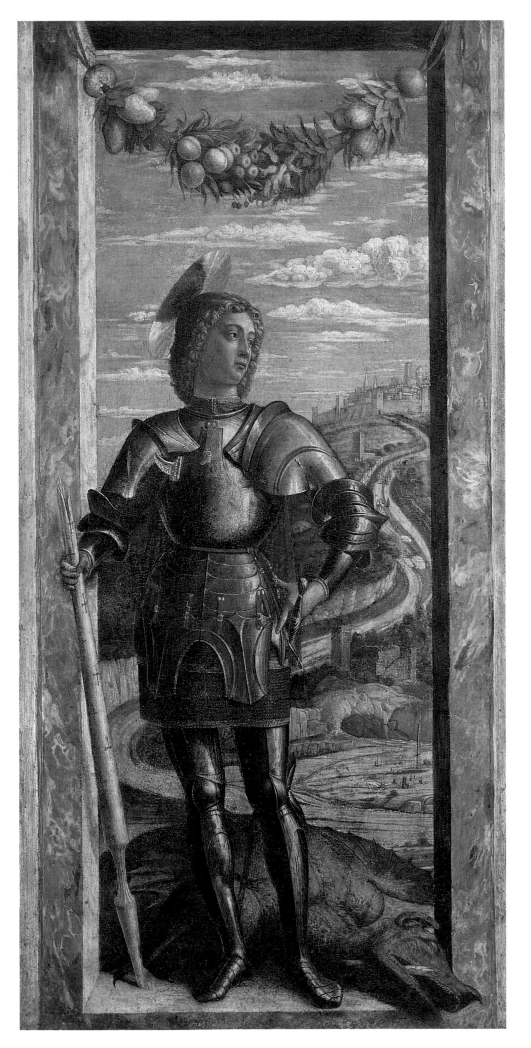

27 *St George,* 1460–1470
Distemper on wood, 66 x 32 cm
Galleria dell'Accademia, Venice

In its spatial organization, this painting is closely related
to Mantegna's *San Zeno Altarpiece* (ill. 33). The saint
stands in a confident and victorious pose in front of the
dragon he has just slain. The artificiality of the scenery is
stressed by the window-like stone frame that provides the
hero with a very theatrical setting and a view of the
landscape that looks almost like a theater backdrop. The
reflection of the back the hero's head in his bright halo is a
sign that Mantegna may have seen the work of the
Florentine artist Andrea del Castagno (ca. 1421–1457),
who was also working in Venice.

28 *Presentation at the Temple*, ca. 1453–1460
Distemper on canvas, 67 x 86 cm
Staatliche Museen zu Berlin – Preußischer Kulturbesitz,
Gemäldegalerie, Berlin

In the foreground, Mary is handing the Christ Child to
Simeon the High Priest. Between them, Joseph is seen
watching thoughtfully. The two background figures
closest to the outside edges of the painting are presumed
to be a self-portrait of the artist and a portrait of his wife,
Nicolosia. Mantegna had married the daughter of the
Venetian painter Jacopo Bellini in 1453 or 1454.

construction of space though perspective defined by
architecture were all previously seen in Donatello's work.
The carved figures on the altar of the Santo clearly
influenced the positioning of the individual figures in
the frescoes, as well as their physical attitudes. Mantegna
must also have been aware of Donatello's work in
Florence, either from Donatello himself or through the
collection of drawings in Squarcione's workshop. In the
lower frescoes of the St James story, for example, the
legionnaire leaning on his diamond-shaped shield (ill. 6)
is reminiscent of Donatello's sculpture *St George* in the
Museo Nazionale del Bargello in Florence.

On the whole, Mantegna stressed the particular. In
the portrayal of the *Trial of St James* (ill. 5), the
triumphal arch has two medallions on which the heads

of classical rulers are shown. According to the German
art historian Ilse Blum, one of these is Nero, the cruel
and unpredictable emperor of pagan Rome; while the
other is Augustus, the wise ruler and a witness to
Sibylline prophecies, making him one of those who
foresaw the coming of Christianity. During the
Quattrocento, such classical elements were increasingly
used to reinforce Christian teaching. But there was also,
independent of any religious intention, a growing
interest in classical images and a desire to include details
that reflected secular themes. The traditional range of
purely religious subjects handed down from the Middle
Ages was gradually being expanded to include classical
themes – a process in which Mantegna occupied a
prominent position.

While working on the Ovetari frescoes, Mantegna took on other commissions, including the *St Luke Polyptych* (ills. 22, 23) for the chapel dedicated to St Luke in the church of Santa Giustina in Padua. The very traditional conception of this altarpiece, which is designed along Gothic lines, reflects a patron with conservative tastes in art. Here the importance of the saints is reflected in their size, scaled down according to their place in the hierarchy. Like similar images in Byzantine art, they stand isolated against a golden background that symbolizes the all-embracing presence of God.

However, a modern element has been introduced with the lower group of saints, where the foreground tapers in sharp perspective, ignoring the boundaries of the painting's fictive space. In addition to this, the solidity

of the figures themselves makes them stand out strongly from the uniform background.

Two other paintings from the same period are *St Euphemia* (ill. 24) and *St Mark* (ill. 25). Like St Mark, St Euphemia has been placed in a stone arch decorated with garlands of fruit and leaves. The two saints have been portrayed in the immediate foreground, bringing them close to the viewer. With her direct gaze, the life-size figure of Euphemia, accompanied by a lion, is open to dialogue with the viewer standing in front of her. In contrast, Mark the Evangelist is sitting at a window and looking past the viewer, though his arm and book seem to reach out over the barrier of the balustrade into the viewer's space. This type of composition was derived from Flemish antecedents. Rogier van der Weyden

29 Giovanni Bellini
Presentation at the Temple, ca. 1460
Oil on wood, trimmed left and right, 80 x 105 cm
Museo della Fondazione Querini Stampalia, Venice

Bellini's version of this subject is clearly connected with the painting by his brother-in-law, Mantegna (ill. 28); it is not clear, however, which of these paintings was executed first. Typical Venetian elements such as the warm colors and soft outlines are a distinctive feature of this painting. In contrast, Mantegna's figures are modelled with stronger tones of light and shade, and his colors are altogether cooler.

(1399/1400–1464) and Jan van Eyck (ca.1390–1441)
often placed their subjects behind stone balustrades or
frames: a well-known example is van Eyck's *Portrait of
a Man (Tymotheus Leal Souvenir)* painted in 1432
(National Gallery, London). Through this visual device,
subjects are given a stamp of authenticity and actuality:
they appear to be sitting, fully alive, just a short distance
from the viewer.

Although more restrained, the main figures in
Mantegna's *Presentation at the Temple* (ill. 28) are able
to overcome the barrier between the picture's fictive
space and the viewer's real space in the same way, since
the point of contact is defined by a stone frame
encircling the picture. The figures emerge from the dark
background with a three-dimensional effect similar to
that of a sculpted relief. Yet in spite of this strong
physical presence, the figures seem private and remote;
none of the figures is looking out of the picture at the
viewer. In comparison, Mantegna's Venetian father-in-
law, Giovanni Bellini (ca. 1430–1516), maintained a
degree of physical distance from the viewer in his version
of the *Presentation at the Temple* (ill. 29). To bridge this
distance, however, he used the young man portrayed to
the right, who stares out at us with a complicit gaze.
Bellini's composition is less urgent than Mantegna's.
The witnesses on either side are spatially at the same level
as Joseph and frame the action. The Italian art historian
Ettore Camesasca presumed this was a devotional image
of the Bellini family, probably painted for some special
occasion such as the birth of a child, or a wedding. On
this interpretation, the old man in the center is Jacopo
Bellini, the two young men to the right his sons Gentile
and Giovanni, and to the left are their mother and their
sister, Nicolosia (Mantegna's wife), who is in the same
position as in Mantegna's picture.

Two further works are an indication of the artistic

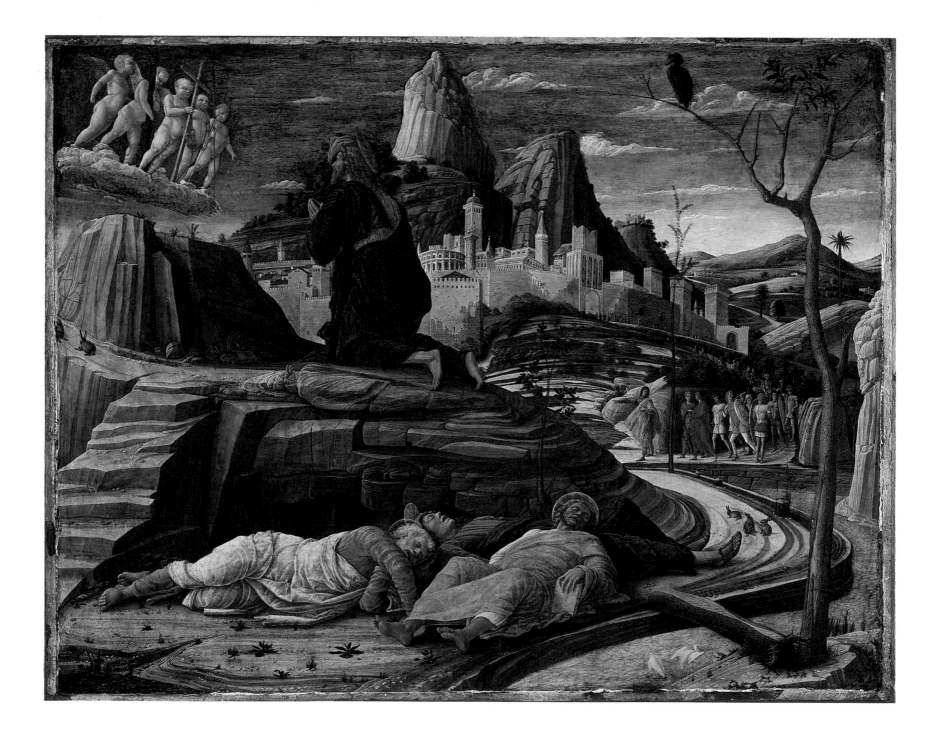

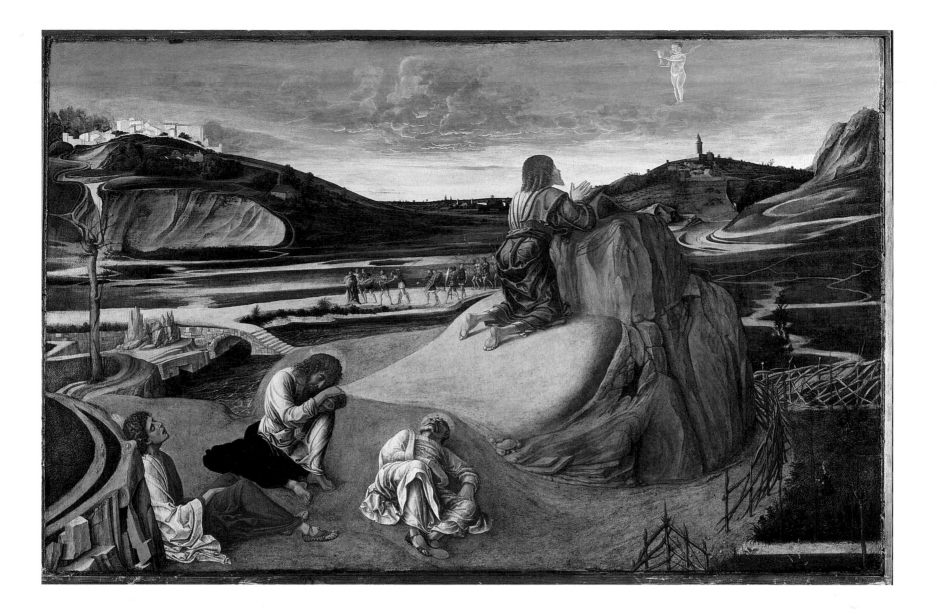

influence that operated mutually between Mantegna and Giovanni Bellini. Mantegna's version of the scene on the Mount of Olives (ill. 30) has a very intense effect, each element appearing with equal emphasis: in spite of its distance, the city seems near enough to touch. In the foreground the sleeping disciples Peter, James and John are lying close together. Christ is kneeling on a rocky outcrop above them, in agonized prayer. Five angels have appeared with a horrifying image of the instruments of Christ's torment. In contrast to Mantegna, who painted a polished and intensely detailed composition focused on the figure of Christ, Bellini (ill. 31) distributed his figures more loosely across a wide landscape. In the foreground the disciples sleep on a clean sweep of sand, while in the background an extensive landscape dotted with woods and villages unfolds. The head of Christ, who is in dialogue with God the Father, is outlined above the whole scene in the rays of the setting sun. Here, Bellini has stressed the atmospheric mood of the evening rather than the drama to come. Bellini, it has to be noted, was far more interested in color than form.

31 Giovanni Bellini
Agony in the Garden (Christ on the Mount of Olives), 1459
Egg tempera on wood, 81 x 127 cm
The National Gallery, London

Depicted as a transparent, immaterial apparition, the angel is symbolically extending the cup to the Son of God, while Christ is still despairingly struggling with his fate: "O my Father, if it be possible, let this cup pass from me; nevertheless, not as I will, but as thou wilt" (Matthew: 26, 39).

The San Zeno Altarpiece

32 Donatello
Altar for the Santo in Padua, after a reconstruction by H. W. Janson

In 1443, Donatello was commissioned to complete a high altar that was dedicated in 1450. The altar was a combination of bronze reliefs in the predella with free standing, fully three-dimensional figures above. The structural device of the columns inspired Mantegna's treatment of space in the *San Zeno Altarpiece* (ill. 33).

33 (opposite) *San Zeno Altarpiece*, 1457–1460
Distemper (and other paints) on wood, 480 x 450 cm
San Zeno, Verona

The framework for this devotional painting of Mary is mostly original, though the three predella paintings were replaced by canvas copies during the 19th century. The original wooden panels are now to be found in Paris (ill. 38) and Tours (ills. 36, 37, 39), legacies of Napoleon's appropriation of works of art as war booty. In the left-hand panel stand Saints Peter and Paul, John the Evangelist and St Zeno, who gave the church and the altar his name. To the right, Saints Benedict, Lawrence, Gregory and John the Baptist are depicted.

Mantegna's twin themes of the representation of space and the use of painting as an illusionistic medium – themes already hinted at in the Ovetari frescoes – were taken further with the altar in the church of St Zeno in Verona (ill. 33). The patron for this commission was Giorgio Correr (1409–1464), who was a notary to the papal Curia and the Abbott of St Zeno. The format was modelled on Donatello's altar for the Santo in Padua (ill. 32), which is no longer in its original form, however, because of later alterations. Donatello had used two columns to separate Mary from the saints around her and had provided her with her own, very compact, space. Similarly, Mantegna retained the separation into three parts as in the design for a panelled altarpiece, but now made the individual sections equal in size, and linked them by having them depict the same space.

Mantegna's altarpiece can be compared with an altarpiece by Domenico Veneziano (ca. 1400–1461) for the church of Santa Lucia dei Magnoli in Florence (ill. 34). Here too the architecture of the scene is divided into three sections – a continuing reference to the Gothic design for a polyptych that can also be seen in Mantegna's *St Luke Polyptych* (ills. 22, 23). In Veneziano's picture, pillars are used to separate the area

round the Madonna from the saints accompanying her, though they share the same overall space. However, Veneciano's structure contains an optical distraction: Mary is sitting in the center of a three-arched loggia that is situated behind the saints. However, because the tops of the arches coincide with the upper edge of the picture, they extend over the heads of the saints and seem to occupy the upper foreground of the painting. Moreover, the architectural setting behind Mary has no firm anchor from a spatial point of view. The central niche frames Mary and seems to provide the backrest for her throne, but the precise alignment of the architecture changes according to where the viewer looks. Nevertheless, the correctly portrayed architectural perspective provides both a structure for the painting and also an ornamental framework for the scene. In addition to this imaginative spatial organization, another innovative feature of Veneziano's picture is that the architecture behind Mary opens to the heavens, the light falling onto the scene being transformed into the picture's light, delicate tones.

In his altarpiece (ill. 33), painted about ten years later, Mantegna went even further. The Madonna and saints are in a box-shaped space on a platform open from all sides. The three-dimensional half-columns of the wooden frame are backed by painted pilasters indicating where the picture's fictive space begins. This space, a stage created by illusionistic devices, provides a framework for a *Sacra Conversazione*. In paintings representing a *Sacra Conversazione,* the saints are there to intercede for the pious worshipper: they offer themselves to the faithful as intermediaries who can be addressed directly.

On the medallions of the piers are painted flat gray-on-gray reliefs of mythological scenes symbolizing pagan antiquity. Below the coffered ceiling runs a frieze decorated with putti, horns of plenty, and palms. According to the Book of Ezekiel in the Old Testament, the palm motif between two angels was a decoration used in Solomon's temple; here, therefore, it is to be read as a reference to the covenant of the Old Testament. The frieze, then, acts as a link between the pagan world as represented on the piers and the Christian world of the New Testament vividly represented in the painting. The

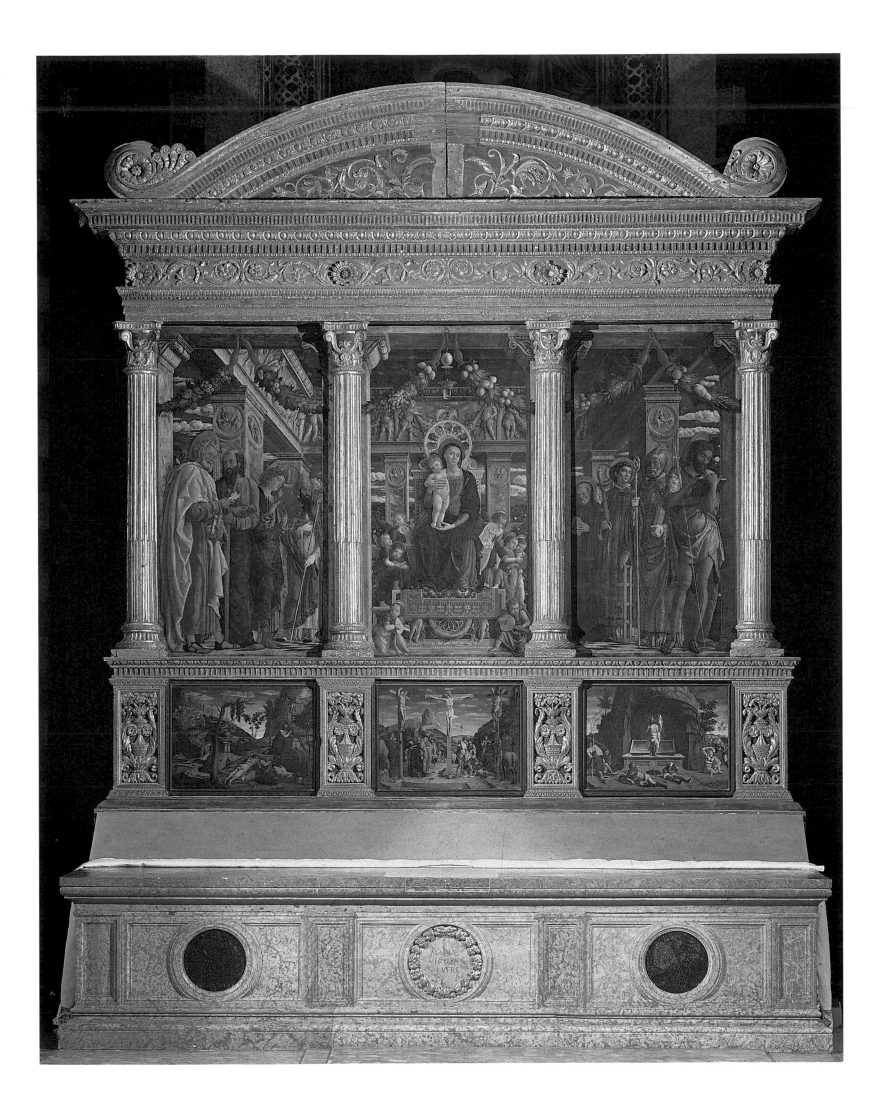

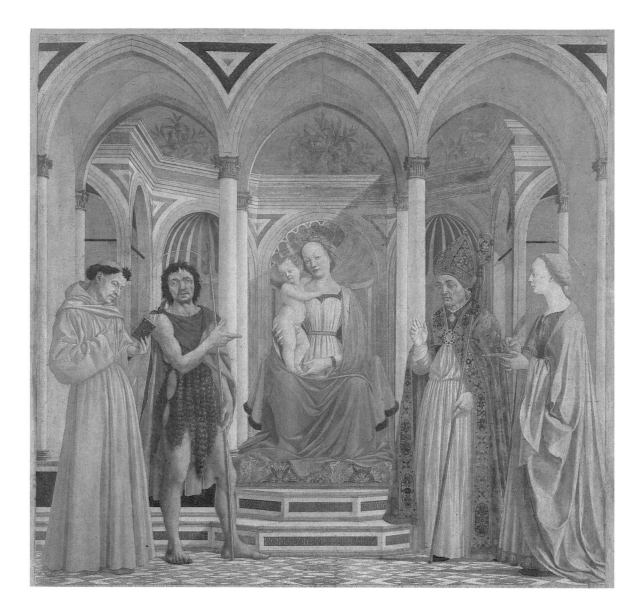

34 Domenico Veneziano
Madonna with Child and Saints, before 1446
Distemper on wood, 209 x 216 cm
Galleria degli Uffizi, Florence

This altarpiece was intended for the chapel of the Uzzano family in the church of S. Lucia dei Magnoli in Florence. Like Mantegna's *San Zeno Altarpiece,* this is a *Sacra Conversazione,* a "holy conversation" or holy gathering in which the Mother of God is surrounded by saints. This is a very early example of a *Sacra Conversazione* in which the figures are shown in a consistently uniform architectural setting.

representatives of the New Testament, life-size and resplendent in bright colors, stand before the two stages of existence preceding them in the history of human development, the world of the Old Testament and the classical world. These earlier stages are represented by works of art. In comparison, Mary and the gathering of saints seem real and animated: they alone can lay claim to the living truth. They appear to occupy the same level of reality as the viewer – it is easy to imagine that we can hear the angels singing. On the steps of Mary's throne (ill. 35) the contrast is quite clear: near the classical stone putti half-hidden by a rug sit little angels making music, a corner of their robes falling out into the viewer's space.

At the same time, the scene within the picture's fictive space is one of spiritual exaltation, an image of the hope of acceptance into this holy circle on the distant day of the Last Judgment. The figures seem almost within reach and yet far removed from us in their heavenly sphere. This paradox was reflected in the very execution of the painting: Mantegna presents painting itself as an instrument of illusion. In this altarpiece he is commenting on the power of painting to illustrate both

earthly and heavenly reality at one and the same time; and, therefore, to represent art itself.

In contrast with the *Madonna and Child Enthroned* on the main panel of the *San Zeno Altarpiece,* the predella shows scenes from the Passion (ills. 36–39). Here too there is a concrete point of reference for the viewer. In the central panel, which shows the *Crucifixion* (ill. 38), two men intrude into the lower part of the painting, as though they were just about to move from the viewer's space outside the picture and climb the steps up to the level of Golgotha. They are cut off cleanly by the frame: the head of the man on the right is just coming into view, while the soldier on the left, who can be identified as Longinus, can be seen clad in Roman armor and holding a lance. Longinus, after piercing Christ's side as He hung on the Cross, was converted when holy blood ran down his lance. Here he is depicted acknowledging the divinity of the Son of Man to his companion, who thus assumes the role of a viewer standing between the two worlds. This witness is the intermediary between the living experience of the Crucifixion and a believer's identification with the story of the Passion every time it is told or illustrated.

35 (opposite) *Madonna with Child Enthroned,* (detail ill. 33), 1457–1460

Mary's throne is covered by a decorative Anatolian rug that testifies to Italy's trading connections with the Orient. The horizontal S-shape on the outside border is the first letter of the Armenian expression for "God the Almighty." Where possible, a place of worship would also be furnished with rugs with Christian symbols.

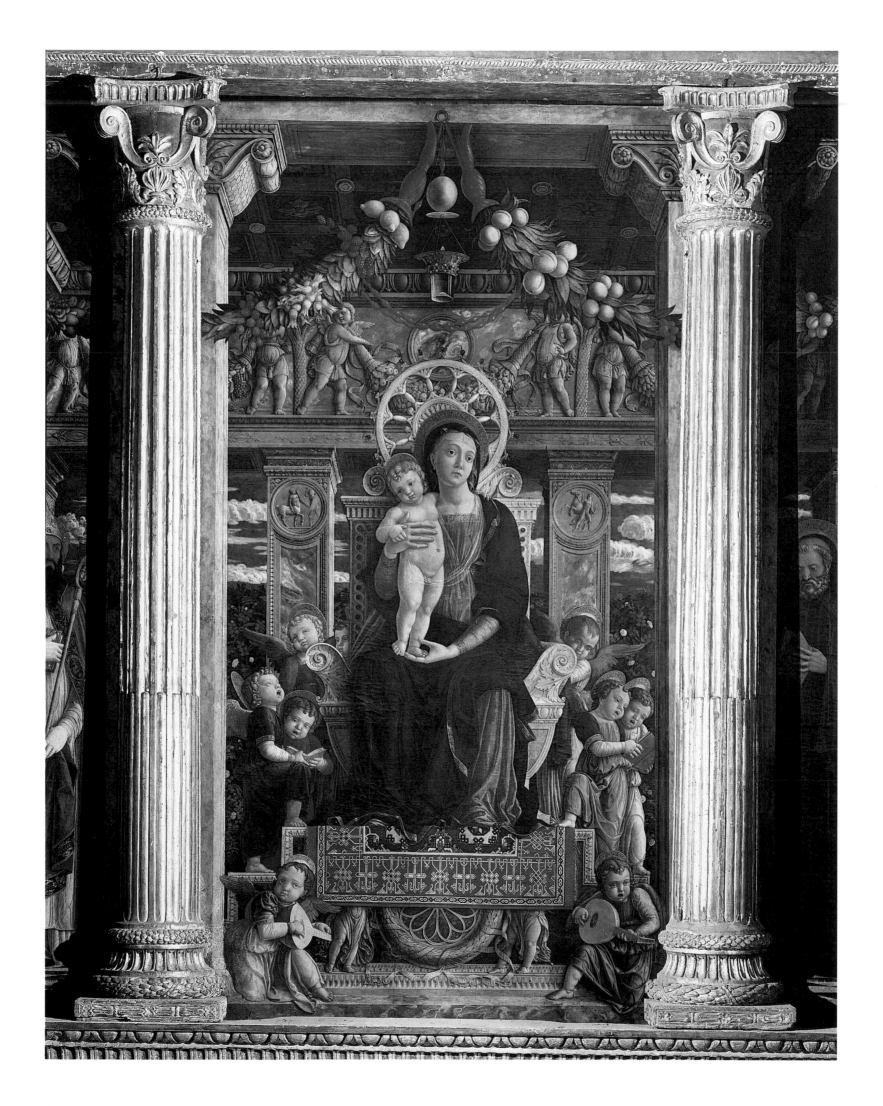

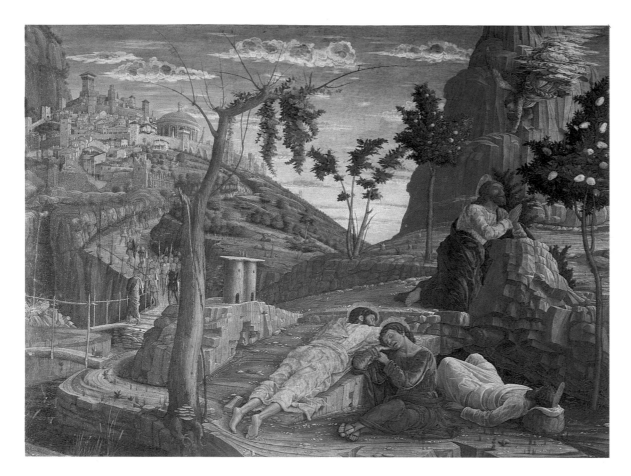

36 *Agony in the Garden (Christ on the Mount of Olives)*,
1457–1460
From the predella of the *San Zeno Altarpiece* (cf. ill. 33)
Distemper on wood covered with canvas, 71.5 x 94 cm
Musée des Beaux-Arts, Tours

The composition of this picture is similar to the version
of the same subject in the National Gallery in London
(ill. 30). Gethsemane is better described as an orchard
than as a garden. As in Bellini's version of the Mount of
Olives scene (ill. 31), an angel is floating on high with the
cup that symbolizes the inexorable fate reserved for
Christ. This detail demonstrates the lively exchange of
ideas between the two artists.

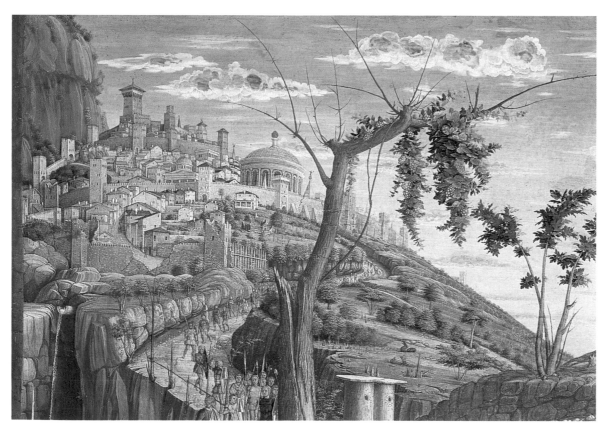

37 *Agony in the Garden (Christ on the Mount of Olives)*
(detail ill. 36), 1457–1460

Beyond the dead tree Mantegna has attempt to depict
Jerusalem in accurate detail. A winding road leads
through a rural scene with unrepaired boundary walls, to
the main gate. The central temple towering over the rest
of the buildings was modelled on the Omar Mosque,
which in the Middle Ages was often taken for Solomon's
Temple.

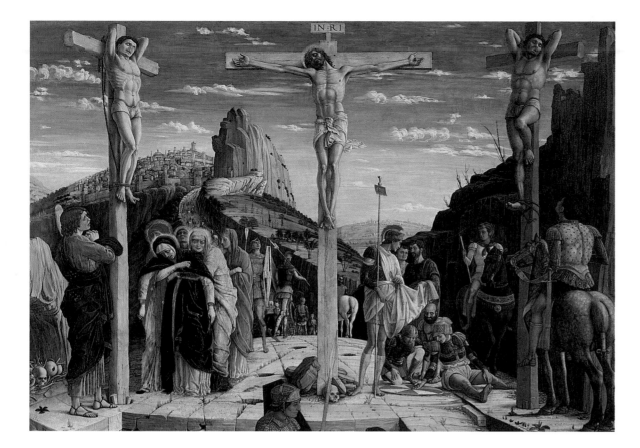

38 *Crucifixion,* 1457–1460
From the predella of the *San Zeno Altarpiece* (cf. ill. 33)
Distemper on wood, 67 x 93 cm
Musée du Louvre, Paris

This scene takes place on a cracked rocky plateau on Golgotha. The place of execution is marked by holes in the rock that had already been used for other crosses. At the foot of Christ's Cross lies the skull of Adam, the first man. According to legend, Adam's grave was at Calvary and was exposed by the earthquake when Christ died.

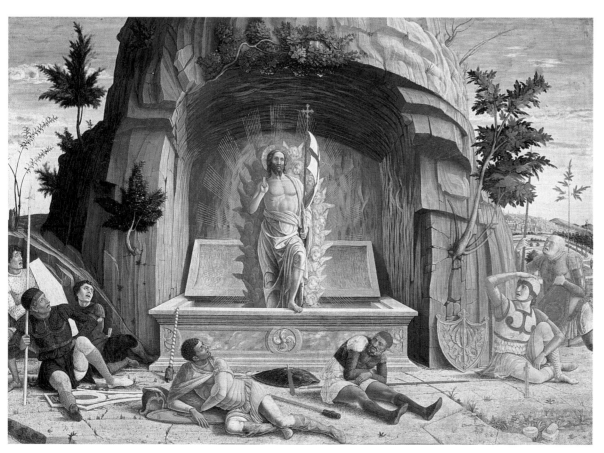

39 *Resurrection,* 1457–1460
From the predella of the *San Zeno Altarpiece* (cf. ill. 33)
Distemper on wood, 71 x 94 cm
Musée des Beaux-Arts, Tours

In the center of this painting, the bright apparition of Christ stands out, emphasized by the darkness of the rocky grotto. The faces of the guards show a range of reactions to the miracle of the Resurrection, from a still sleepy figure gazing in front of him to a soldier rising to his feet in amazement.

40 *Lamentation Over the Dead Christ (Christo morto)*,
1464–1500
Distemper on canvas, 66 x 81 cm
Pinacoteca di Brera, Milan

This picture was in Mantegna's studio when he died. The
Italian title in the inventory of the estate was *Cristo in
scurto*, "foreshortened Christ," a prosaic studio
description that describes not the subject but how it was
presented. We do not know who the patron was, where it
was meant for, or exactly when it was painted. Perhaps the
artist had painted this picture, with its very unusual color
scheme and composition, for himself.

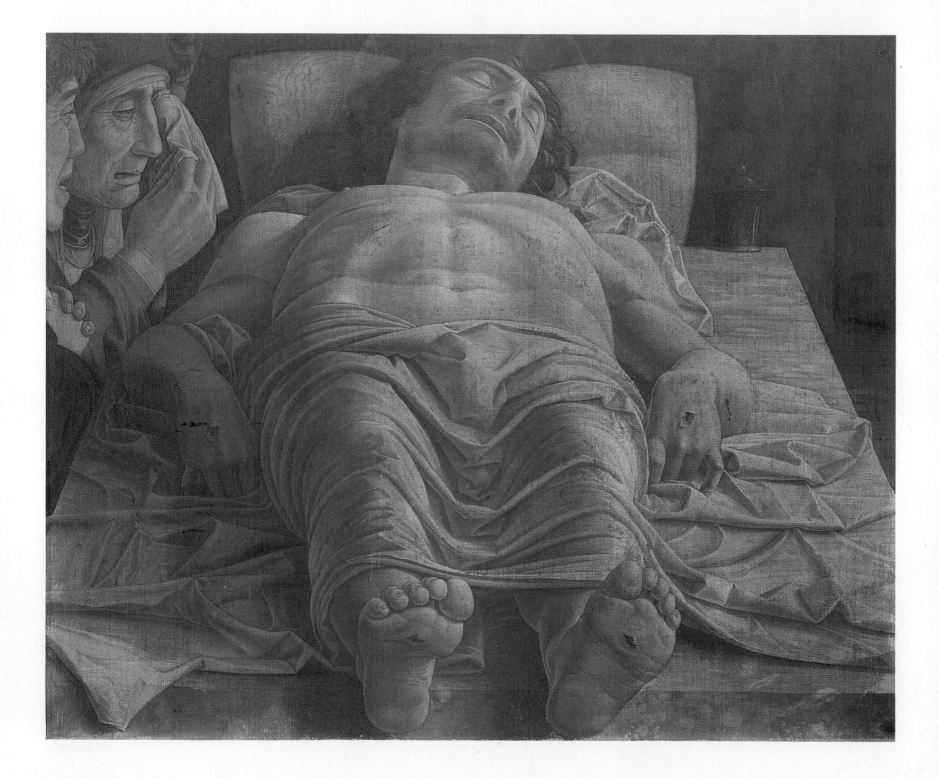

The body of Christ lies as heavy as lead on a mortuary slab, the cloth molds itself to the body and to the slab as though it were wet (ill. 40). The figure of Christ has a chiselled look, as if each element, the body, the cloth, and the slab, were carved from of the same material. The skin cracks dryly around the wounds, which the position of the hands and feet make clearly visible.

Unprecedentedly, we have a view of the soles of Christ's feet, which are hanging out towards us over the edge of the slab. The body is extremely foreshortened, the head resting on an upright support that lifts it just above the level of the torso. In spite of the foreshortening, the body has a physical presence undiminished by the unnatural posture or the depth of the perspective. In contrast, the body of

St Christopher in Mantegna's Eremitani frescoes (ill. 13), and the sleeping disciple in the foreground of the *Agony in the Garden* (ill. 30) lead our eyes to the heart of the painting. But here, in the *Lamentation over the Dead Christ,* the figure points to nothing but itself. The vanishing point of the perspective is above the composition so that the viewer is looking down at Christ, but not over Him to something else, as the edge of the picture behind Christ's head prevents the eye from moving on. This perspective and the device of bringing the body right up to the edge of the painting appear to deny the dignity of the corpse and the distance inherent in His divinity. He becomes an immediate, profane presence, a direct and provocative summons.

The corpse occupies the center of the painting. To the left,

41 (below) *Man Lying on a Stone Slab,* 1470–1480
Ink on paper, 16.3 x 14 cm
British Museum, London

Mantegna had certainly executed studies from life for his portrayal of *Cristo morto* (ill. 40). In this pen drawing, the relationship between the figure and the stone slab is similar to that in the painting. But here a living figure is represented, not necessarily Christ. It could also be a classical warrior in repose or Lazarus raised from the dead.

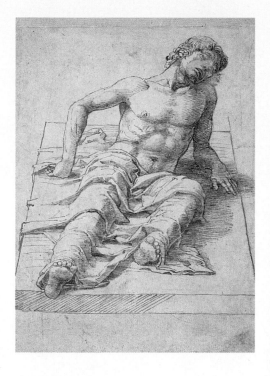

42 (right) Rogier van der Weyden
Lamentation Over the Dead Christ, ca. 1450
Oil on wood, 110 x 96 cm
Galleria degli Uffizi, Florence

This painting combines the subjects of interment and mourning. The lid of the sarcophagus, has been used as the mortuary slab, as the jar of oils standing to the right in the foreground shows. The slab is now serving as a base for Christ and John. The inspiration for setting the scene of mourning in front of the tomb presumably came from one of the compositions by Fra Angelico (ca.1400–1455) that Rogier van der Weyden saw during his travels in Italy in 1450. This painting by van de Weyden documents the two-way exchange of artistic ideas between the Netherlands and Italy.

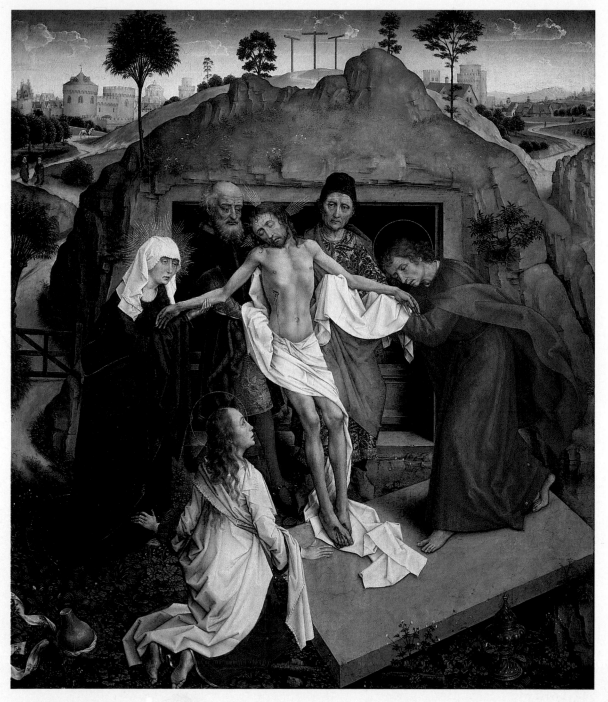

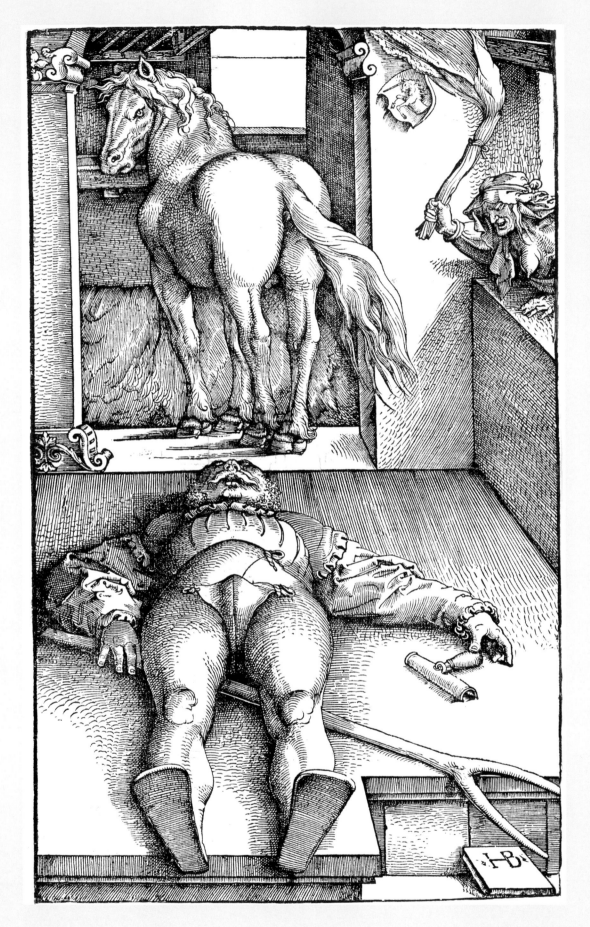

crowded against the edge of the picture, are three faces consumed with grief. Two of these are radically cut off at the edge. The opposite side appears to be empty at first sight, but the jar of oil standing on the upper corner of the slab provides the key. By framing the head like this, on both sides, Mantegna reveals the double subject of the picture: the lamentation and the dressing of the corpse. This narrative, however, is only symbolically indicated. Mary is just drying her tears; next to her lies the body of Christ, alone, with no-one touching Him, as is the custom with mourning.

Like the action, the colors are restrained and help to distance the event further from reality. The body lies pallid on the reddish slab, as though it had drained the figure of blood. The slab is stained with blood, tears, and oils. With this device, the accoutrements of death acquire a special significance as concentrated symbols of the Passion. In accordance with Jewish burial rites, after being removed from the cross, Christ's corpse was washed, dressed with aromatic oils, and then wrapped in clean linen. This ritual was carried out on a slab on which Mary's tears "left marks which, to this day, have not been eradicated," in the words of the 12th-century Byzantine writer Johannes Cinnamus (quoted by the art historian Andreas Prater, 1985). The mortuary slab, which was at that time kept in Constantinople, was considered one of the greatest relics to have been lost after the Turkish invasion of 1453. This aspect of the painting may provide a clue to a possible patron. When considered in connection with the propaganda about the re-conquest of the Holy Land, the presentation of Christ on the slab could be seen as a challenge to bring this relic back. This is why Andreas Prater suspects that the patron for this work was the renowned Cardinal Bessarion (ca. 1403–1472), the tireless proponent of the union of the Eastern and Western Churches and supporter of the crusades against the Ottoman Turks.

But independently of these specific pointers, Mantegna's work is by no means a mere display of skill or a bravura exercise in the illusionistic and representational possibilities of perspective, which can reconstruct any object one desires, from any viewpoint. Since viewers are looking at the Savior with lowered eyes, a more humble approach may be attributed to them. As close to the body laid out on the slab as the three figures to the left, we are drawn into the scene and become one of the mourners, completing the picture. It is a devotional image that arouses the sharpest feelings of sympathy and grief.

Mantegna's new viewpoint provided the stimulus for a series of severely foreshortened bodies (ills. 43–45). Step by step, the symmetrical and hierarchical composition typical of the early Renaissance was being left behind. How much influence this image had on later artists is demonstrated by a work of the Baroque painter Annibale Carraci (1560–1609), who worked on the same theme as Mantegna, but who set the body apart more, so that it seems constrained by the composition (ill. 44).

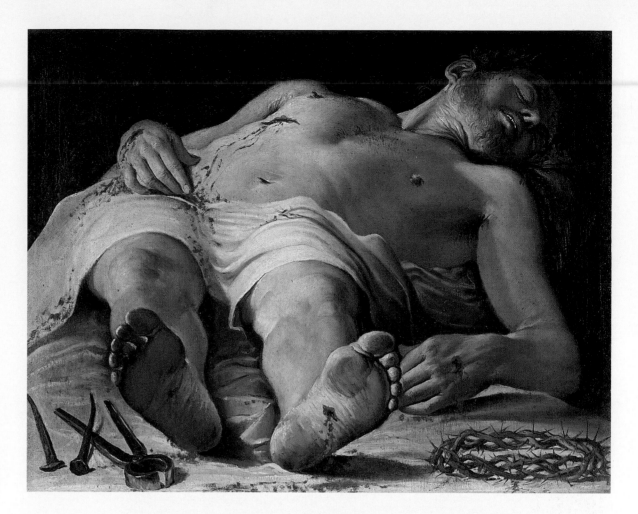

43 (opposite) Hans Baldung Grien
The Bewitched Groom, ca. 1534
Wood engraving, 34.2 x 20 cm
Staatliche Museen zu Berlin – Preußischer Kulturbesitz,
Kupferstichkabinett, Berlin

A fascination for extreme foreshortening of the body is
also illustrated by this wood engraving by a German
artist. Here, Hans Baldung Grien (1484/85–1545), who
made prints of a whole series of sinister witch scenes,
based himself on Mantegna's work, though no specific
prototype has been found for this intriguing scene. Horse
and witch are looking with wild expressions at the
outstretched groom, whose dead faint makes him look
slightly absurd.

44 Annibale Carracci
Dead Christ, ca. 1583–1485
Oil on canvas, 70.7 x 88.8 cm
Staatsgalerie, Stuttgart

Whether or not the great Baroque painter ever saw
Mantegna's *Lamentation Over the Dead Christ* (ill. 40) for
himself is not known, but this version is very close to
Mantegna's. The instruments of the Passion – the two
nails of the cross, pliers, and a crown of thorns – are lying
by the feet of the corpse, which is still bleeding. Carracci
has shifted the upper torso of the figure of Christ out of
center and twisted it slightly so as to bring the tormented
body and the head closer to the viewer.

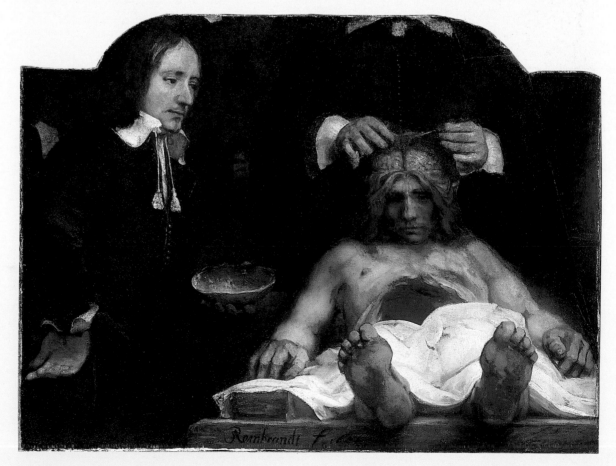

45 Rembrandt van Rijn
Anatomy Lesson of Dr Joan Deyman, 1656
Oil on canvas, 100 x 134 cm
Amsterdams Historisch Museum, Amsterdam

Influenced less by Mantegna than the challenge severe
foreshortening presented to many artists, in this picture
Rembrandt testifies to the activities of the School of
Anatomy in Amsterdam. This is a fragment of a painting
that was originally much larger and showed several
figures; all that is left of the doctor are his hands as they
cut open the forehead. Deyman carried out autopsies
during his lectures on anatomy in the Surgeons' Guild in
Amsterdam. A master of the guild is assisting him and is
holding the crown of the skull.

IN THE SERVICE OF THE GONZAGA

46 *St Sebastian*, 1459
Distemper on wood, 68 x 30 cm
Kunsthistorisches Museum, Vienna

A bearded horseman can be seen in the cloud to the left.
Images in the clouds like this can also be seen in other
paintings by Mantegna, for instance in the third scene of
Triumphs of Caesar (ill. 91) and the painting *The Triumph
of Virtue* (ill. 109). Already described in classical art
theory and adopted by Alberti and Leonardo da Vinci,
these were ascribed to the genius of nature, which could
stimulate artists and inspire them to improve on nature
with their creations.

In 1456, Ludovico III Gonzaga (1414–1478), Marquis
of Mantua, invited Mantegna to be his court artist.
Mantegna did not take up this invitation until three
years later, after the Marquis had improved his
conditions of employment several times. He promised
Mantegna and his family a monthly salary of fifteen
ducats, adequate supplies of corn and wood,
accommodation, and the cost of moving from Padua to
Mantua. In addition to this, Ludovico also gave
Mantegna the right to bear the Gonzaga coat of arms
and gave him fine materials in the Gonzaga colors so
that he could have his court costume made. Yet in spite
of all these privileges, Mantegna continued working in
Padua after 1456, particularly on the altarpiece for San
Zeno in Verona, and at the end of 1458 he even bought
a house in Padua. He was clearly undecided about
whether he should place himself under the authority of
a ruling family, since that would mean he had to work
exclusively for the Gonzaga court. Commissions, after
all, were plentiful in Padua, where he worked for
influential personalities such as Giacoma della Leonessa,
the widow of the renowned commander Gattamelata
(1370–1443), in whose palace Mantegna decorated a
room with scenes from the life of her husband (works
destroyed by fire in 1760).

The small, exquisite painting of *St Sebastian* (ill. 46)
dates from this period, possibly commissioned by Jacopo
Antonio Marcello, governor of Padua and a confidant of
the Gonzaga. Images of the saints were extremely
popular. As a handsome young Roman officer in the
service of the Emperor Diocletian, *St Sebastian* chose to
stand by his fellow Christians in the prisons of Rome
during the violent persecutions of the early Church.
Because he survived the first martyrdom of being shot
by the arrows of Numidian archers, and only met his end
through a second torment, by being cudgelled to death,
he was seen as having conquered death, and was therefore
chosen as the patron saint of plague victims. In 15th-
century Italian art, portrayals of St Sebastian offered the
opportunity of depicting an idealized nude figure in a
classical setting. Mantegna tied the saint to the column
of a triumphal arch both to emphasize his heroism and
at the same time to stress the precise historic setting. Yet
the atmosphere is less authentic than it might seem at

first glance. The triumphal arch stands in a courtyard
closed off by a wall: he would certainly never have found
a setting like this in antiquity. Debris from statues and a
fragment of a bacchanalian relief lie around, indicating
the fall of the pagans and the victory of Christianity. Even
this is to be understood more as a symbolic reference,
since, from the historical point of view, paganism was far
from being overthrown in Sebastian's time. The nude
figure of the saint appears more sensual than agonized.
The clergy could not be absolutely sure that the believers
praying before this depiction of the saint, whose softly
lit body twists in unnatural *contrapposto*, were filled only
with chaste thoughts.

Mantegna proudly signed this work, in Greek letters,
on the left-hand side of the triumphal arch, as though
he wanted to assume the mantel of the great Greek
painters. However, this is not simply the expression of
an excessive degree of self-confidence, because even his
contemporaries acknowledged him as "the new
Apelles," equating him with the famous painter of
classical Greece.

While he was completing these works, Mantegna was
repeatedly allowed to defer taking up his post by the
patient Ludovico III Gonzaga. Finally, however, in
1460, Mantegna let his house in Padua and on 7 August
moved house to Mantua. As Mantua had no strong
artistic tradition of its own, Mantegna – not yet thirty
years old and with his reputation as one of the leading
moderns – was a great coup for the court. Ludovico
wanted his residence, the Castello San Giorgio, built
1390–1406, transformed into a palace. The conversion
work was also to include the royal chapel, the decoration
of which became one of Mantegna's first duties. This too
was destroyed, this time in the second half of the 16th
century.

Today, three paintings from this chapel are mounted
as a triptych in the Uffizi in Florence (ills. 47–49),
though they were probably given this format as recently
as 1827, when the frame was made. The differing sizes
of the paintings, and the inconsistencies in both
composition and iconography indicate that these are
individual works rather than parts of a uniformly
planned altarpiece. Nevertheless, these three paintings
(ills. 47–49) could have been created for the same chapel.

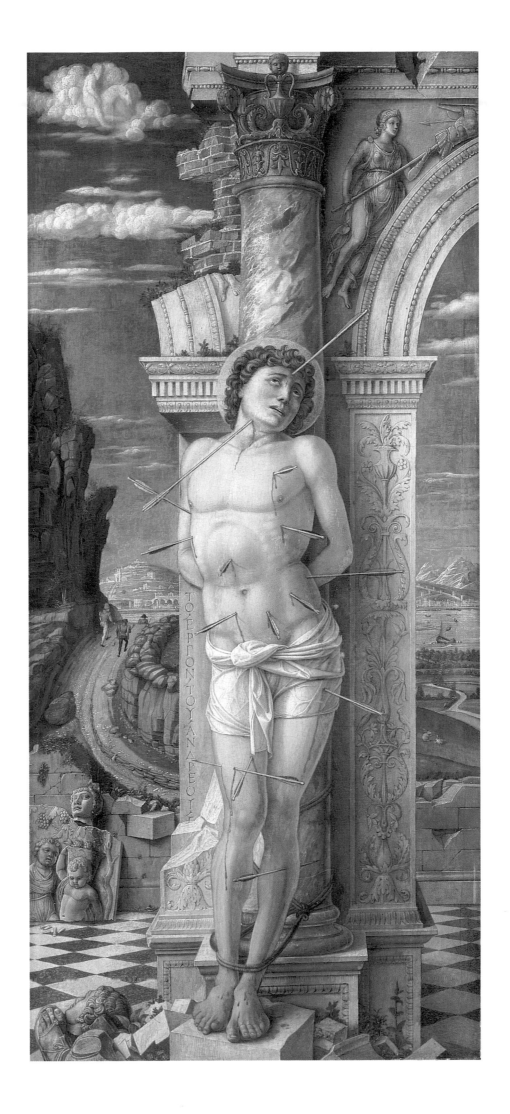

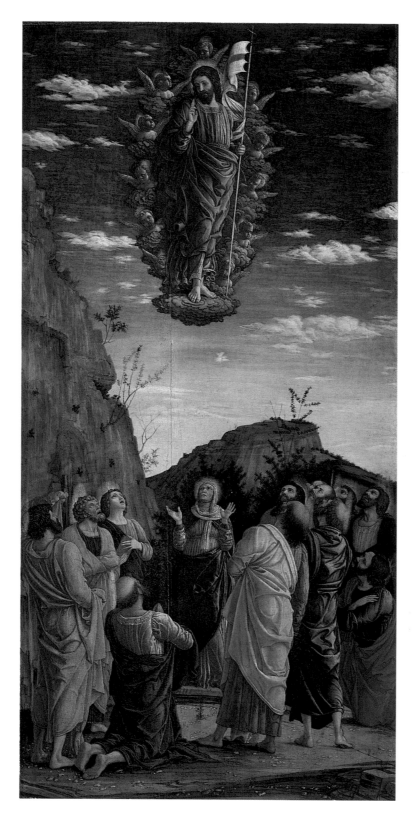

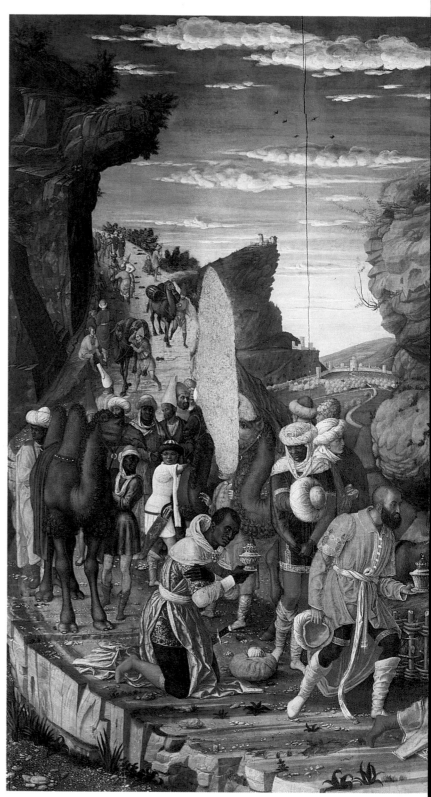

47 *Ascension*, ca. 1460
Distemper on wood, 86 x 42 cm
Galleria degli Uffizi, Florence

Above the saints, who gaze upwards, Christ floats
somewhat stiffly, surrounded by a mandorla of angels.
Immediately below Him stands Mary, occupying a special
place in the lower section, the only figure facing forwards
and slightly raised on a ledge of rock. Compared with the
imaginatively decorated depiction of *The Circumcision of
Christ* (ill. 49), this painting, executed for the same
chapel, seems fairly uninspired.

48 *Adoration of the Magi*, ca. 1460
Distemper on wood, 76 x 76.5 cm
Galleria degli Uffizi, Florence

The Three Magi symbolize both the three ages of man
and also the three continents known at that time, Asia,
Europe, and Africa. The adherents of different cultures
among the followers of the kings are depicted realistically
– they were familiar because of the activities of
cosmopolitan Venice, a major trading center and slave
market. The wise men pay three-fold homage to Christ:
they bring gold for the King of Man, frankincense for the
Son of God, and myrrh, an allusion to Christ's sacrificial
death to redeem mankind.

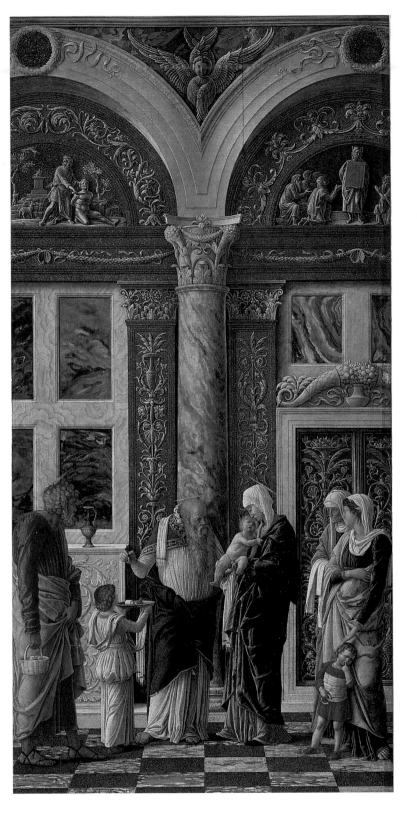

49 *The Circumcision of Christ,* ca. 1460
Distemper on wood, 86 x 42 cm
Galleria degli Uffizi, Florence

The subject of this this painting is the circumcision of Christ
eight days after birth, therefore on New Year's Day. Since the
late Middle Ages, New Year's Day had often been connected
with images of the presentation at the temple 40 days later,
as prescribed by the law of Moses (Luke 2: 21–38). Joseph is
carrying a sacrifice of two doves in a basket. The setting is
very richly decorated. In the lunettes, two related scenes
from the Old Testament are depicted: left, Abraham's
sacrifice; right, Moses' presentation of the stone tablets on
which the Ten Commandments were written.

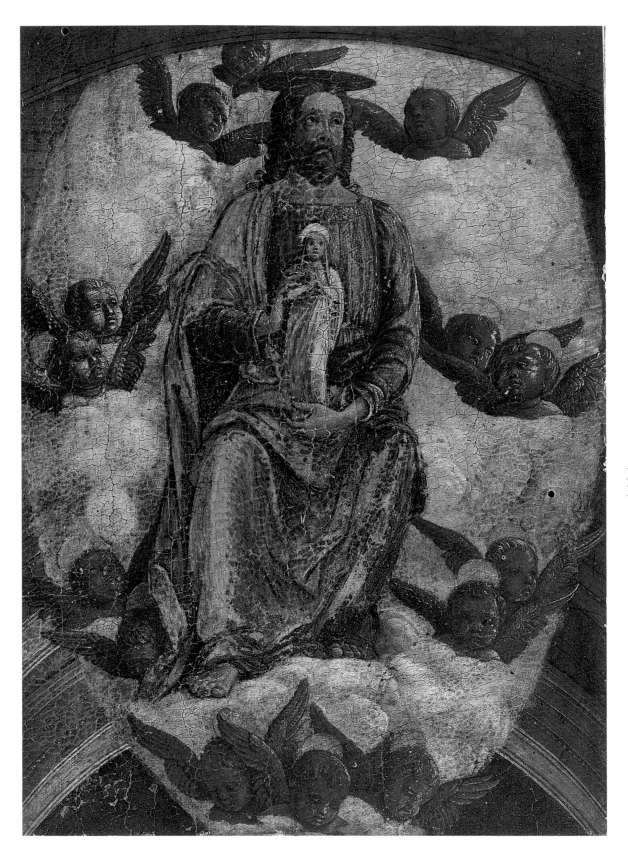

50 (left) *Christ with the Virgin's Soul,* ca. 1460
Distemper on wood, 27 x 17 cm
Collezione Baldi, Ferrara

As a vision perceptible to the viewer, but not to the disciples, Christ is floating in an aureole in the vault.

51 (below) Reconstruction of the original link between *Christ with the Virgin's Soul* (ill. 50) and *Death of the Virgin* (ill. 52).

The overall composition depicted in this reconstruction was based on a mosaic in the Mascoli Chapel in St Mark's in Venice. This was formerly attributed to Mantegna, but today it is thought to be the work of Andrea Castagno.

If all of these paintings belonged to the chapel, then the decoration must have been based on a simple scheme of incidents from the holy story, from the birth of Christ to Mary's death. Since it was a court chapel, the *Adoration of the Magi* (ill. 48) was the principal picture and was presumably placed in the altar niche (which accounts for the concave format of the panel). We can assume that it was flanked by two vertical paintings that have not been preserved. All the panels are exceptional for their rich colors and the use of gold. Mantegna did not use real gold, but a color simulating gold, as recommended by Leon Battista Alberti (1404–1472) in his famous treatise "De Pictura" (On Painting). Patrons often wanted gold leaf, as this meant that they could make a public display of their wealth while also demonstrating God's splendor. But this type of gilding always seemed flat and artificial, and disturbed the unity of the composition, whereas a paint that looked like gold

52 (opposite) *Death of the Virgin,* ca. 1460
Distemper on wood, 54 x 42 cm
Museo del Prado, Madrid

This scene takes place in a hall viewed in perspective. Mary is on a bier at a distance from the viewer, with the eleven Apostles around her, each with his own part to play in the sacrament of death. The view from the window is spectacular. It shows Mantua with the long bridge over the river Mincio.

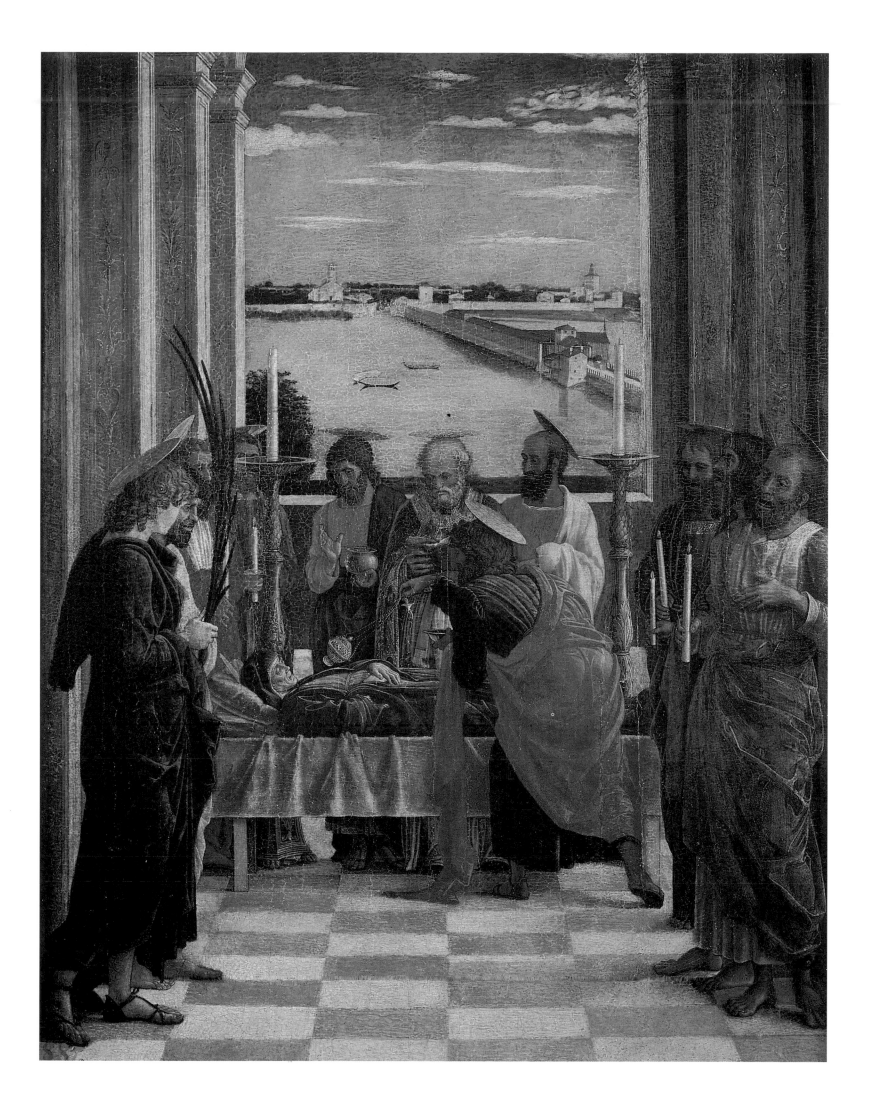

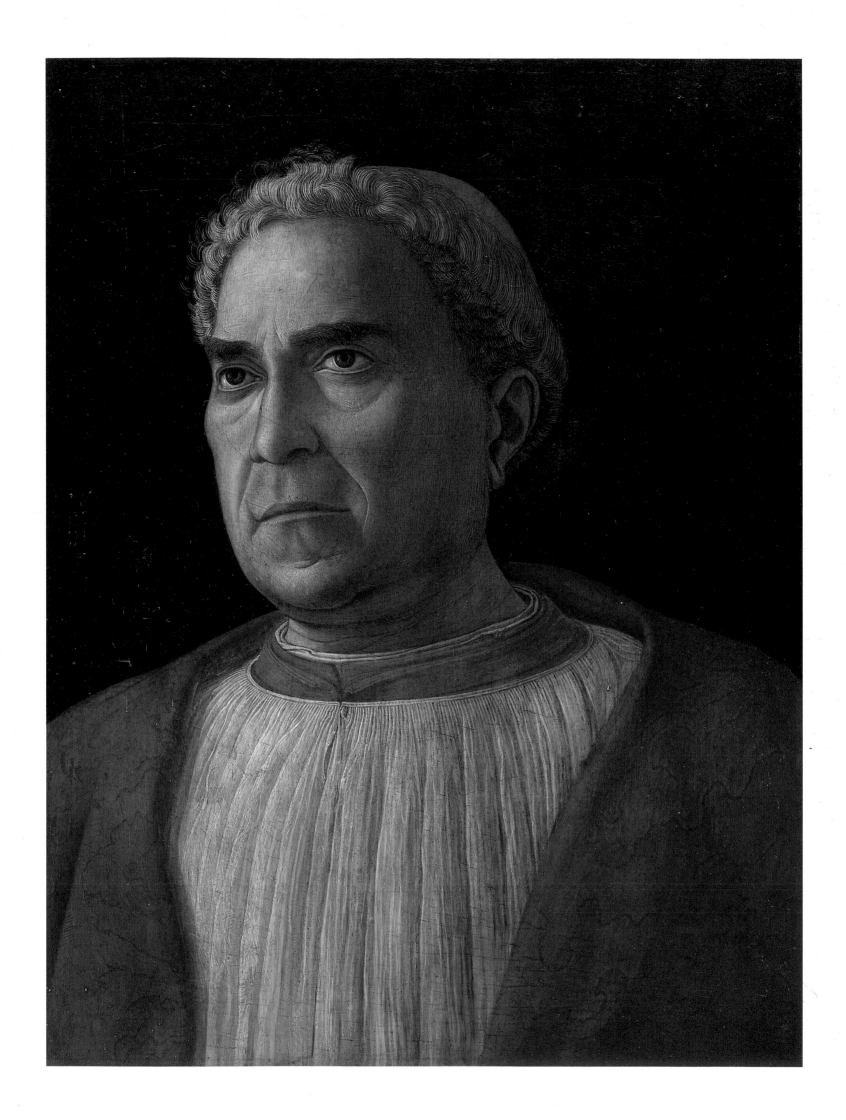

53 (opposite) *Portrait of Cardinal Lodovico Mezzarota,*
1459/60
Distemper on wood, 44 x 33 cm
Staatliche Museen zu Berlin – Preußischer Kulturbesitz
Gemäldegalerie, Berlin

The sketches for this portrait were completed during the
Church Council convened by Pope Pius II in 1459/60,
which was to have united Europe against the Ottoman
Turks. Cardinal Ludovico Trevisano (1401–1465) was a
warlike prince of the Church, fully conscious of his
power, and a close friend of Ludovico III Gonzaga. The
portrait is one of the earliest examples of the use of the
three-quarter profile in Italian art, a format that had been
developed in the Netherlands during the first half of the
15th century.

54 (below) *Portrait of Cardinal Carlo de' Medici,*
1460–1470
Distemper on wood, 41.5 x 29.5 cm
Galleria degli Uffizi, Florence

Carlo de' Medici (1428–1492) was an illegitimate son of
Cosimo de' Medici, the influential ruler of Florence. His
robe identifies him as a prelate; his seat was Prato
Cathedral. In 1466 Mantegna was working in Florence
for Ludovico Gonzaga and may have painted the
Cardinal at this time. However, recent research has
thrown doubt on the identity of the sitter.

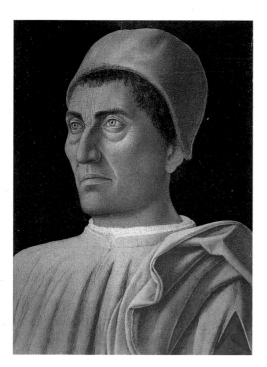

55 (right) *Portrait of Francesco Gonzaga,* ca. 1460–1462
Distemper on wood, 25.5 x 18 cm
Museo Nazionali di Capodimonte, Naples

This portrait of Francesco, the second son of Ludovico
Gonzaga, was probably Mantegna's first painting for the
court in Mantua. Francesco was called to the papal Curia
in Rome as a boy, in 1459. During the Quattrocento the
standard portrait format was the bust in profile, adopted
from classical medallions.

could achieve a finer effect. Mantegna used this gold
paint for haloes and for angels, for ornamentation on
buildings, sumptuous materials, vessels, candelabra, for
candle flames, and even for the reflections of light
on garments. In this way, instead of stressing the use of
a precious metal, he was able to place more emphasis
on its decorative effects and the reflection of light.
The detailed portrayal of the vessels and various other

objects in interiors demonstrated Mantegna's inventive
gifts, which the Marquis was able to exploit to the full.
His court artist had to design bronze vessels and
tableware, statues, and tapestries. He collaborated with
architects in the conversion of rooms and internal
courtyards, and was responsible for the decorations for
festivals, and for stage sets and costumes, which have
since been lost.

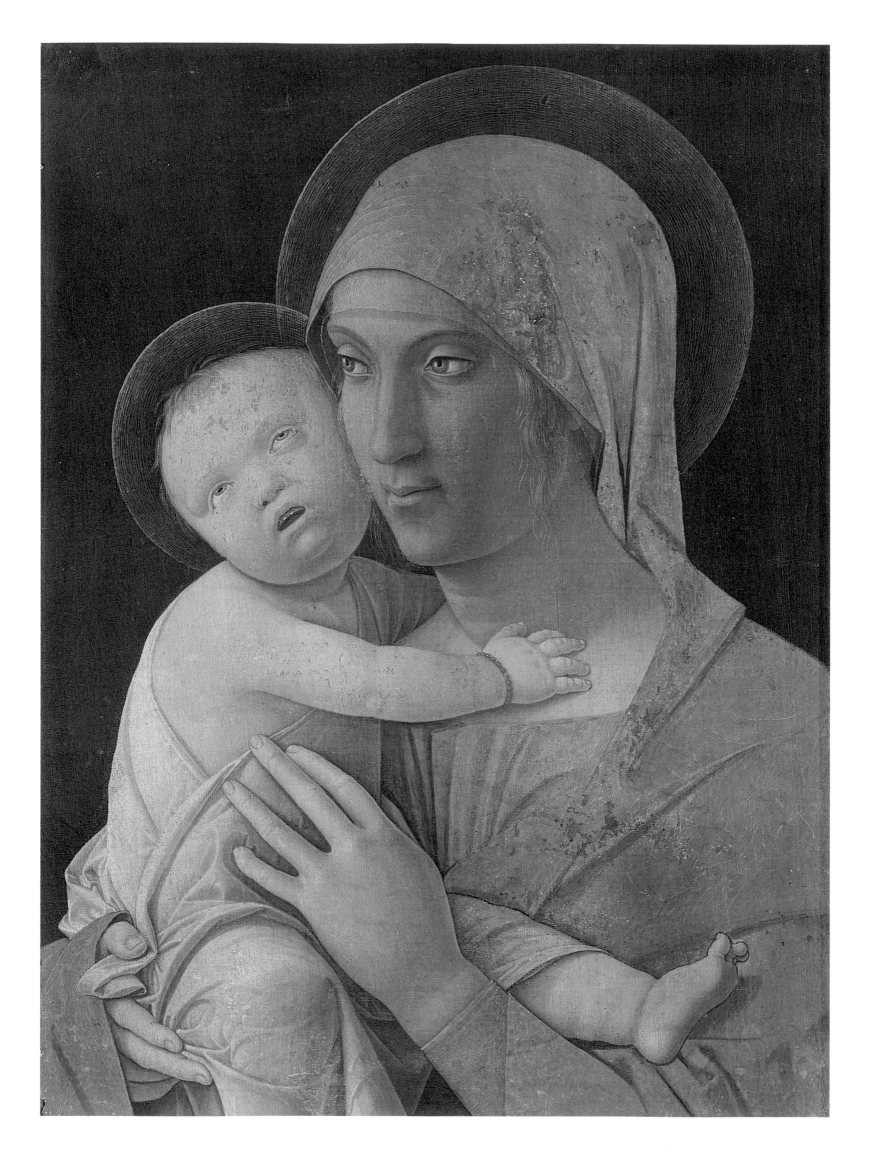

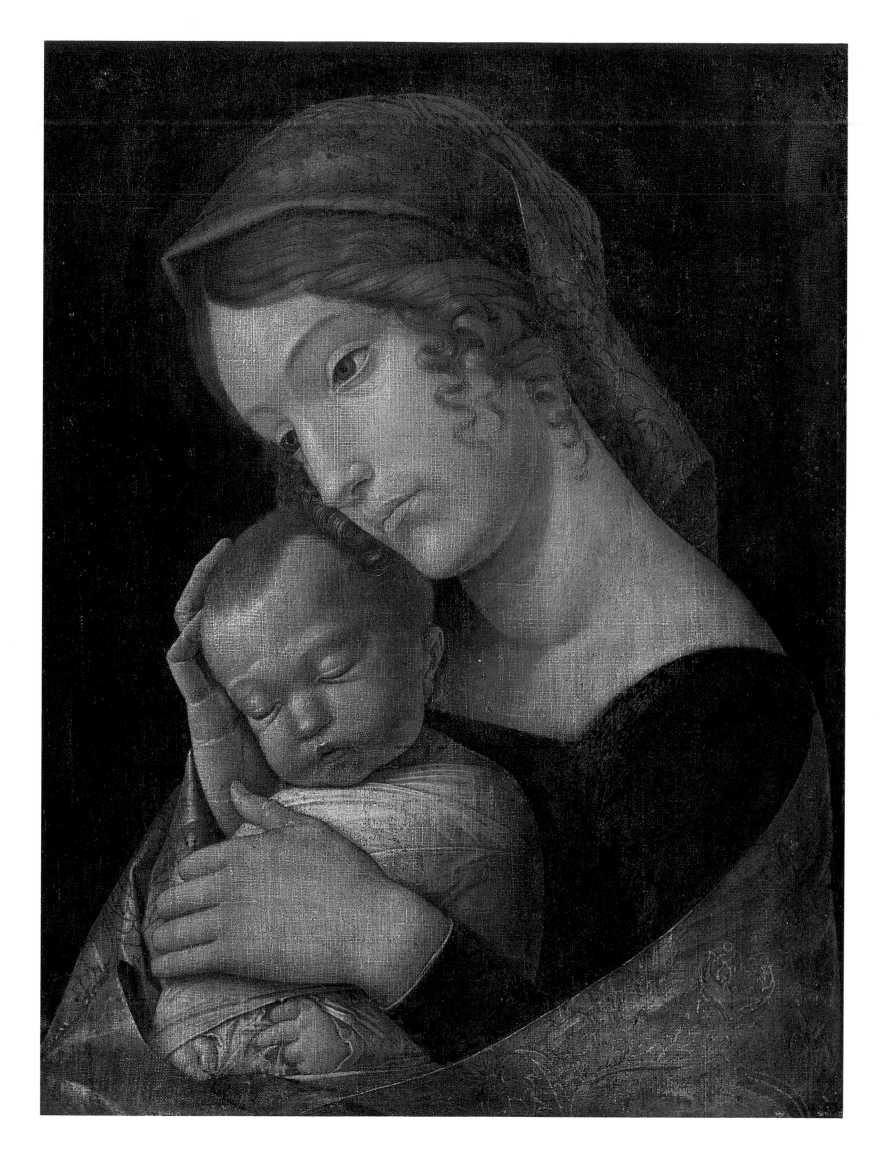

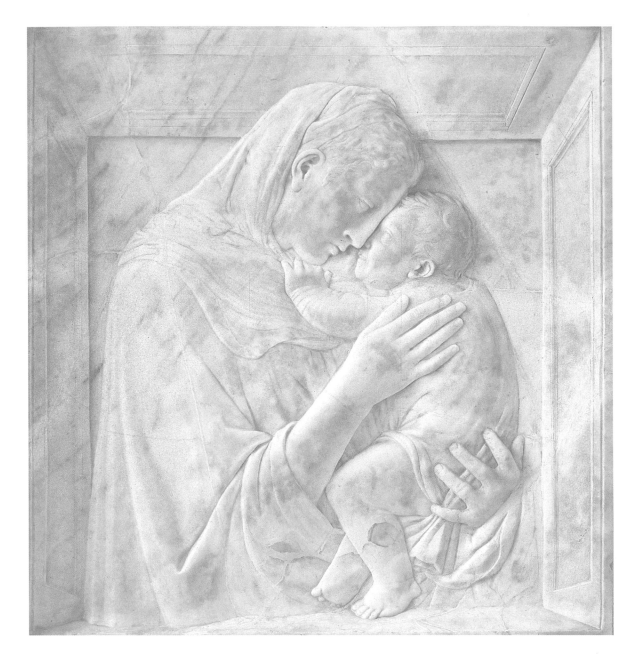

56 (previous double-page, left) *Virgin and Child,*
1480–1495
Distemper on canvas, 43 x 31 cm
Accademia Carrara, Bergamo

Around His wrist, Christ is wearing a coral bracelet, the
blood-red beads of which are a reference to His death on
the Cross. However, coral is also seen as bringing good
luck, though the Christ Child, with His upturned eyes,
already appears to be beseeching God the Father.

57 (previous double-page, right) *Virgin and Child,*
ca. 1465–1470
Distemper on canvas, 42 x 32 cm
Staatliche Museen zu Berlin – Preußischer Kulturbesitz,
Gemäldegalerie, Berlin

Cloaked in a brocade robe, Mary is holding the sleeping
child tenderly in her arms. In their close embrace, the two
figures merge into a single silhouette. Mary's melancholy
gaze forewarns of the Passion of Christ in the distant
future. Mantegna's treatment of color here is very
reminiscent of the devotional painting of the *Lamentation
Over the Dead Christ* (ill. 40) and the *St Sebastian* in Paris
(ill. 87). The composition also betrays the influence of
Donatello.

58 Donatello
Madonna Pazzi, ca. 1420
Marble, 74.5 x 69.5 cm
Staatliche Museen zu Berlin – Preußischer Kulturbesitz,
Gemäldegalerie, Berlin

Donatello's low relief, together with the striking
foreshortening of the hands and feet, creates a convincing
sense of the three-dimensional quality of the figures. The
perspective of the frame surrounding Mary suggests a
view from below. Mary is shown in a classical profile and
without halo. Mother and child touch noses tenderly.
Some of the features, such as the frame, the natural
posture, and Donatello's close observation of human
emotion, can be seen in Mantegna's work.

Major commissions included devotional paintings in
private apartments, and also portraits of members of the
family. Portraits (ills. 53–55), were important as a record
for later generations, and also made it possible to
exchange likenesses with allies and future marriage
partners. This type of work was to some extent
problematic since the sitters tried to avoid the boring
task of sitting as a model. The portraits therefore often
had to be completed from sketches or from memory, one
of Mantegna's skills that was highly appreciated.
Mantegna was not completely happy and in his letters
he complained about his working conditions. But the
patrons were not always satisfied either. Isabella d'Este,
for example, sent her portrait back immediately,
probably because the naturalism of the painting did not
flatter her enough.

During his early years in Mantua, on 22 September
1464, Mantegna traveled to Lake Garda with his fellow
artists Felice Feliciano, Giovanni Marcanuova and
Samuele da Tradate. The companions addressed one
another with classical names and titles such as Imperator
and Consul, wore laurel wreaths on their heads, and
rowed across Lake Garda singing to the sound of lutes,
clearly feeling as though they had transported
themselves to the realms of Arcadia. Their interest in
classical art led them to visit ancient sites such as
Toscolano, mainly to copy the inscriptions there.
During the Quattrocento, knowledge of inscriptions
was particularly significant and often replaced direct
contact with classical works of art. Feliciano and
Marcanuova filled books with copies and imitations,
and carved their own inscriptions on the stones and also
on new work in the classical style. At this time a spirit
of research was intermingled with a general enthusiasm
for antiquity that had no qualms about adding to
authentic material.

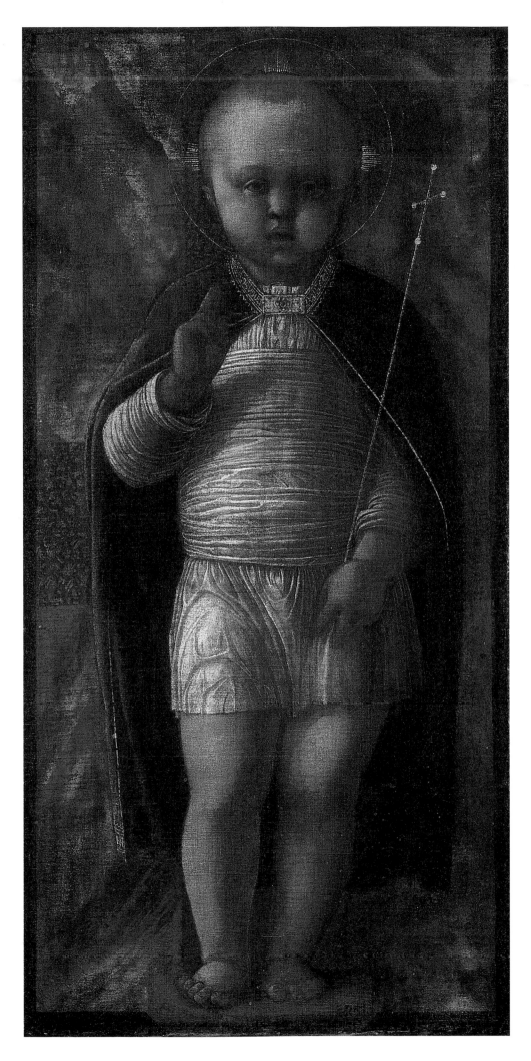

59 *The Infant Redeemer*, 1485–1495
Distemper on unprepared canvas, 70 x 35 cm
National Gallery of Art, Washington

This is the equivalent in painting of the devotional statues
of the Child Jesus, used mainly in the Franciscan ritual.
The Christ Child is depicted as *Imperator Mundi* (Ruler
of the World), his right hand raised in blessing. In His left
hand He holds a wand on which there is a cross; this
wand is at once a regal scepter and a symbol of the
Passion to come. The picture was presumably hung over a
doorway so that Christ gave a blessing to all those coming
in and going out.

THE CAMERA DEGLI SPOSI

The *Camera degli Sposi* is on the first floor of the northeast tower of the Castello San Giorgio in Mantua, a tower distinctive because of its off-center windows. The castle was built between 1390–1406 in what was even then a consciously historical style: though it is clear that *all'antica* did not mean simply an historically correct classical style, it also covered the style of the Romanesque Middle Ages. From about 1456, Ludovico Gonzaga had the walls extended to make an impressive residence; the courtyards had loggias added, and sweeping spiral staircases giving riders (and their horses) access led to the upper floors, which were decorated with frescoes.

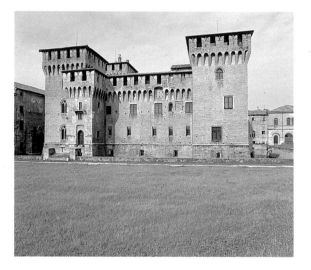

Mantegna's main work in Mantua, a work that was to form the basis of his reputation and that of his patron, was the *Camera degli Sposi* as it is known (ill. 61), the only completely preserved room of frescoes by Mantegna. The name "Room of the Bride and Groom" was given in the 17th century, probably because weddings were celebrated there and because the frescoes represent the Marquis and his wife. The earliest name we have is the *camera picta,* simply the "painted room." The Camera degli Sposi occupies an intermediate position between the private and public apartments of the Marquis. It was furnished with a monumental bed and used as reception room: a room for family gatherings and a place where contracts were sealed, including marriage contracts.

The smooth walls of this square room have almost no architectural features apart from two windows and two doors. The flat ceiling vault has apertures for lunettes. The only projecting features are the fireplace, the door frames, and the capital-like corbels that seem to be supporting the vault. The architectural elements on the walls – the bases, columns, and wall arches – are in fact painted. In addition, from one capital to the next Mantegna picturesquely simulated poles from which heavy, gold-embossed curtains with colored linings appear to be attached all the way round the room. At some points these hangings are thrown back to reveal a

scene, and at others they are left down, dividing or closing off the room and covering two of the walls like tapestries (ill. 62). The bed stood in the corner by these curtained walls. This left enough space in front of the hearth for guests, and so the narrative of the frescoes was fully open to view.

The ceiling is a marvel of illusionistic *trompe l'œil* (ill. 63): a deep vault is simulated, its fake beams having rosettes at the junctions and gold mosaic cells between. This gives the room a classical atmosphere, with grisaille painting used to simulate marble reliefs. In the eight large caissons, putti are used as caryatids, bearing medallions from which Roman emperors look down. Mythological scenes from the lives of Hercules, Orpheus, and Arion are depicted in the triangular cells between these (ills. 64–66). This ceiling decoration was intended as a hymn of praise to the Marquis, who allowed himself to be presented here – with aspirations far in excess of those of a ruler of a small Italian dukedom – as a prince in the tradition of the Caesars. The heroes of the mythological scenes symbolize the determination to succeed through strength, courage, skill, and intelligence. In addition to all this, the stories of Orpheus and Arion are centered on music, the favorite art of Ludovico's long-serving tutor, the humanist Vittorino da Feltre (1378–1446). The central section of the ceiling fresco opens onto the sky, where the allegorical praise of the Duke is subtly continued. Playfully toying with the traditional insignia of rank, a small putto is holding a laurel wreath above his own head, while another putto is holding an apple to symbolize the orb of a ruler, and a third is holding a baton in his hand in place of a scepter. This free interplay of symbols is a demonstration both of an unpretentious court régime and of the burlesque humor of the age.

Mantegna's ceiling fresco was completely novel, something never previously seen in painting. The architectural prototype was the Pantheon in Rome (ill. 67), with its central vault open to light, air, and rain – though it is not used as a climbing frame for angels, people and the animals as Mantegna's is! In the Camera degli Sposi a foreshortened balustrade frames a view dominated by the blue of the heavens, from which

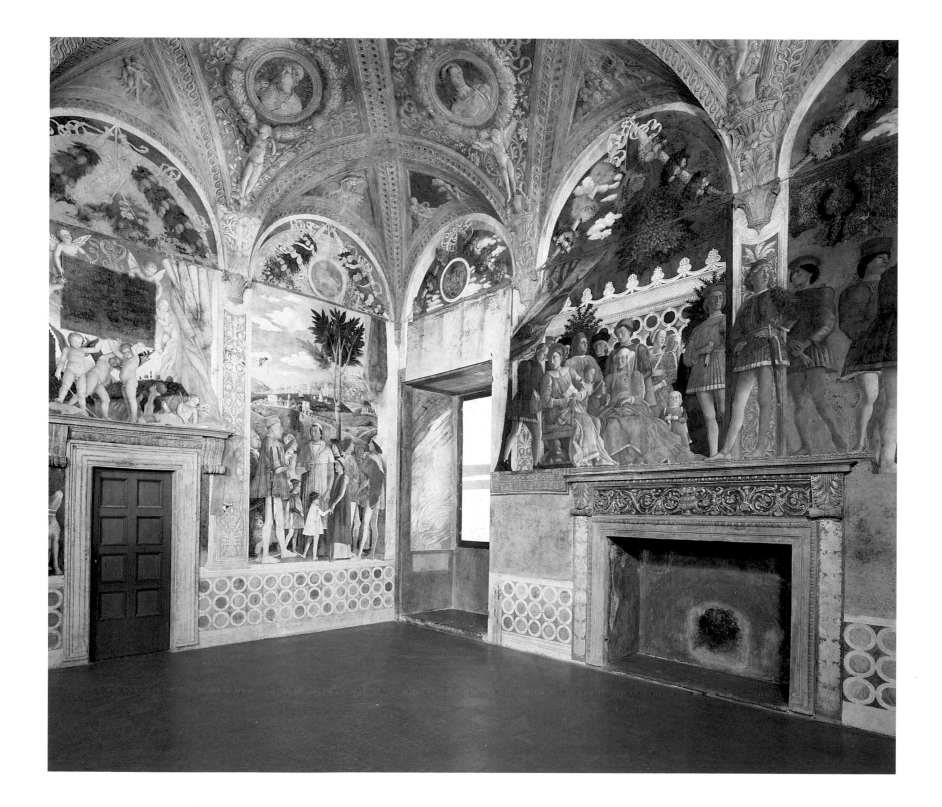

various figures look down (ills. 63, 68). Three women standing together in a friendly group smile at the observer. Near them, a maid turns towards a woman whose head-dress identifies her as a woman of noble birth. An orange tree has been precariously balanced on the rim of the balustrade and a peacock is stretching towards it from the opposite side. The whole effect is bright and lively.

The scenes on the walls, on the other hand, are much more sober. *The Court* occupies the north wall (ills. 69–72). The Gonzaga family is gathered with its intimate friends on a high terrace that seems to sit on the room's real fireplace. The space in the scene is bounded at the back by a wall with round marble insets.

To the left, dressed in a robe, and with a hat that identifies him as the *condottiere*, the commander in chief of the army, Ludovico is shown sitting in an almost domestic setting. A dog has settled down under his seat. Like his successors, Ludovico was an enthusiastic breeder of dogs and horses: breeding such animals was seen as a suitable occupation for a nobleman, and was at the same time a lucrative source of income. In addition, Ludovico's well-paid post as commander-in-chief for the Sforza allowed him his ostentatious lifestyle and his artistic projects. Because of Mantua's geographical position, he had to maintain good relations with his two powerful neighbors, Milan and Venice. These states had an interest in Mantua since they wanted

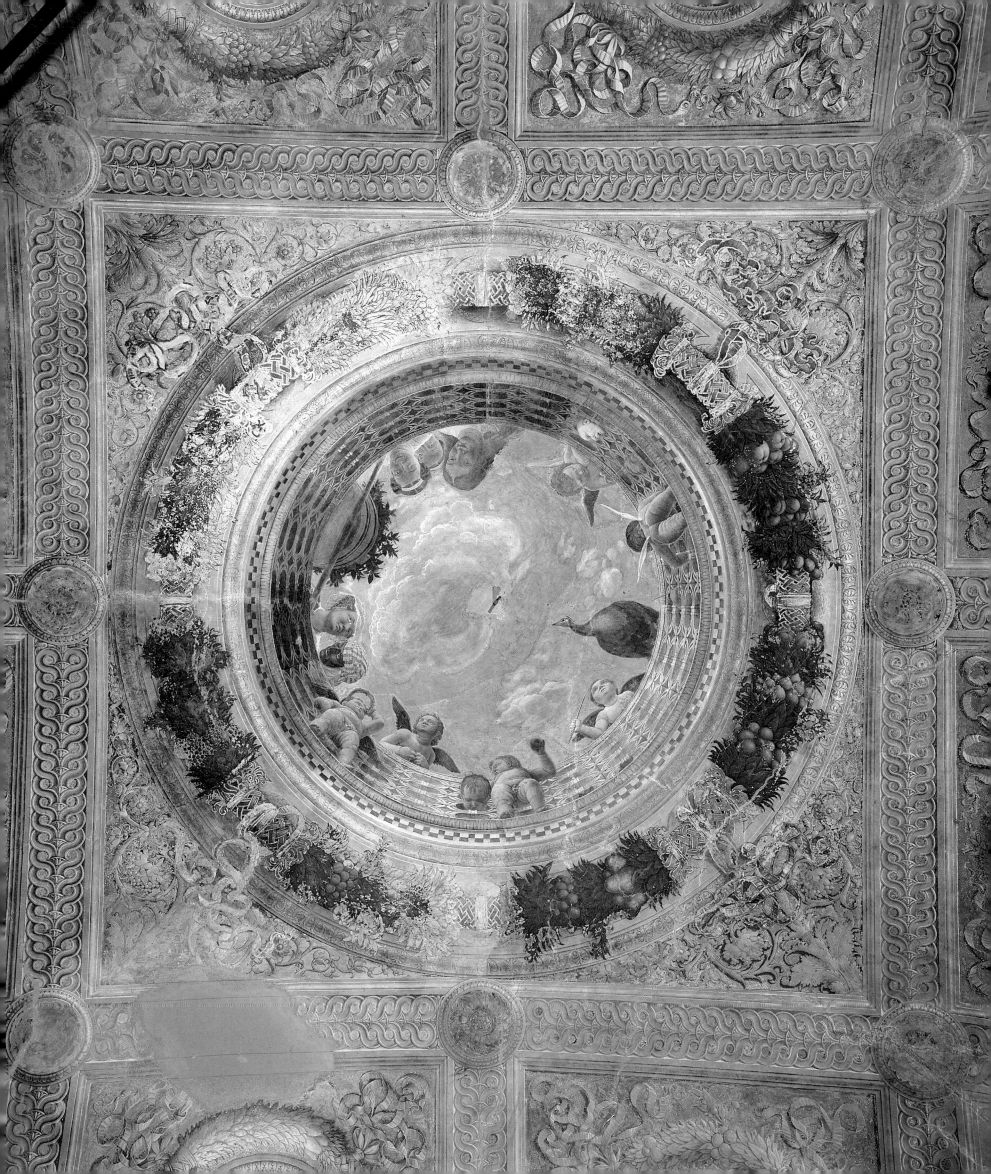

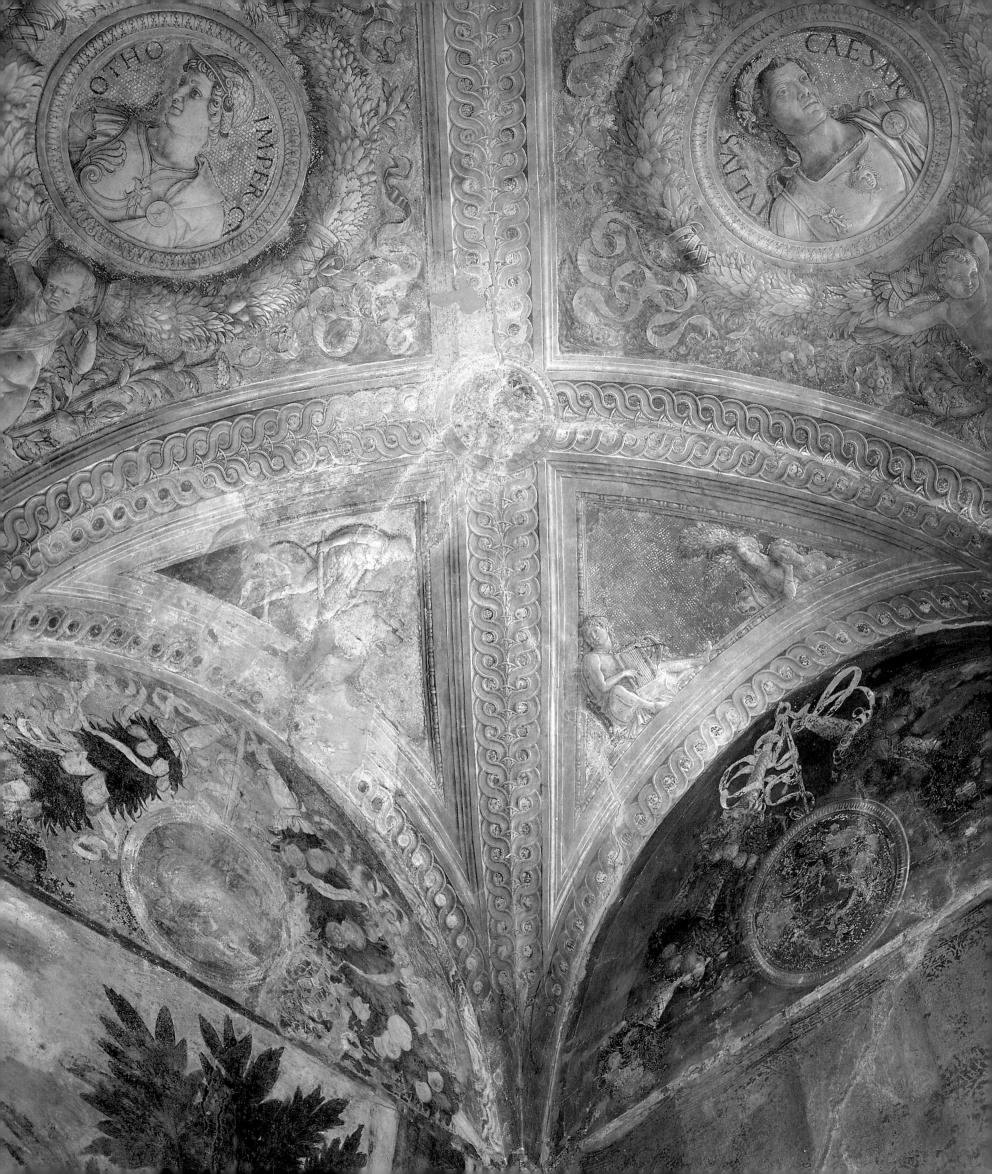

Here the last of the twelve tasks of Hercules is represented: the taming of Cerberus, the guardian of Hades. Next to this, Orpheus is shown playing his lute. Above these cells the emperors Caesar and Otho are shown. The wall lunettes are decorated with Gonzaga devices, including the spotted salamander and a turtle dove.

65 (below) Camera degli Sposi, ceiling detail

In a further section we see part of the story of the poet and musician Arion. A dolphin that heard Arion's song saves him from pirates. Next to this the Caesars Tiberius and Caligula are depicted. The lunette contains a garland of plants set against a background of blue sky, a motif repeated in the center of each wall.

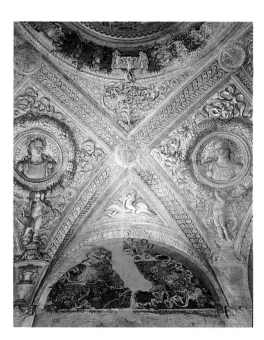

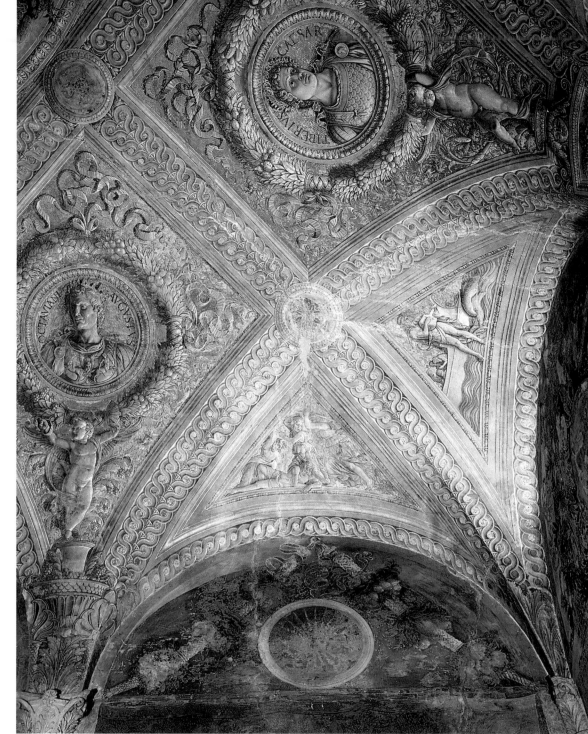

66 (right) Camera degli Sposi, ceiling detail

Here we see two classical scenes: the death of the singer Orpheus, and Arion being threatened by pirates as he crosses from Sicily to Corinth. The caissons represent the classical emperors Augustus and Tiberius, while the wall lunette is decorated with a Gonzaga seal with a young doe.

to extend their boundaries to control either the trade routes going north or the shipping routes on the other side of the river Po. Ludovico skillfully maintained his position through diplomatic finesse and his opportunistic tendency to serve those from whom he expected most advantage.

By 1459 Ludovico had brought himself to the notice of Pope Pius II by offering a meeting place for the Ecumenical Council, which was to call for a crusade against the Ottoman Turks. The costs this incurred for Ludovico pushed him into debt for many years. At the time, Pope Pius was scathing about the unsuitability of the location – in marshland where nothing was to be heard but the croaking of frogs. But decades later, Ludovico's drive as builder and patron had so transformed his capital that several princes, even including Pope Julius II in 1506, chose to make a detour to Mantua to visit this brilliant center of the arts. The Florentine architect and art theorist Leon Battista Alberti, who had been in the Pope's entourage in 1459, made an important contribution to this brilliance. Over the next few years he designed the churches of Sant' Andrea and San Sebastiano in Mantua. Mantegna, who had met Alberti during the Council, also certainly met him later, as Mantegna'a house was situated close to the site of San Sebastiano.

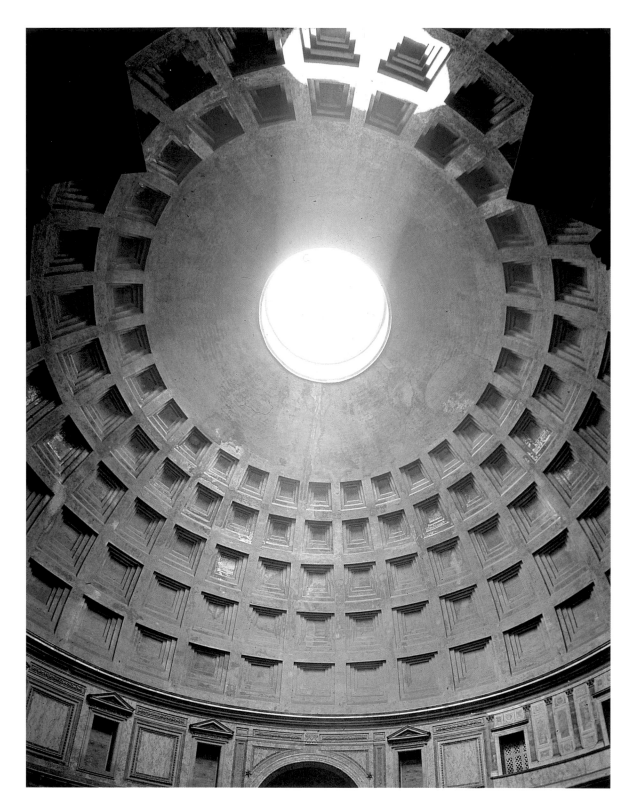

67 The Pantheon, AD 118–125
Dome with a circular opening
Santa Maria ad Matyres/Santa Maria Rotonda, Rome

This temple, dedicated to all the gods, was the most
spectacular circular building of antiquity, its finely
balanced proportions influencing the domed buildings of
the Renaissance. In the center of the hemispherical vault,
a circular opening of nine meters was left open to the sky
to allow daylight into the interior. This circular building
was built by the Emperor Hadrian in 118–125 AD to
replace an older temple that had been destroyed by fire.

By 1476, the year inscribed on a stone stele standing
on the site, the artist's family home (ill. 74) had been
built on a plot given to him by the Marquis. Work on it
probably began that same year. The building was based
on a very original design, probably by Mantegna
himself, with a certain amount of advice from Alberti
and Luca Fancelli (1430–1495), architect to the
Gonzaga. It has a plain, square, three-storey exterior that
surrounds a circular inner court of only two stories, a
design that produces a clear contrast of geometric
shapes. The courtyard may well have had a dome: a
space of this type could only have been lit by an opening

above. Just as in the Camera degli Sposi, so even in
Mantegna's own home the eye is drawn upwards:
whether the courtyard was covered or open, the effect
was the same, a contrast between a solid structure and
the airy view of the heavens.

In 1466, on the deaths of his brothers, Ludovico
became sole ruler of the now united state of Mantua,
which gave him a welcome opportunity to style himself
head of state in all confidence. On the fresco depicting
the ducal household he had himself portrayed as a busy
man of affairs, surrounded by his family and with
streams of visitors flocking to see him. His secretary has

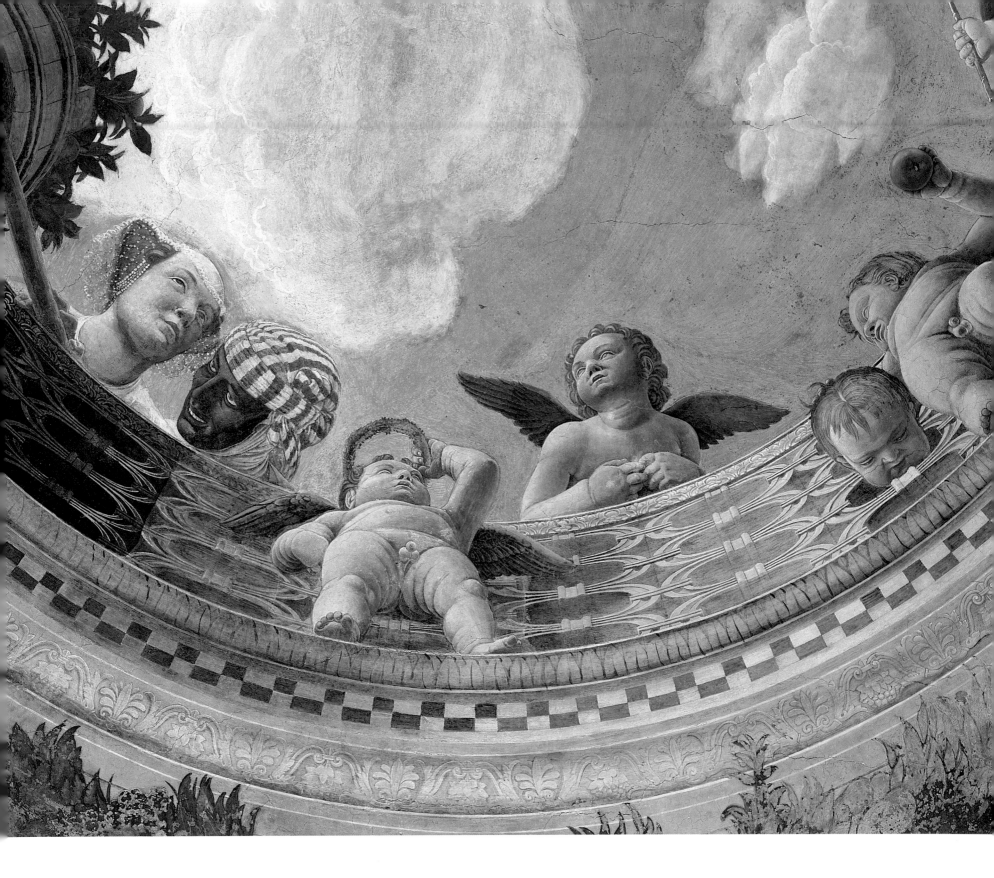

just approached him to give him a letter (ills. 71, 79). The heads of these two figures are at about the same level. If he were standing, the Marquis would be far taller than his secretary. Since it would not be right for a person of low status to overshadow a higher ranking individual, the physical size of the secretary has been scaled down – here a remnant of the medieval concept of rank is still apparent.

On Ludovico's left his wife, Barbara of Brandenburg, is seated amid their children. It was the custom of the Gonzagas to form alliances with ruling houses north of the Alps in order to ensure they had allies over an

extensive area. Between the golden yellow dresses of Barbara and her daughter Barbarina, and the dark clothing of the older woman in the background, a female dwarf introduces a touch of red (ill. 72). In this court, a dwarf could not be regarded a bizarre contrast from whom one could expect entertainment, nor as someone to be condescendingly put down. Surrounded as they were by their marshy lands, the Gonzaga themselves were prone to malaria and rickets and were sometimes hunchbacked and obese. This was the reason that one young scion of the Sforzas of Milan rejected his proposed bride, Ludovico's daughter Dorotea. The

68 Camera degli Sposi, ceiling (detail ill. 63)

Here the viewer looks up towards the figures from a ground-level perspective. The bulging thighs of the putto balancing in front of the balustrade clearly shows that Mantegna has divided up the physical structure of the little putto's body into cylindrical sections.

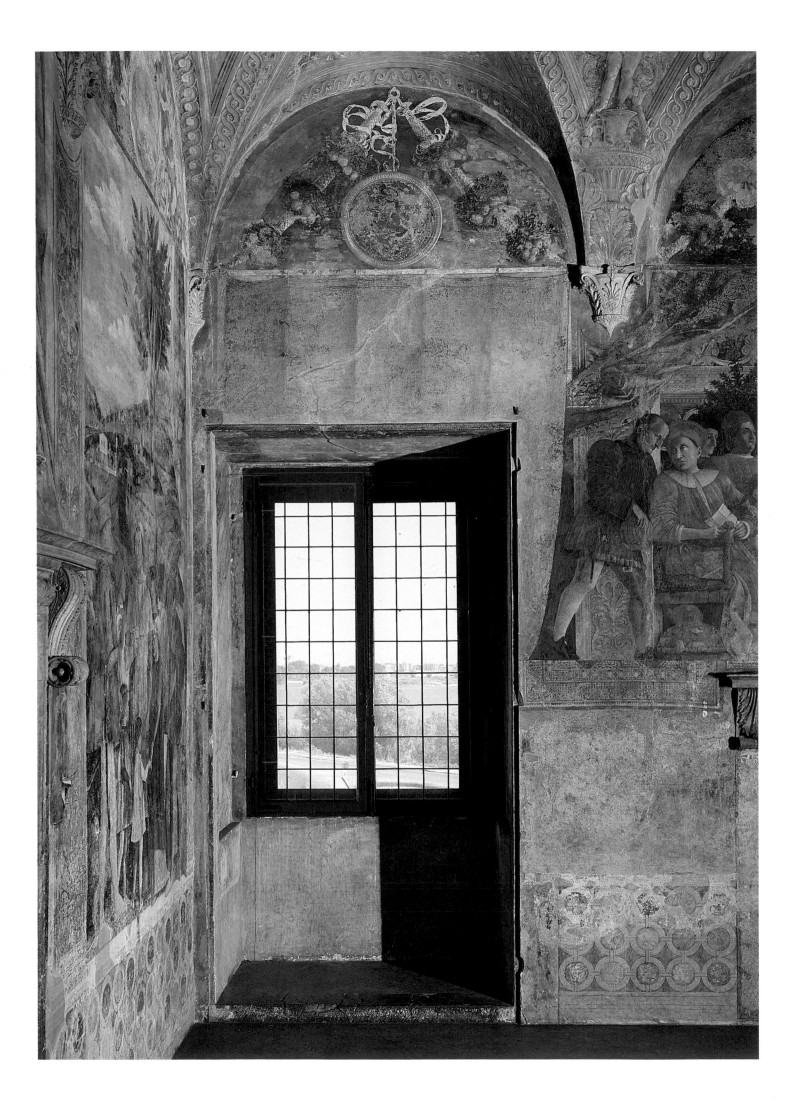

69 (opposite) Camera degli Sposi, detail of north wall

The Camera degli Sposi is lit by two windows; this one throws a ray of light onto the west wall, which is also lit directly by the east window. Mantegna took the actual lighting of the room into account when planning light and shade for his frescoes. In the wall of the north window bay is an inscription, in Mantegna's hand, dated 16 June 1465, presumably the date the frescoes were started.

70 (right) *The Court*, identification of the figures (cf. ill. 71)

1 Marsilio Andreasi (?), secretary of Ludovico III Gonzaga; 2 Ludovico III Gonzaga; 3 Gianfrancesco, third son of Ludovico III; 4 Ludovico, the youngest son of Ludovico III; 5 Paola, the youngest daughter of the Marquis (?); 6 Rodolfo, the fourth son of the Marquis; 7 Barbara of Brandenburg; 8 Barberina Gonzaga (?); 9 the tutor Vittorino da Feltre (?).

71 (below) *The Court,* north wall, Camera degli Sposi

Ludovico Gonzaga maintained a lavish lifestyle and at times had up to 800 people at his court. Here, we see his family with their closest confidants. To demonstrate their affluence, they are dressed in brocades threaded with gold. Mantegna's interest in antiquity can be seen in the linear sequences of figures, reminiscent of the reliefs on classical sarcophagi.

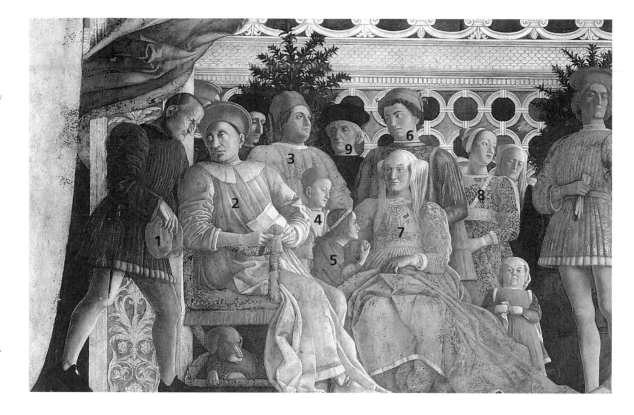

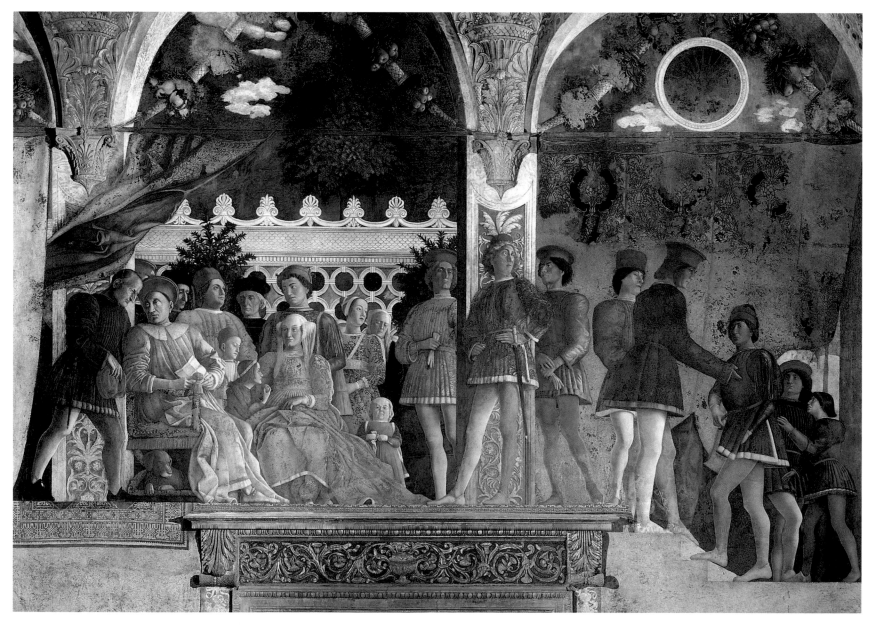

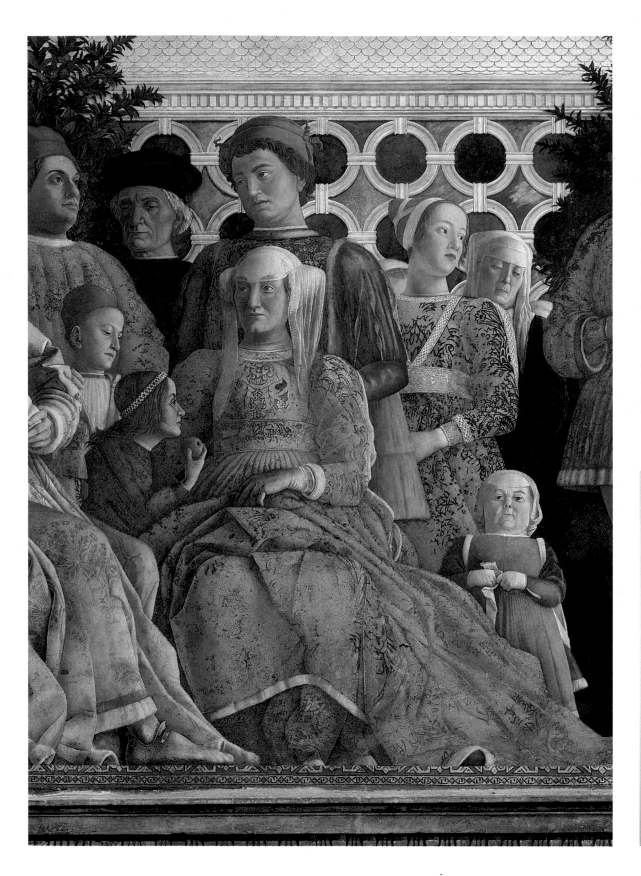

72 (left) *Barbara of Brandenburg and dwarf* (detail ill. 71)

Standing beside the Marquise is a dwarf, the only person to gaze unswervingly out of the painting and thus make contact with the viewer. In those times it was very common to keep dwarfs as jesters or companions.

73 (below) Donatello
The Prophet Habakkuk (Il Zuccone), 1423–1425
Marble, height 195 cm
Museo dell'Opera di Santa Maria del Fiore, Florence

This statue originally stood in a niche in the Campanile of Florence Cathedral. Donatello himself worked on the robe, which is so subtly sculpted that it contributes to the characterization of the figure. Mantegna's sculptural representation of figures is derived from the works of Donatello. In addition, the block-like representation of the robes in the frescoes of the Camera degli Sposi, particularly in the meeting between Ludovico and Francesco (ills. 75–77), gives an impression that the bodies are solid pedestals for the expressive heads that are set on them. This is especially true if they are compared with the finely differentiated heads and bodies in Donatello's work.

family portrait does not show deformities of this kind.

Though he made the faces naturalistic, Mantegna was obliged to idealize the overall figure, and he achieved this mainly through a geometrical approach to depicting bodies that provided added dignity. Nevertheless, the rules of anatomy were strictly applied. It is possible that a school of anatomy was founded in Mantua in Mantegna's time; certainly his approach to painting figures seems to indicate a knowledge of dissected corpses. More evident, however, is his study of classical sculpture, for his figures clearly possess a sculptural solidity. Their statuesque qualities recall Donatello (ill. 73), whose robed figures, fashioned with classical discipline, Mantegna had already seen in Padua.

A white-haired man dressed in black stands out between two sons of the Marquis. This is possibly Vittorino da Feltre, who was long dead by the time Mantegna came to paint this fresco. He was the court

74 (opposite) Mantegna's house in Mantua

The inscription AB OLYMPO can be seen over the central door of the internal courtyard of Mantegna's house. For Mantegna, inspired as he was by the classics, his workshop was the symbol of Mount Olympus, the abode of the Greek gods. His art was his route to eternal fame.

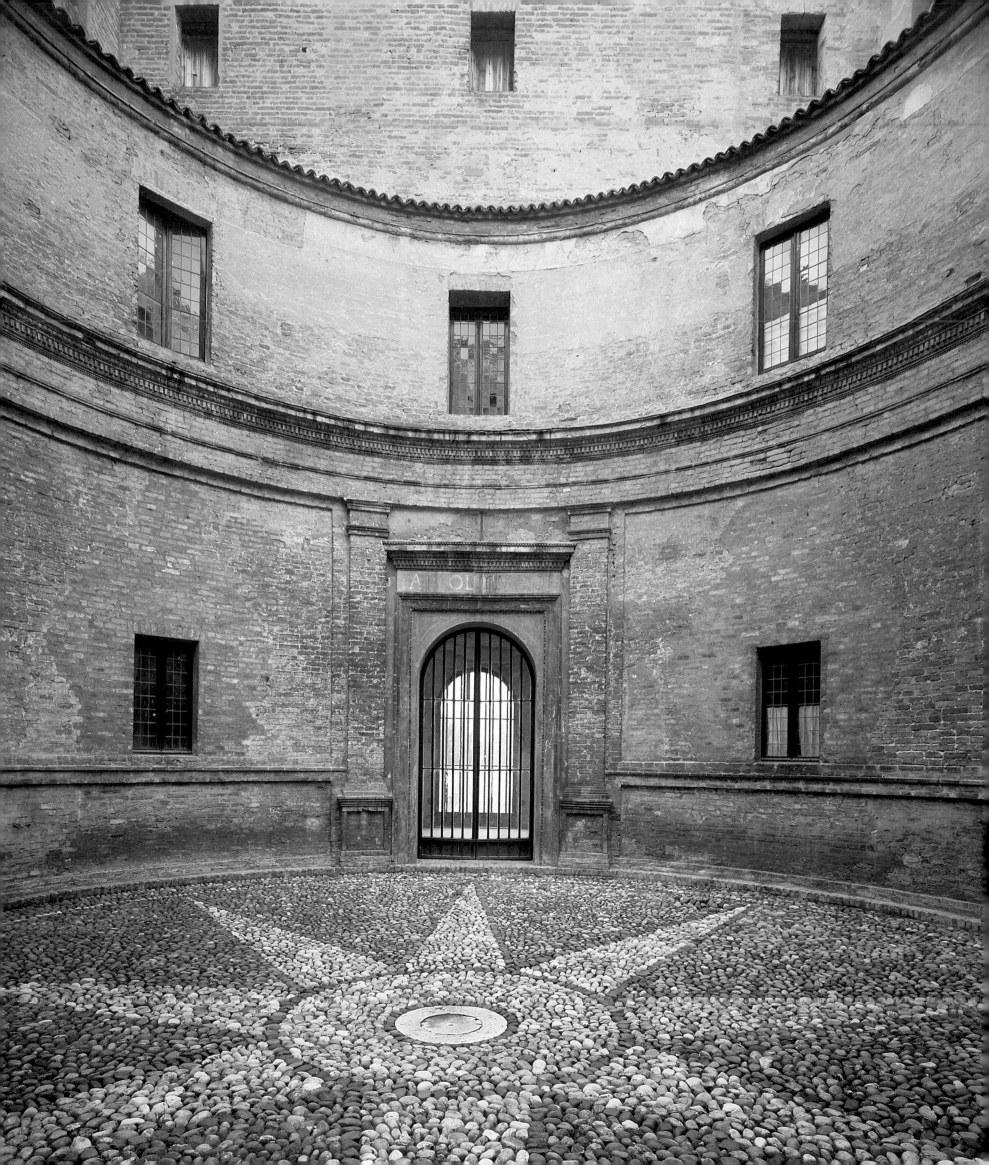

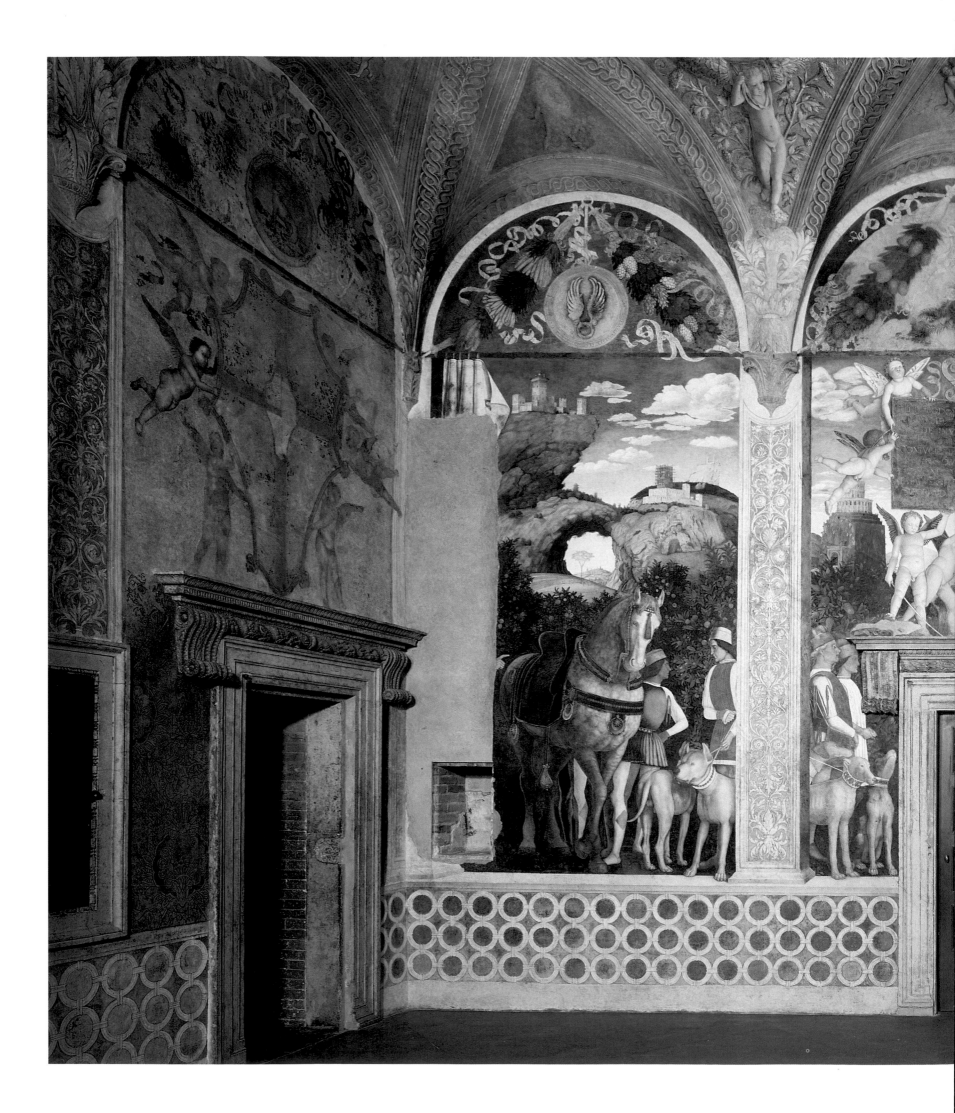

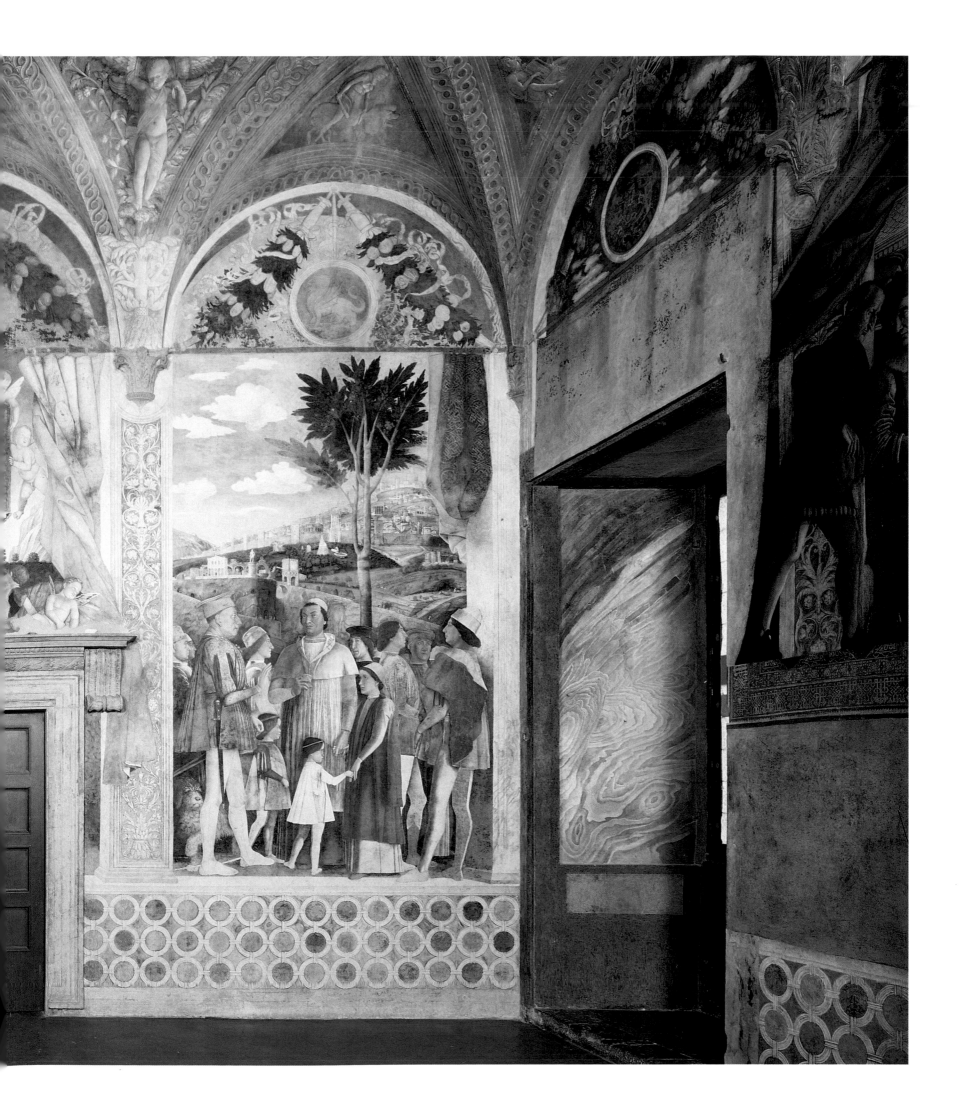

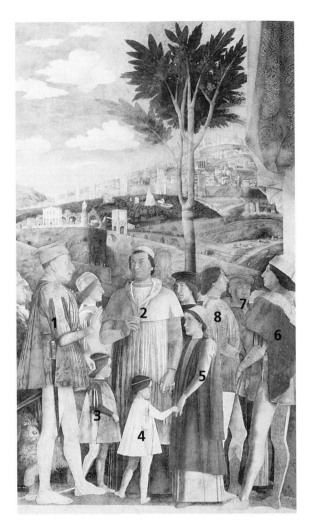

in front of an extensive landscape (ills. 76, 77). This scene portrays a meeting between Ludovico III and his son, Francesco, who has been made a cardinal. Francesco is holding Protonotary Ludovico, the youngest son of Ludovico III, by the hand, and he in turn is holding out his left hand to little Sigismondo, Ludovico's grandson (the son of Federico I, who is standing to the right in the picture). This careful arrangement of figures is mainly an expression of the hope that the successors will provide future dignitaries of the Church. In his right hand the cardinal is holding a letter (ill. 77). Although nothing other than Mantegna's signature can be read on this piece of paper, it may indicate a link between the scenes depicted on the two walls.

In fact it is not easy to decipher the narrative content of these frescoes, as there is a complete lack of any dramatic development. However, the Italian art historian Rodolfo Signorini developed an interpretation in 1985 that we can briefly outline. Despite their differences, the two episodes, it can be argued, are dealing with two closely connected historic events. On 1 January 1462, Ludovico III received a letter that is now in the Mantua archives. This letter was a call from Bianca Maria Visconti to Ludovico Gonzaga, commander-in-chief of the Milan armies, to come to the support of her husband Francesco Sforza. This letter is being handed to Ludovico in the court scene (ill. 79). At the same time, festivities were to be held in Mantua on the elevation of Francesco Gonzaga to the rank of cardinal. On his way to Milan in the pursuit of his duty, Ludovico meets his son outside the city (ill. 77). However, the city in the background does not look like Mantua; some of the classical structures are more reminiscent of Rome (ill. 78). But why should the Eternal City be portrayed like a mirage on the flood plains of the Po? One possible explanation lies in the complex range of references contained in the frescoes. Some very important individuals are travelling with Francesco's retinue: these have been identified as Christian I of Denmark and Frederick III of Hapsburg, who are presumably going to participate in the festivities. Their presence testifies to the influence of the Gonzaga and to their policy of alliances. In this context, Rome would stand for the power of the Pope, whose goodwill had been guaranteed by the 1459 Council and within whose immediate sphere of influence Ludovico had now entered, since a member of his family had assumed an important position in the church hierarchy as a cardinal.

In addition, on the hill to the left, over the horses (ill. 80), a faint group of three men with camels can be seen, painted *a secco* (that is, on the dry plaster) and now flaking off. They suggest the Three Magi, and so indicate the time of year this scene took place. The oranges on the trees are also an indication of the time of year – winter, which could imply January 1462. However, this group could just as well be an example of Mantegna's exotic imagination. The meeting before the city gates could have taken place on one of Francesco's innumerable later visits, for instance in August 1472,

librarian and also tutor to Ludovico and his brothers and sisters; and Ludovico owed his extensive education to this man. Vittorino had also taught the ten-year-old Barbara of Brandenburg when she came to Mantua, bringing her up to be a princess capable of handling government business while her husband was on military campaigns as commander-in-chief. To the right of the royal family stand several men who, judging by their red, white and gold livery, work for the Gonzaga court (ill. 71). A flight of steps leads down to a passageway where the curtain has been pulled back to reveal a small section of landscape. Visitors crowd around, welcomed by a nobleman standing on the steps. This gives the impression that the scene on the chimney wall portrays a specific event to which visitors are flocking.

All the frescoes have one characteristic in common: the protagonists are self-assured and composed. In the foreground they are depicted with monumental proportions, a fact which intensifies their already heightened presence. This effect is emphasized even further by the fact that, apart from at the edges of the fresco, hardly any conversation or interaction is taking place between those present, and each figure occupies a space of its own. On the other hand, in spite of the lack of drama, these frescoes do portray an event. The episode depicted on the west wall (ill. 75), adjacent to the court scene, may help to clarify what is happening. In the right-hand section of this wall, people congregate

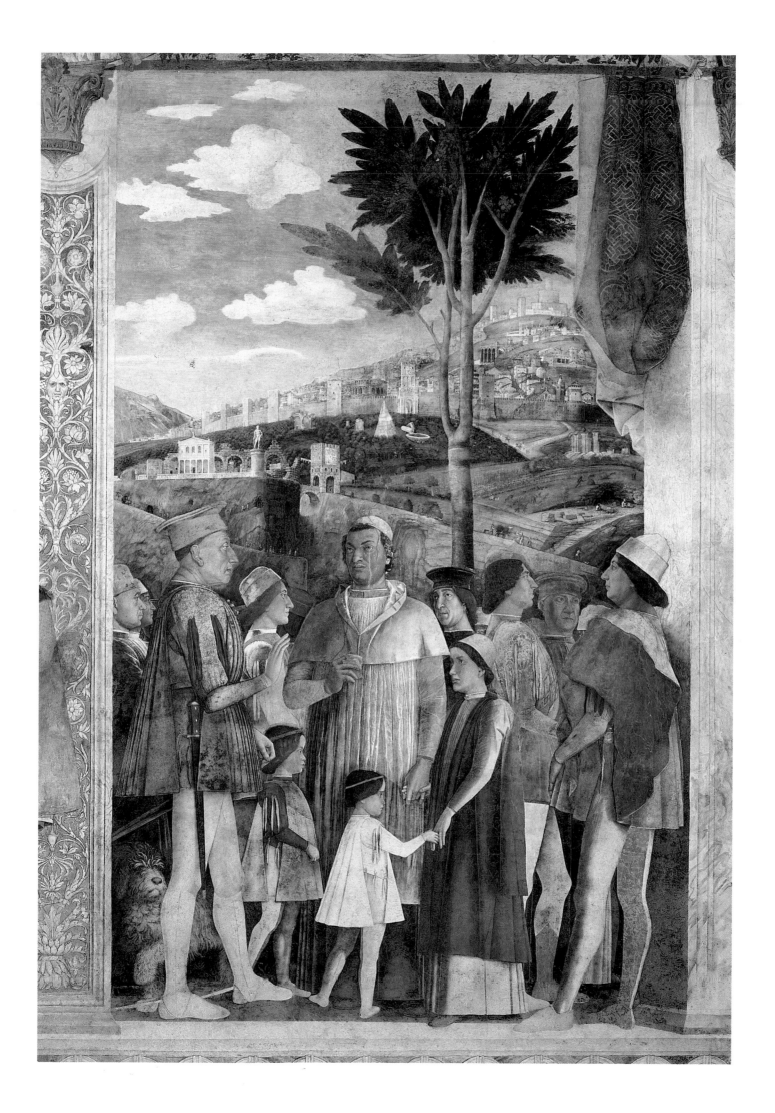

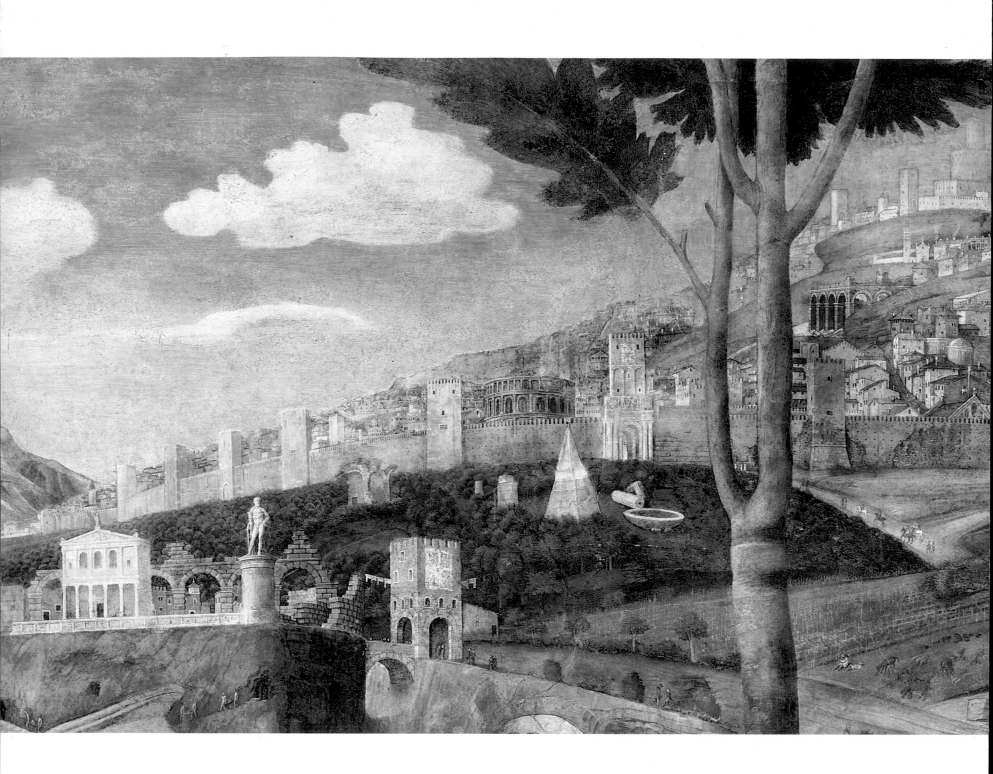

78 (above) *The Meeting* (cf. ills. 61, 77)

The city could be Rome, as several classical buildings can
be recognized, such as the Pyramid of Cestius outside the
city walls, a theater (the Marcellus Theater or Coliseum),
and the Angels' Fortress, on the hill. It was common
knowledge that Rome was built on seven hills, and the
painting shows several areas of higher ground ranging one
behind the other. However, the view of a continuous
slope leading up to the fortress does not correspond to
any actual view of Rome.

79 (opposite) *The Court* (cf. ills. 61, 71)

The piece of paper that Ludovico is holding in his hand
here and has possibly passed on to his son in *The Meeting*
(ill. 77) poses the question of whether the scenes on the
two walls really were drawn from actual events in the
history of the Gonzaga. A unique historic event would
give added depth to this generalized portrayal of the
family.

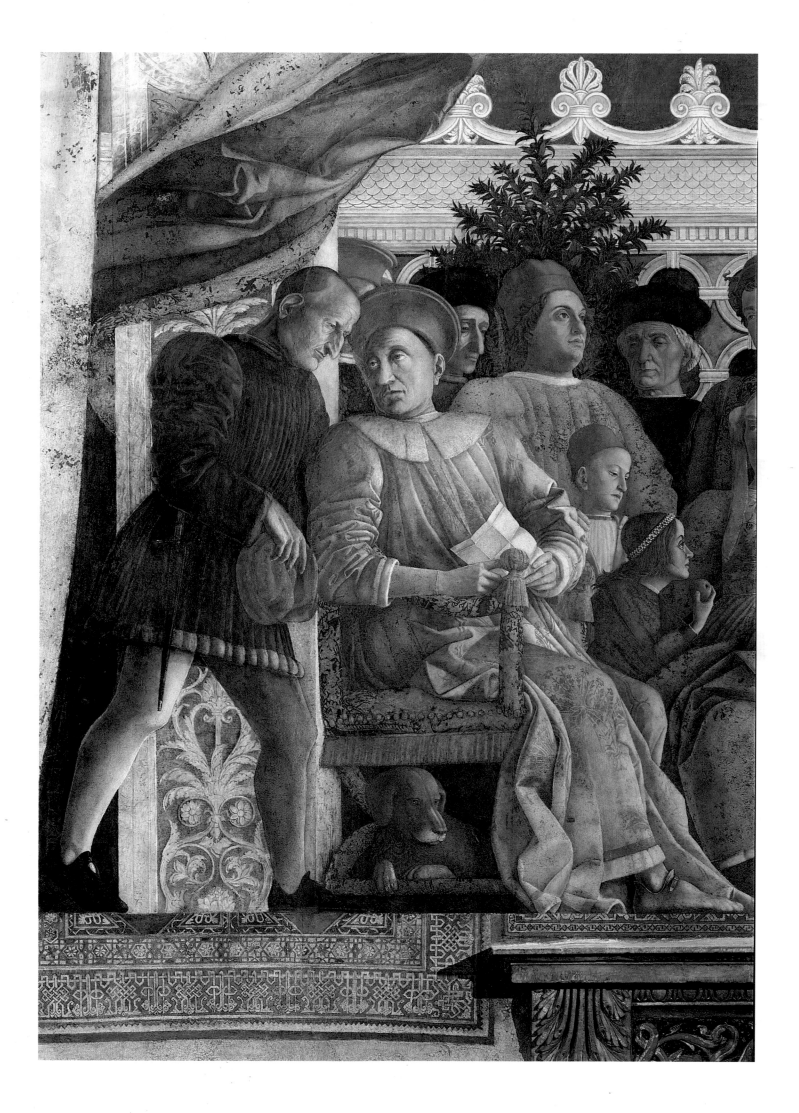

when he became titular cardinal of the church of Sant' Andrea in Mantua. Ludovico is dressed for riding out, as indicated by the enormous spurs on his shoes. The left side of the fresco shows servants with dogs holding ready a horse whose saddle and reins are decorated with the Gonzaga insignia, a sun in an encircling crescent moon. Instead of going to Milan, Ludovico could therefore simply be intending to ride out to the hunt.

Even the application of a detective's skills to art history has not been able to resolve the puzzle of the fresco's meaning. Some of the members of the family were not old enough to be portrayed in 1462. For instance, Sigismondo was not born until 1469. He is represented as being about five years old, which would have been his age about the time the frescoes were completed. Bearing in mind that the Quattrocento was not necessarily interested in a strict representation of reality, the concept of these frescoes was more likely an idealized gathering of family members, friends and allies rather than the depiction of the event in 1462. If this had been a portrayal of a contemporary event, why were the Sforza's themselves not shown at a moment when their power was so significant for the Gonzaga, rather than simply represented by a piece of paper? The relationship with the Sforzas was difficult at times, among other things because of the failed marriage plans mentioned above. But to refer to this influential family and at the same time banish it from the painting would seem too cryptic as a vehicle for any imaginable double meanings. Moreover, there is not the slightest hint as to who wrote the letters. It is improbable that any single incident from the changing fortunes of the Gonzaga family was to be recorded for eternity. An impressive

official family portrait of three generations containing general references to their relationships, for example with the Pope, would be much nearer the mark. In addition, the frescoes illustrate events that took place daily in this room: the conveyance and signing of documents.

Over the lintel of the door that breaks up the narrative on the west wall, putti with butterfly and bird wings are holding up a large tablet which gives the date of completion for the frescoes as 1474 (ill. 82). The dates for the beginning and end of the work on the frescoes of the Camera degli Sposi are also known in other ways; for instance, through orders for materials: on 26 April 1465 Ludovico placed a personal order for two cartloads of lime for the preparation of the walls, and in March 1474 he ordered gold and azurite. It was customary for work with these fine and costly materials to be carried out last.

All in all, Mantegna followed a well thought out color scheme: from festive gold on majestic red, to natural green and airy blue. The varying intensity of the colors is partly a result of Mantegna's experiments with different techniques in fresco painting. The ceiling, curtained walls, and the scene illustrating the meeting were painted *a fresco* (that is, painted onto the damp plaster). Details like the garlands of fruit around the ceiling occula are *a secco* (painted onto dry plaster). For the portrayal of the court, Mantegna used thick distemper on the dry plaster, a technique copied from antiquity and described in the 1st century AD by the writer Pliny the Elder (AD 23/24–79) and the architect Vitruvius. During the Renaissance, experiments with technique were part of a painter's vocation.

80 *Servants with Horse and Dogs*, detail of the west wall (cf. ill. 75)

There is now no indication of what the small hand on the far left is pointing at, or who is doing the pointing. Presumably there was once another figure standing in front of a curtain drawn back over this pilaster (traces of a curtain can be seen in the top corner of the scene).

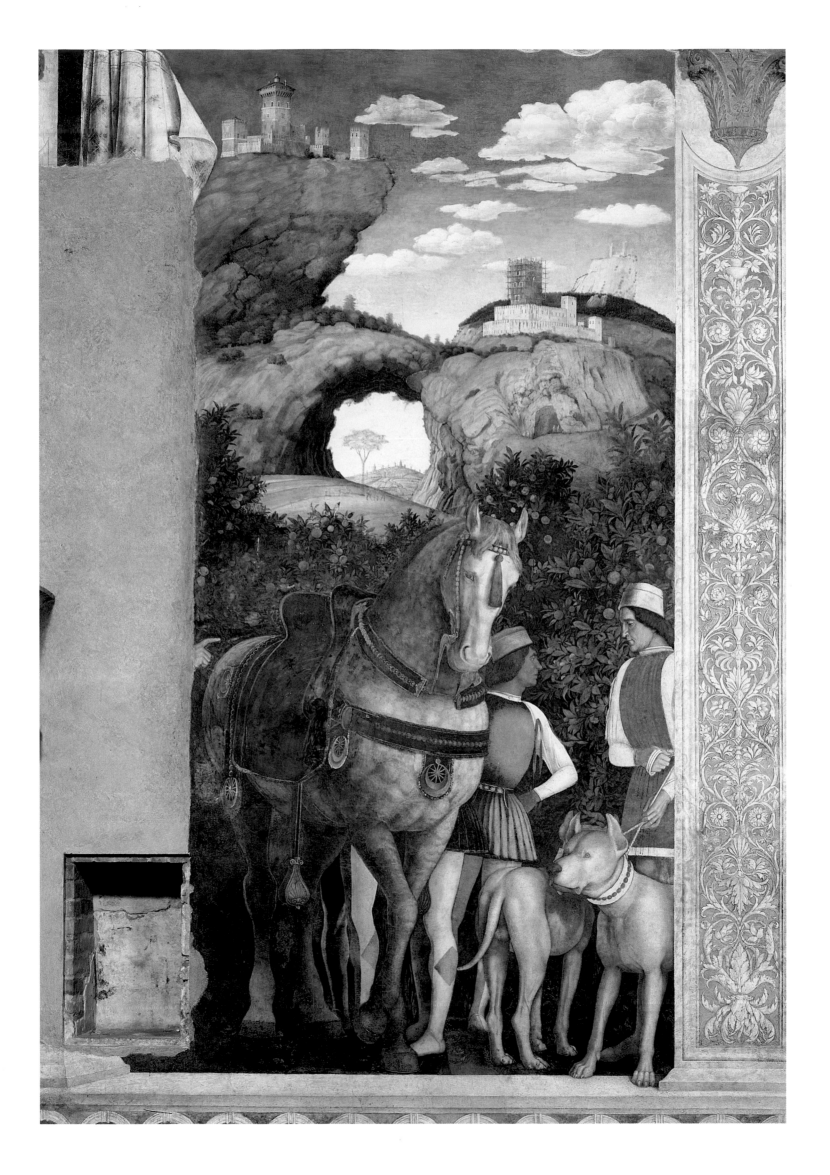

81 (left) *Two Men with Dogs,* detail of the west wall (cf. ill. 75)

These two men link the parts of the wall separated by the door. The dogs connect them with the left-hand scene, and they in turn are looking across to the main event on the right.

82 (below) *Putti holding the dedicatory tablet,* detail of the west wall (cf. ill. 75)

In this inscription, Mantegna celebrates the royal couple and dedicates his work to them: "For the renowned Ludovico, the second Marquis of Mantua, an exceptional prince of unchallenged probity, and for the esteemed Barbara, his wife, most excellent of women, your servant Andrea Mantegna completed this slight work in their honor in the year 1474."

83 (opposite) *Self-Portrait of Mantegna,* Camera degli Sposi, detail of the west wall (cf. ill. 82)

Mantegna left behind in the Camera degli Sposi not only his name, but also a self-portrait, which appears on the last wall to be painted. It is hidden away among the grotesques decorating the pillars. The artist is shown not as a member of the court, but as a silent observer of both them and the viewer.

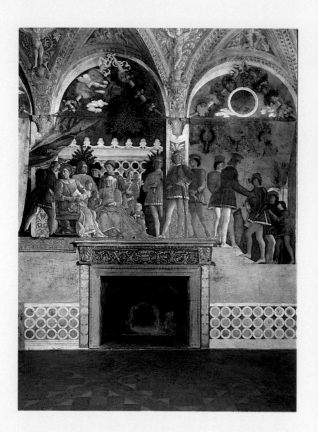

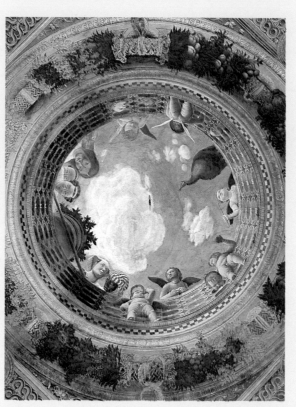

84 (far left) *Camera degli Sposi*, detail of the north wall (cf. ill. 61)

The presence of the fireplace was a major factor in the composition of the frescoes. Mantegna extended the painted scene by skillfully depicting a flight of steps leading up to the mantel of the fireplace.

85 (left) *Camera degli Sposi*, ceiling detail (cf. ill. 63)

Opening up the room to the sky and painting the figures in extreme foreshortening, as seen from the viewer's point of view immediately below, were sensational devices in Mantegna's day. This was the first time a rigorous *sotto in sù* perspective, that is, foreshortened from below, had been painted successfully. This provided a point of departure for the development of ceiling frescoes that was exploited to greatest effect during the Baroque.

Instead of there being another floor above the Camera degli Sposi (ill. 61), there appears to be a roof terrace from which smiling figures are looking down at us. At first sight, the Camera degli Sposi seems to be an open pavilion with arcades behind which a continuous area extends, as in the *Martyrdom of St Christopher* (ill. 15) in the frescoes in the Eremitani. But there is a discontinuity: at one moment, we are looking at a terrace adjoining the palace (ills. 71, 84), next to which extends a broad tract of land that must lie outside the town (ill. 75). So between the fireplace wall and the west wall the setting changes and the apparent continuity of time and place break up. Nevertheless, each side is a complete and consistent work in its own right and subject to the overall architectural structure of the space.

Nor is the spatial structure itself as unified as may initially be supposed. The fictive space of the frescoes is shaped to a great extent by the painted curtains, which are partially drawn back to reveal the narrative. The curtains appear to be covering the wall surfaces and to belong to our space. The curtain on the west wall makes this very clear, draped as it is over the projecting door jamb, with folds falling over the pillar. The wall surfaces do not serve simply as a boundary between the viewer's space and the fictive space of the scenes.

In addition, the curtains pose the question of the illusionistic capacities of painting, a theme that began with the competition between the Greek painters Zeuxis and Parrhasios (ca. 440–390 BC) at the beginning of the 4th century BC. Zeuxis had painted a still life that looked so deceptively real that the birds came flying down to peck at the grapes. Parrhasios took up the challenge from his proud colleague and finally invited him into his workshop to give his approval to one of his paintings. Zeuxis rushed up to the picture sure of winning, and tried to lift the curtain over it. But it was a painted curtain and it was Parrhasius' turn to triumph: "You could only trick the birds, but my art can even deceive a great painter like you."

In addition to these *trompe l'œil* effects, which were to reach their peak in the ceiling frescoes of the 16th and 17th centuries, the curtain was invested with varying degrees of significance in defining and controlling space. The curtain pulled back high over the seated Ludovico resembles a canopy; for Mantegna's successors, drapes like this were a familiar element in portraits of rulers. However, things get more complicated: in the portrayal of the court, a curtain hanging to the left covers the remainder of the wall, presumably obscured at the time by a real curtain over the window (ills. 69, 84). The painted curtain on the right clearly has to be hung at the same level as the one on the left. But the material is stretched out and falls full length, separating the external space behind the wall from the steps in front of the wall and the connecting terrace: Ludovico's secretary and a nobleman in the center are both standing in front of the pillars.

Clearly Mantegna was no longer satisfied just to allow figurative details to project into the viewer's space. He divided the wall into sections: the back of the terrace is closed off by a wall, behind which a tree can be seen,

86 Giulio Romano
Sala dei Giganti, detail of the wall and ceiling, 1524–1534
Fresco
Palazzo del Tè, Mantua

The Palazzo del Tè is a unique ensemble for which Giulio Romano (ca. 1499–1546) took the credit both as architect and artist. In the Sala dei Giganti he was inspired by the wall dispersal in the Camera degli Sposi. The whole room is in movement, the walls appear to be falling in to bury the rebellious giants beneath them. Jupiter is floating above all this, surrounded by the gods. The master of the house, Federico II Gonzaga, used the room as a theatrical set piece and stressed the comic aspects with simulated thunder and lightning.

indicating that the scene's fictive space continues. The wall surface coincides with the fronts of the pillars and the continuous base, and the curtains seem to hang in front of this surface. Therefore, the terrace projects out in front of this, into the viewer's space. We have an internal and an external background, an intermingling of fictive space and the viewer's space. Real space and the painted space interact: painting is creating space.

This fictive space continues the viewer's actual perspective. When we stand in the center of the room we are being observed – from the ceiling, heavenly eyes look down on us; and the dwarf next to Barbara and one of the putti holding the dedicatory tablet are looking at us. We in turn can quite unobtrusively watch the action of the individuals around us, intent as they are on their everyday affairs. We are not overwhelmed by the powerful effects of the kind created half a century later by Giulio Romano (ca. 1499–1546) in the Palazzo del Tè in Mantua (ill. 86), also for a member of the Gonzaga family. With Mantegna, we are a guest of the Gonzaga, sharing their experience of place and time with them.

The initial impression of the Camera degli Sposi is of a closed space, a room. Only gradually do the details of a changing sense of place and time reveal themselves to the observant visitor. These frescoes provided the original inspiration for the illusionist spatial compositions from Correggio (ca. 1489–1534), who had worked in Mantegna's circle, until the Baroque.

THE CLASSICAL WORLD AS SETTING

87 *St Sebastian*, 1480–1485
Distemper on canvas, 275 x 142 cm
Musée du Louvre, Paris

87 *St Sebastian*, 1480–1485
Distemper on canvas, 275 x 142 cm
Musée du Louvre, Paris

Saint Sebastian is standing like a piece of sculpture on a fragment of a building that looks like a pedestal, well above the archers, whose heads are at the same level as that of the observer. Our gaze is drawn upwards towards the saint, whose eyes are also looking upwards to higher things. As an altarpiece, the whole composition was designed to be placed high up.

Ludovico III Gonzaga died of the plague in 1478 and for six years his son Federico held the reins of power. He did not want to lose his father's renowned court artist, and Mantegna continued to work at the court, but unfortunately very little of his work from this period has been preserved.

By 1484 the eighteen-year-old Francesco II had come to power in Mantua. To begin with he was indecisive about whether to follow the tradition of his two predecessors in relation to the principal artist at his court. Mantegna therefore approached Lorenzo de'Medici in Florence, sending by way of recommendation a picture (possibly a portrayal of the biblical Judith in miniature), and asking for financial assistance. Since 1476, Mantegna had been occupied with the construction of his town house and needed money for this very slow-moving building project. The artist had previously lived outside the city with his family, and then, during the extended construction period, had taken rented accommodation in various parts of the city. The house must have been completed soon after 1494. But Mantegna was able to enjoy his new home for only a few years, for in 1501 the Marquis claimed the building, wanting to incorporate it into his new Palazzo di San Sebastiano.

The first works from this period were probably the large *St Sebastian* (ill. 87), and the *Lamentation Over the Dead Christ (Christo morto)* (ill. 40), which is discussed in Inset 1. Both pictures were painted on canvas, the paint so thin that the texture of the material is apparent. The restrained, chalky, gray-toned color also gives the impression that these pictures are linked. The large *St Sebastian* was intended as an altarpiece. It has been shown that during the 17th century it was in the Sainte Chapelle at Aigueperse, a castle in the Auvergne in France, and recent research has assumed that this was where it was originally hung. The painting may have been executed for the marriage of Chiara Gonzaga and Gilbert de Bourbon-Monpensier in 1481. It is naturalistic to the last detail. The figure of the saint is straighter than in the smaller portrayal of *St Sebastian* (ill. 46) that can be seen in the Kunsthistorisches Museum in Vienna. Here again, Mantegna introduced an indication of the rivalry between the arts of painting

and sculpture: to one side of Sebastian's feet is a fragment of a marble statue, a foot in a Roman sandal.

This rivalry between Quattrocento painters and sculptors was based on a dispute about which of these arts was the more important. Sculptors argued that sculpture was superior for they could represent a figure as a whole, so that it could be viewed from every side. Compared with this, painting was able only to offer one view at any one time. The painter Giorgione (1477/78–1510) represented the opposing view in this *paragone* (dispute about art). According to Vasari's account, this student of Giovanni Bellini declared that the advantage of painting was precisely that it could represent different gestures and poses at one and the same time. In a painting which is now lost, Giorgione depicted a male nude with his back to the viewer. A front view was reflected in a clear spring at his feet, and side views in highly polished armor to one side and a mirror to the other. Mantegna, who also supplied sketches for sculptures and worked as an architect, took up this challenge in a different way. His painting aimed to represent the contrast between life and art, and he consciously compared the rich variety of colors in images of the living with the monochrome tones of stone. According to Alberti, painting, as the most intellectual medium with the greatest difficulties to overcome, was superior not only to sculpture, but also to poetry, since both the eyes and mind of viewers were brought into play. Mantegna was the prime example of such an artist. He was one of the most important humanist painters of his day, and his interests in archeology and literature gave him the grounding for an art directed at the educated upper classes.

One of Mantegna's finest illustrations of this ability is a work for the young Francesco Gonzaga: the *Triumphs of Caesar* (ills. 89–97). Nine paintings, all of the same size, show a train of followers bearing looted trophies of war past the viewer; the procession reaches its high point in the ninth picture with a portrayal of Caesar on a triumphal chariot. Like his ancestors, Francesco was both a successful army commander and a cultured humanist, and closely identified himself with the great Caesar. The cycle of paintings was intended to honor Francesco's victories as well as those of the Roman

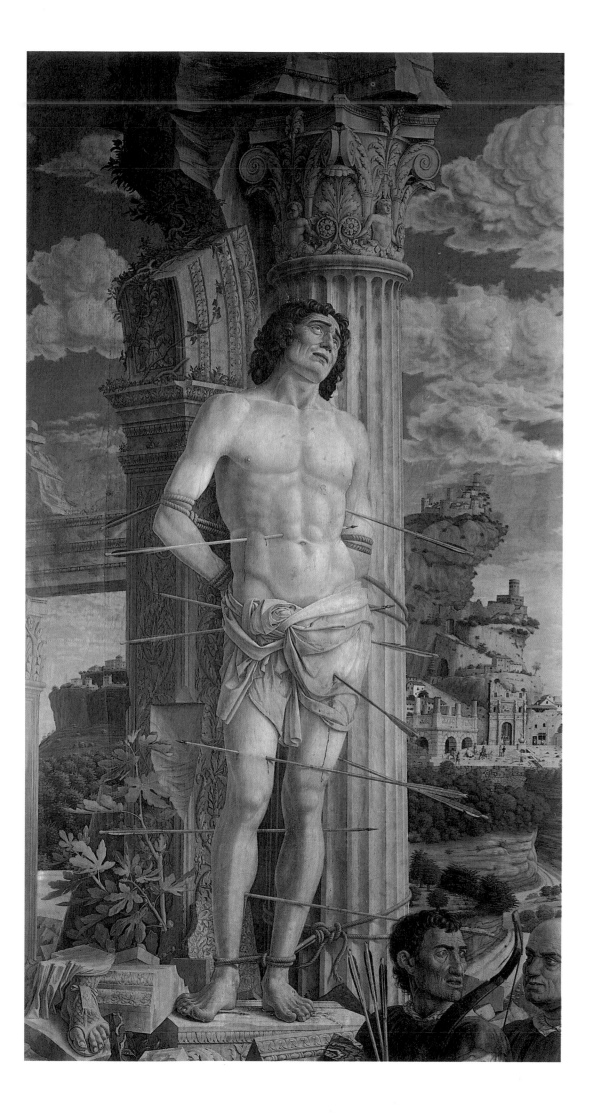

commander. But this reference was obviously not direct enough for him, for seven of Mantegna's canvases were brought to the Palazzo San Sebastian in 1506 and complemented by the *Triumphs of Francesco* painted by Lorenzo Costa (ca. 1460–1535).

Mantegna certainly created the first designs for the *Triumphs of Caesar* (ills. 89–97) soon after Francesco came to power. It was to be expected that the patron would provide the inspiration for the series, but the overall composition lay completely in the artist's hands. In a letter to Mantegna, Francesco described the cycle as the work of both the artist's hand and his mind. The Marquis greatly admired the scenes, which created the effect of a "living tableau," and rewarded the painter

handsomely with gifts from his estates. The *Triumphs* series was either intended to be hung in a line along a passageway or a loggia, for example, or to decorate the great hall on the second floor of the castello. Presumably it was never properly hung there, since there is no accompanying set of frames. Engravings show that the individual scenes were separated by pilasters, which makes the gaps between the episodes more understandable. The pilasters could be an indication of the architectural setting for the *Triumphs*. Perhaps the pilasters were also painted, with the intention of giving the impression that the procession was taking place behind them. But if the paintings were meant to decorate a specific hall, why had Mantegna not painted

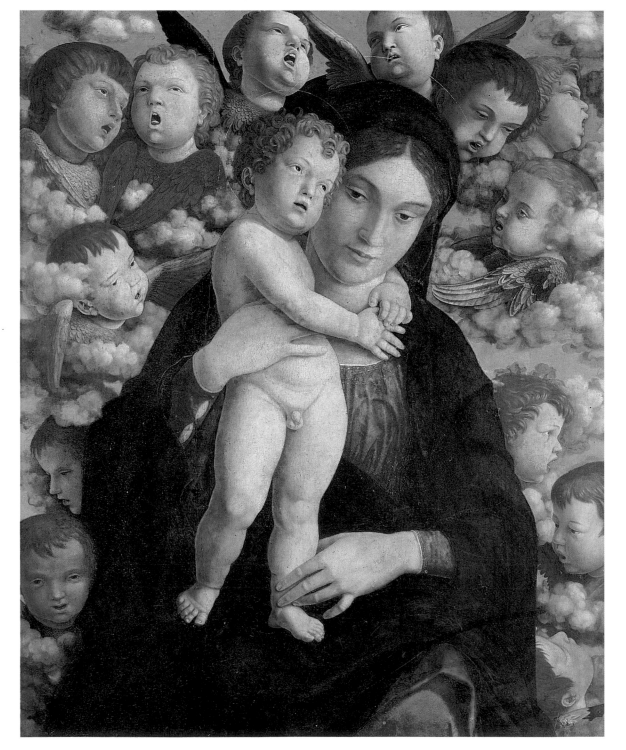

88 (left) *Virgin with Child and Cherubim,* 1480–1490(?)
Distemper on wood, 70 x 88 cm
Pinacoteca di Brera, Milan

The Madonna appears here immediately in front of a cloud of singing, winged angels' heads. This painting was attributed to Mantegna after its restoration in 1885, though some researchers doubt this, preferring to link it to Giovanni Bellini. It is possibly identical to a painting ordered from Mantegna in 1485, at the request of the Duchess of Ferrara.

89–97 (cf. pages 77–85) *Triumphs of Caesar,* 1484–ca. 1494
Distemper on canvas, each scene 267 x 278 cm
Hampton Court Palace, London

The Gonzaga domains fell into decay in the 17th century, and in 1629 the nine paintings of the *Triumphs of Caesar* were sold to Charles I of England, and were on exhibition in England from 1649. Since then they have been subjected to over-painting and restoration on several occasions; their condition today is, for the most part, extremely poor. Nevertheless, the series still illustrates Mantegna's highly inventive conception of Caesar's triumphant entry into Rome.

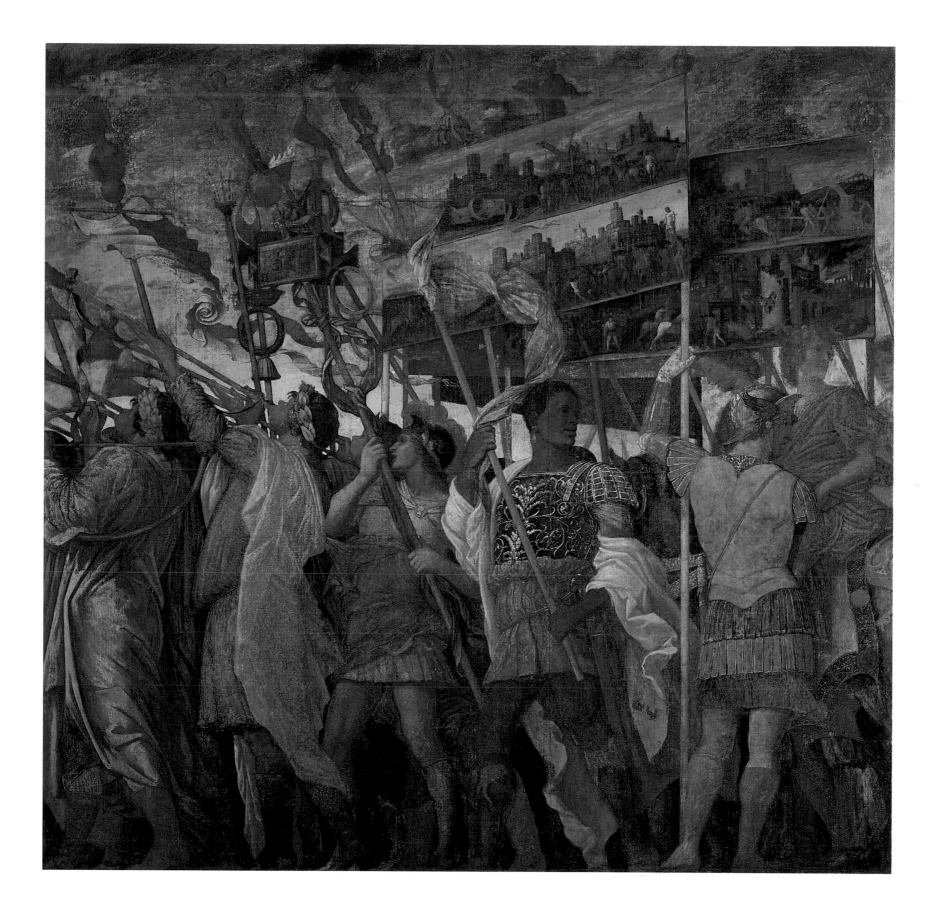

the scenes onto the wall, as in the Camera degli Sposi, instead of splitting it up onto nine canvases? Because the advantage canvases have over frescoes is that they are transportable. Presumably the scenes of the *Triumphs* were intended as a decoration for festivities and were meant to be set up in different surroundings. In 1501 six of the pictures were exhibited with other works during the Carnival period, in a sumptuous, specially designed setting. They occupied a wall in a theater in which the atmosphere of a classical building had been re-created. In addition, canvases were thought to be more durable than frescoes. In 1474, Mantegna's brother-in-law Giovanni Bellini had received a commission to restore the historic decoration in the Sala del Maggior Consiglio, the largest state room in the Palazzo Ducale in Venice. He did not paint directly on

89 *Triumphs of Caesar:* (scene 1) Trumpets, Bearers of Standards and Banners

The soldiers are carrying boards with paintings of battles and views of conquered cities. These boards give Mantegna's vision of lost classical painting, of which little was known in the 15th century compared with the knowledge of architecture and sculpture. Pompeii and Heraculaneum, with their extensive house frescoes, were not excavated until the 18th and 19th centuries.

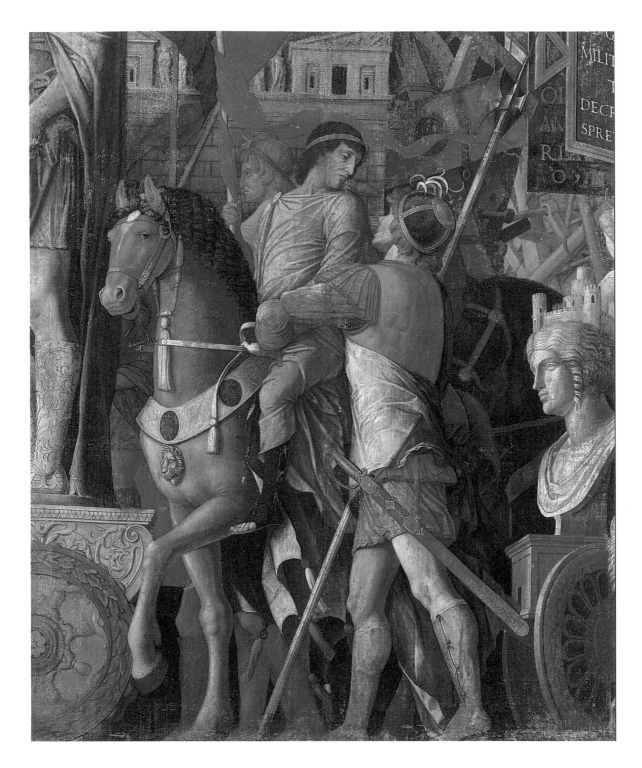

the existing frescoes, which were seriously damaged by damp, but on canvases that were to cover them.

Because of the size of the paintings, Mantegna could not work on the *Triumphs* at home and so a room was made available to him at the Corte Vecchia, which was no longer used for day-to-day state functions. On 26 August 1486 the series of paintings was shown to Ercole d'Este, the father of Isabella d'Este, who had just arrived from Ferrara, which means that the designs must at least have reached a stage of development suitable for viewing. Between 1488 and 1490, Mantegna interrupted his work for a period of one-and-a-half years, spending this time working on a chapel for Pope Innocent VIII in Rome. From Rome Mantegna wrote concerned letters to the court in Mantua asking whether

the windows in the room in which the canvases of the *Triumphs* were being kept had been repaired, so that they would not be damaged during his absence. These works meant a lot to both painter and patron, a fact confirmed by contemporaries and their successors, and the cycle of paintings became a main attraction for visitors.

Historical records describe five triumphal processions for Caesar. Caesar's biographer Suetonius mentioned these processions to Rome several times, though without describing them in detail. There are several accounts of Roman parades in the works of the writers Plutarch, Scipio, and Livy. Roberto Valturio's treatise "De re militari" (The Arts of War) and Flavio Biondo's "Roma triumphans" (Rome Triumphant) were major 15th-century publications, both printed in 1472, the

first in Mantua and the second in Verona. Biondo's book contained paraphrases of all the important classical texts. Mantegna tried to create a historically accurate reconstruction of a triumphal procession in the form of a fantasy-driven vision of a lost classical glory. Besides these literary descriptions, Mantegna also drew upon his knowledge of classical buildings, medallions, sculptures and drawings for the content of his pictures. The collections of Francesco Gonzaga, the Protonotary Ludovico Gonzaga, and Mantegna himself contained a wealth of material. However, there were no clear prototypes. Mantegna's period in Rome, during which he was able to carry out precise, local research – research that interrupted his work on the *Triumphs* – nevertheless found no visible reflection in the paintings. In the *Triumphs* he uses general references to Rome, such as the

91 *Triumphs of Caesar:* (scene 3) Trophies and Bearers of Containers filled with Coins

Containers filled with gold illustrate the material gains of conquest. The enormous vase on the chariot bears stylized oriental lettering, as does the decorative harness between the horse and the chariot in the ninth painting (ill. 97), thus indicating Caesar's conquests in the Near East. In the center of this painting stands a soldier sunk in melancholy reflection.

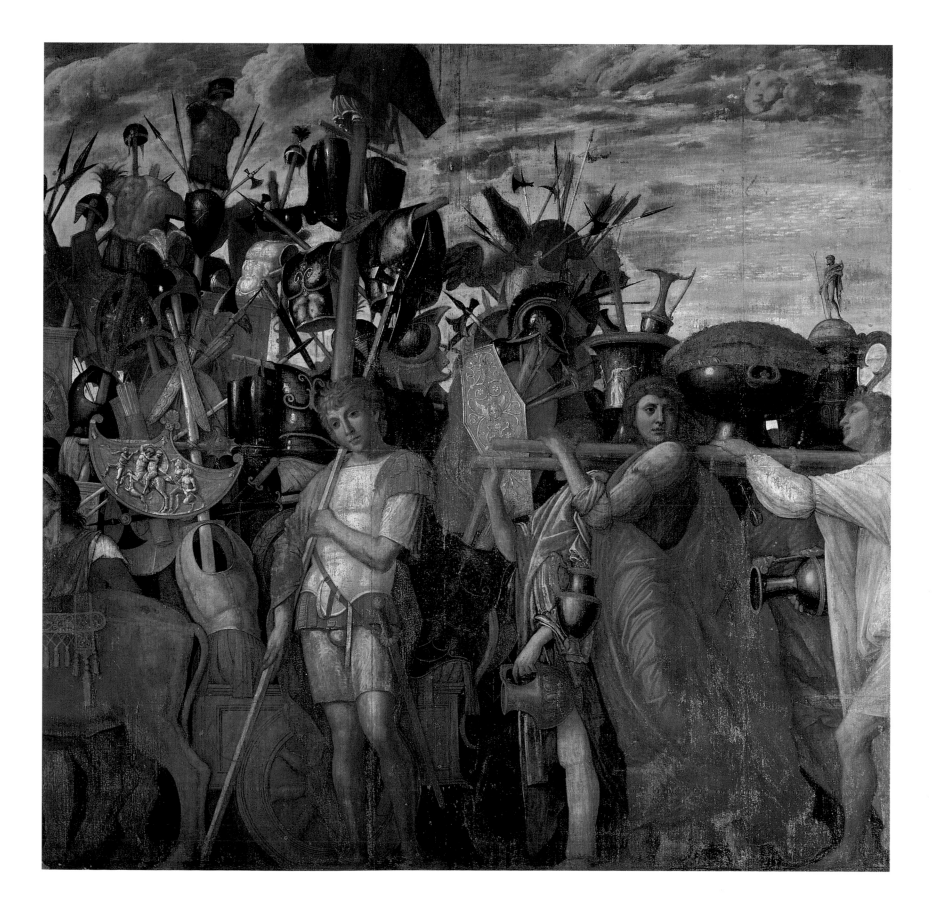

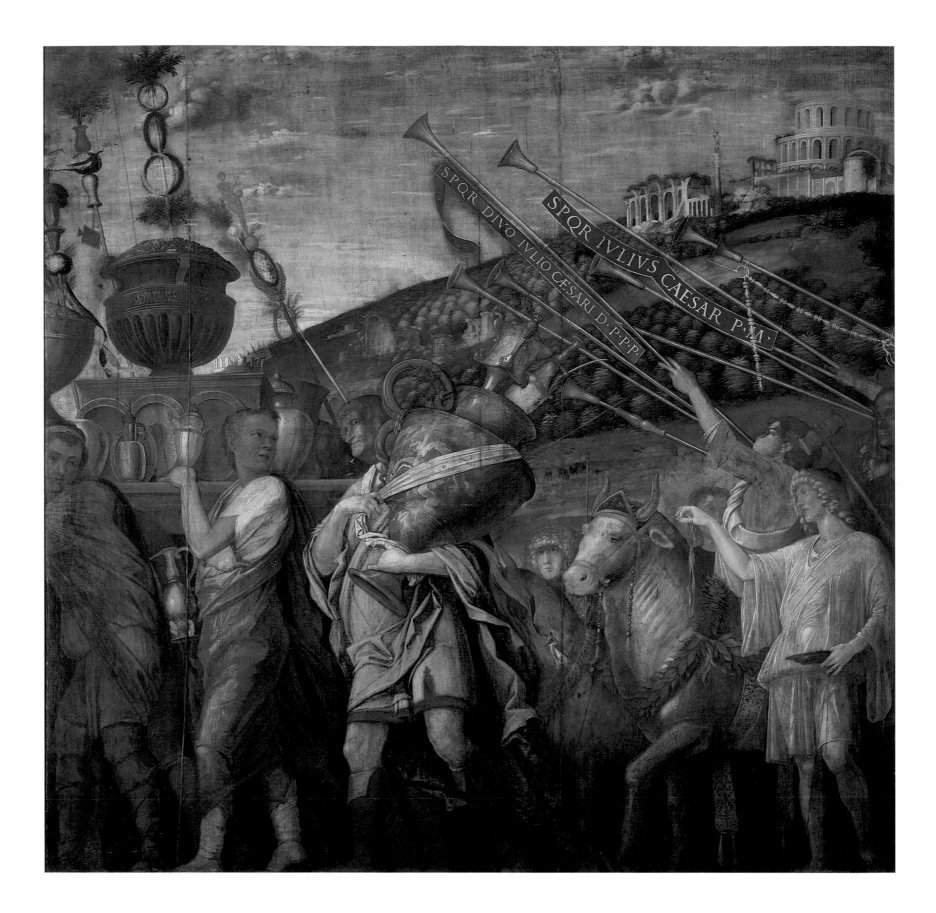

92 *Triumphs of Caesar:* (scene 4) Bearers of Vases and
Containers filled with Coins, Youths Leading Oxen,
Trumpeters

The left-hand section of this painting in particular has been
over-painted. However, the young man to the right, painted
in brighter colors, together with the ox beside him, show
Mantegna's finely differentiated style of painting. With his

blond curls and graceful stance, the boy represents an ideal
found in Mantegna's later works. On the banners we can see
the letters SPQR, the abbreviation of *Senatus Populusque
Romanus* (the Sanate and the Populace of Rome).

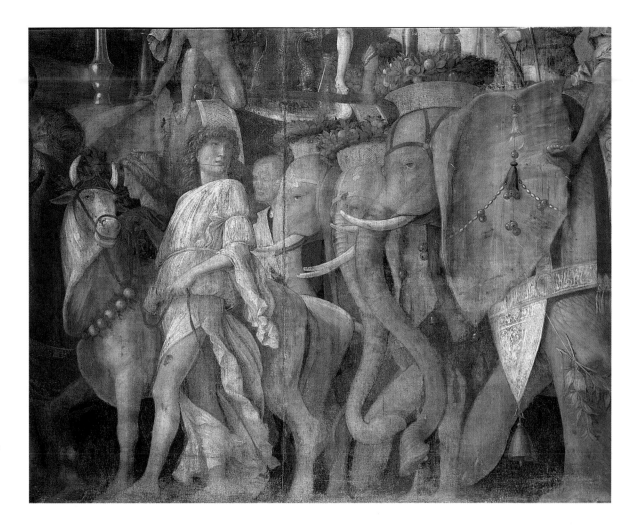

93 *Triumphs of Caesar:* (detail of scene 5) Trumpets, Youths Leading Oxen, Elephants with Attendants

An elephant was brought to Mantua in 1479. These animals were already known through stories of medieval origin. Here they are represented as being strangely small, their proportions quite unrealistic, which suggests they were probably painted from memory. Some of them are carrying enormous torches intended to illuminate the scene.

setting for the ceremonial procession and the names of Caesar's victories. In the second scene, an inscription on a banner refers to the Gallic Wars. The buildings, the standards and the paintings show us several different aspects of Rome. However, among the weaponry depicted we have a form of war axe first generally used in the 15th century (ill. 91), as were some of the helmets shown in this scene.

The beginning and end of the procession are not portrayed, so that unending movement is suggested: what is fixed before us is only a part of the whole. It would be unusual for Caesar's chariot to mark the end of the procession (ill. 97). The expectation was that he would be surrounded by a larger crowd admiring his victories and his greatness. In addition, the guardian angel holding the laurel wreath over Caesar's head is looking backwards, suggesting that the procession stretches out behind them. Certainly, the picture showing Caesar was to be followed by another picture with senators, who, according to Valturio's "De re militari", normally travelled behind the emperor's chariot. An engraving from Mantegna's school and a drawing (in the Albertina, Vienna) illustrate the missing scene. They were probably based on a drawing by Mantegna himself. It is not known why this canvas was not executed.

The procession is viewed from slightly below: the feet of participants crowding together close to the edge of the picture are not seen. Only the figures at the front are completely recognizable, while the others disappear in the dense crowd. A lively rhythm animates this gathering, and symmetrical organization, neat parallel rows, and repetition are avoided. Each painting has its own viewpoint, and walking past the whole series leaves the viewer with an impression of great animation. The figures illustrate a wide range of postures and a head is rarely seen in profile. Many of the figures are looking backwards, a device by which the individual sections are linked. It is not until the seventh painting (ill. 95) that a few prisoners are recognizable, the profiles of their hanging heads intended to emphasize their resigned submission. The multiplicity of objects and gestures, the wealth of contrast in color provide *varietà*, the diversity of content demanded by Alberti. Although the ancient procession went through the streets of Rome, no uninterrupted streets of houses are depicted along the route shown by Mantegna. The contemporary conception of classical Rome was influenced less by the idea of everyday habitation than by a knowledge of monumental structures. The general impression is of an heroic amalgam of temples, theaters, triumphal arches, statues, and palaces. Moreover, the general absence of a realistic portrayal of streets in Mantegna's pictures provides a contrast between the open areas of landscape and the packed throng of the procession – artistic considerations were more important to him than historical accuracy.

The individual paintings are grouped together in

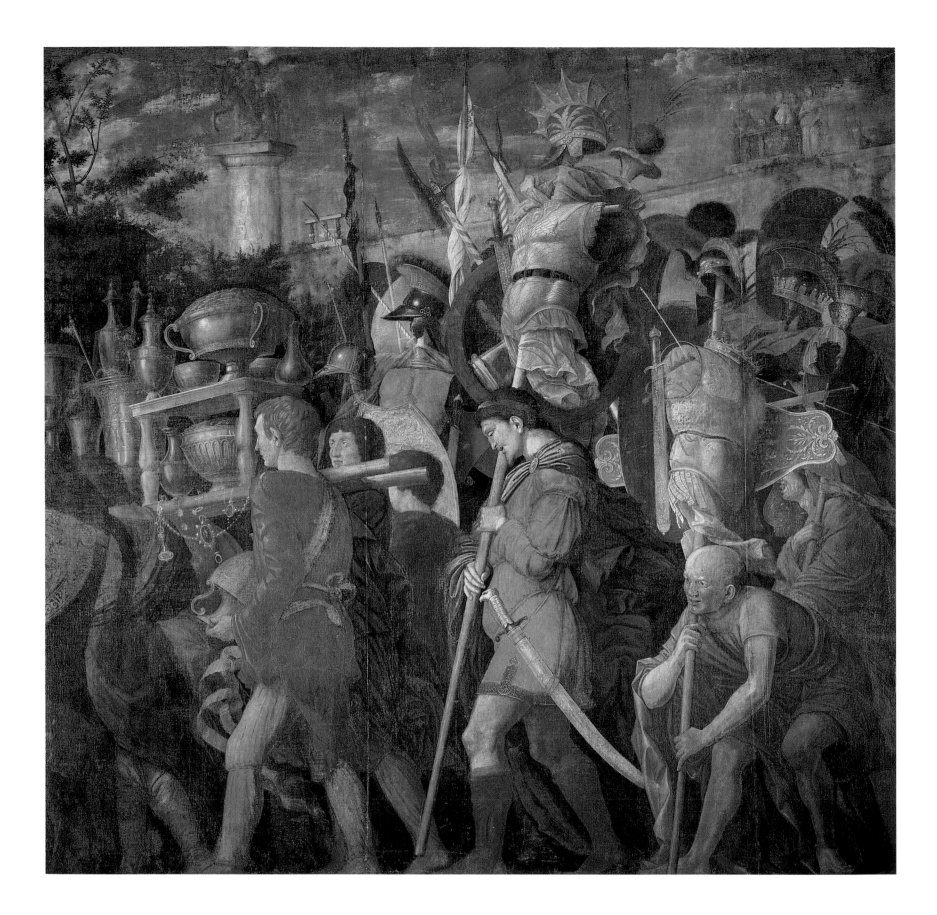

94 *Triumphs of Caesar:* (scene 6) Bearers of Coins and
Plate, Trophies of Royal Armor

Richly worked royal weapons and body armor are
energetically hoisted on poles by the bearers. The use of
contrasting red-green coloring gives the scene a
penetrating glow.

sequence. The first three paintings (ills. 89–91) have no
background details: the backdrop to the trophies and
ensigns is simply the sky. This concentrates the
attention on the objects being carried along, which are
depicted in the upper half of the painting. In the fourth
painting (ill. 92), the background is formed by a wooded
hill, dotted with ruins, which becomes a rocky slope just
behind the figures. The sixth scene (ill. 94) is dominated

by a high bridge. Only here and in the next painting (ill.
95), which is unequivocally closed off by a massive
building, do spectators appear to watch the procession
pass by – in the first instance from the bridge, and in the
second from behind barred windows. In the eighth
episode (ill. 96), the architecture gives way to landscape
again, and in the ninth episode a triumphal arch
symbolizes the honor to Caesar (ill. 97).

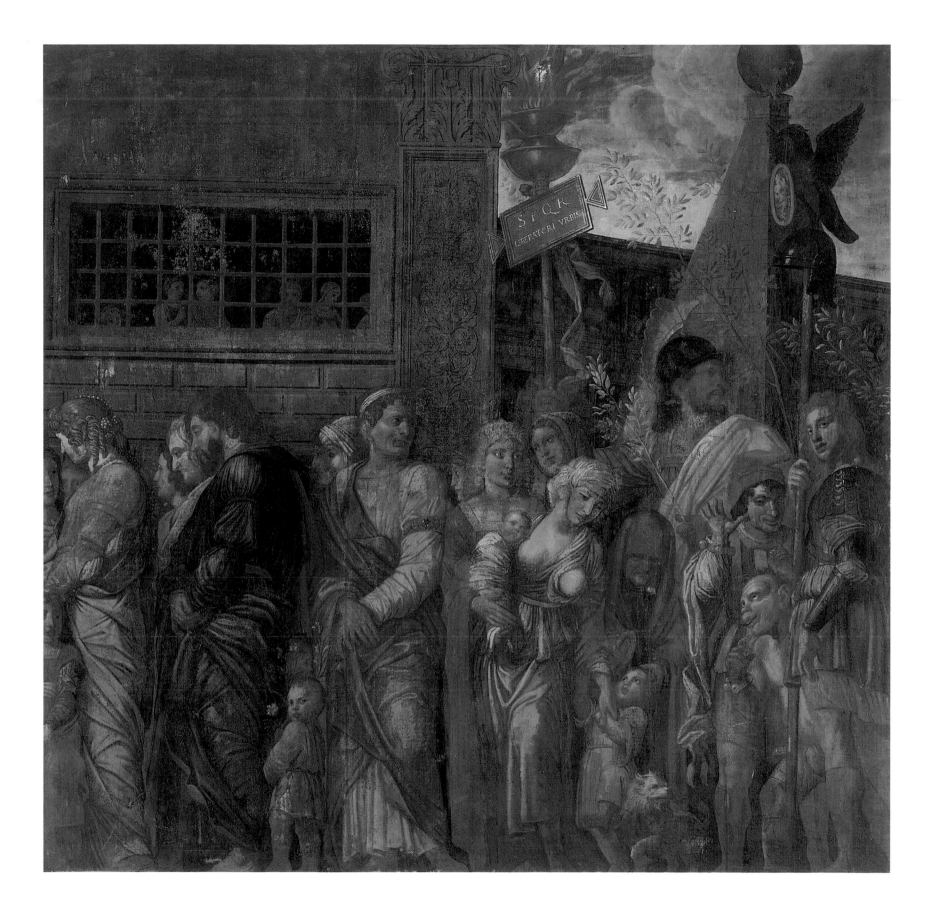

Colorful costumes, a panoply of booty, elephants, oxen, horses, and sheep provide both everyday and exotic details in a procession in which figures from the widest diversity of races are taking part. There is little subsidiary narrative, though there are a few anecdotal elements, such as the conversation between soldier and officer in the second painting (ill. 90). The objects represented contain multiple references to the emperor's all-embracing drive for power. In several scenes sculpted busts and heads of men and women are being carried along on poles (ills. 90, 96), some of them wearing the town crown. This could be in honor of Cybele, the goddess of fertility from Asia Minor, who had been adopted as *magna mater* in Rome in 204 BC. Later, Mantegna portrayed her again in his *Introduction of the Cult of Cybele to Rome* (ill. 119). The busts may also very

95 *Triumphs of Caesar:* (scene 7) Prisoners and Standard Bearers, Buffoons and Soldiers

Even as prisoners the buffoons play the fool and entertain the procession. In his description of this scene, Vasari was particularly impressed by the small boy who turns to his mother in pain because he has a thorn in his foot. This badly damaged canvas was completely over-painted during the 18th century.

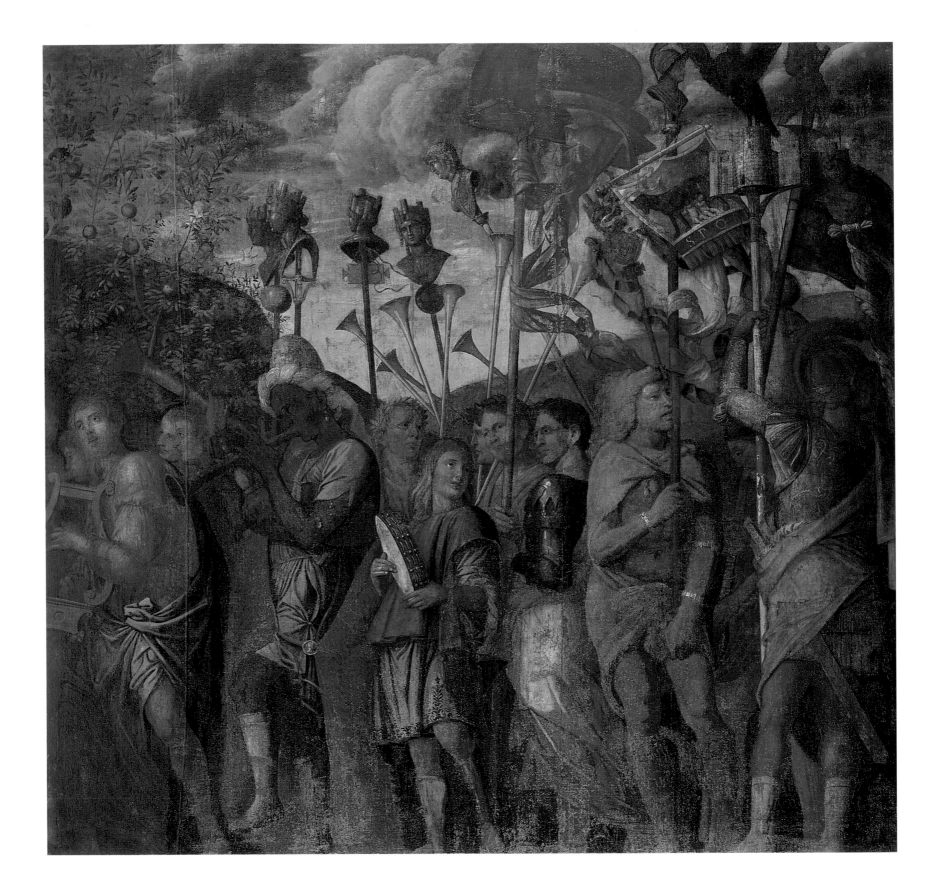

96 *Triumphs of Caesar:* (scene 8) Musicians
and Standard Bearers

A colorful band of musicians pass by carrying a wide
range of instruments, including the tambourine,
trumpets, bagpipes, and the lyre.

possibly represent another Roman goddess, or perhaps
the province of Gaul, since most of them are positioned
directly below the inscription referring to Gaul.

The figures in these nine canvases of the *Triumphs* are
different in style from those in the Camera degli Sposi.
Their movement appears more natural, they are no
longer constructed from geometrical shapes, and their
clothing is less stiff and heavy. Nor are there any
identifiable portraits here, but rather the impression of

types, notably the ideal figure of a blond, curly headed
youth typified by the boy leading the oxen (ill. 92).
With this cycle, Mantegna was entering on a much more
classically oriented phase of his work.

On 2 March 1494 the frescoes in the Camera degli
Sposi and the canvases of the *Triumphs* were proudly
shown to Giovanni de'Medici, who later became Pope
Leo X. At this time the *Triumphs* series was probably
almost complete. Copperplate engravings and wood

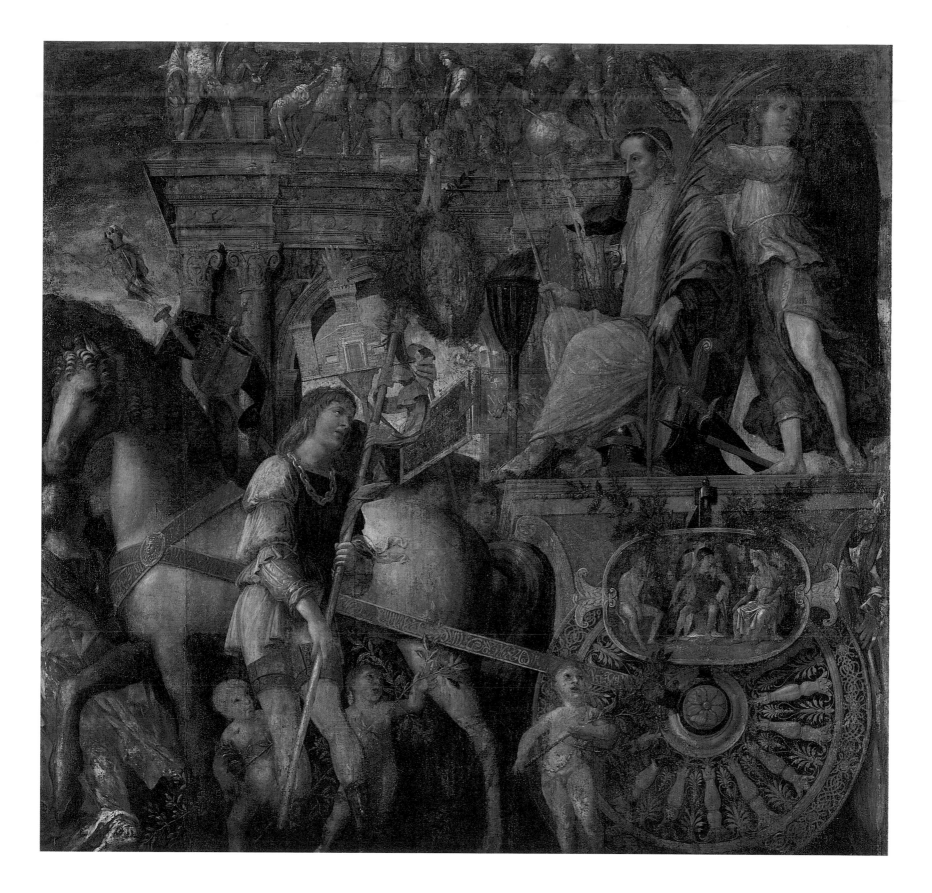

cuts, as well as painted copies, quickly spread its reputation; as early as 1500 there were engravings by Antonio da Brescia and others. Since the original paintings are not well preserved and have been heavily restored, an exact impression of the detail of the *Triumphs* is available today only from the wood cuts completed from 1598 onwards by Andrea Andreani (active between 1584–1610).

97 *Triumphs of Caesar:* (scene 9) Julius Caesar in the Triumphal Chariot

The triumph of the emperor, who sits like a god in his triumphal chariot, is heralded and lauded – as shown by the presence of putti, which appear only in this painting, the laurel wreath with which Caesar is about to be crowned, the sculptures of conquered warriors on the triumphal arch, and the images of the gods.

98 *Bacchanalia with a Wine Vat*, ca. 1470
Copperplate engraving, 33.5 x 45.5 cm
The Metropolitan Museum of Art, New York

Drunkenness, sloth, and depravity are the consequences of the bacchanalia. Even the idealized figure of Bacchus, which may have been copied from the figure of the God Mars on a Roman sarcophagus, raises doubts about his dignity. He is leaning on a horn of plenty and reaching for a grape. Bacchus, or Dionysus, the God of fertility and wine, was the model of immoderation, the counterpart to Apollo.

Mantegna was the first major painter in Italy to involve himself in printing techniques. Copperplate engraving, which had been developed in southern Germany around 1430 (therefore at about the time of Mantegna's birth) made it possible to produce finer reproductions than with wood cuts, which had been used until then. In the second half of the 15th century, engraved reproductions of the major altarpieces were being sold to pilgrims; devotional inserts for prayer books were also being printed, as were playing cards and calendars. Another important aspect of this development was the use of decorative engravings and major individual works as teaching materials for artists' workshops. This was how innovations in art spread throughout Europe.

Vasari, in the first edition of his "Lives", published in 1550, described Mantegna as the decisive influence in the development of copperplate engraving in Italy. In the second edition, published in 1568, he described the Florentine artist Maso Finiguerra (1426–1464) in this way – certainly Finiguerra's skills as a leading *niello* artist helped him to create finely worked engravings consisting of light motifs on a dark background. These derived from the metal plates used in his niello workshop, on which silvered motifs contrast with a black background. Mantegna also used printing to achieve *chiaroscuro* effects, the interplay of light and shade with which he achieved results similar to those in his grisaille painting and simulated reliefs. Nevertheless, he did not view engraving as one of his main achievements.

Although he was happy to experiment with the new medium, he left the reproduction of his works to professional engravers, of whose work he was highly critical. Printing enabled Mantegna to earn extra money, and to disseminate his *invenzioni*, his creative insights.

Drawing and printing were also an area where new ideas could be tried out. Because of the unusual size of the plates used by Mantegna, the *Battle of the Sea Gods* (ills. 99, 101) should be regarded more as a work of art in its own right than a reproduction after an existing painting. Nevertheless, the engravings *Bacchanalia with a Wine Vat* (ill. 98) and *Battle of the Sea Gods* were frequently linked with Mantegna's early works: with the decoration of the Gonzaga's summer palace, painted during the 1560s. These paintings have not been preserved, though they appear to have been copied in engravings.

The German artist Albrecht Dürer (1471–1528), who was to be the most important graphic artist of the early 16th century, was particularly interested in Mantegna's engravings. He became acquainted with graphic works by Mantegna during both of his journeys to Italy, in 1494/95 and 1505–1507, and during his second visit tried to visit Mantegna himself in Mantua, though this was prevented by Mantegna's death in 1506. In 1494, Dürer copied two of Mantegna's engravings: the right half of the *Battle of the Sea Gods* and the *Bacchanalia with a Wine Vat*. These fine drawings (in the Albertina, Vienna) are proof of the great respect the young German had for the older master, as well

100 (above) Albrecht Dürer
Death of Orpheus, 1494
Pen drawing, 28.9 x 22.5 cm
Hamburger Kunsthalle, Kupferstichkabinett, Hamburg

There is a description of this scene in Ovid's
Metamorphoses. It takes place on a high plateau with no
shade, on which all nature's creatures have gathered
around, charmed by the power of music. Grief at the
death of his wife Euridice had caused Orpheus to turn to
pederasty, a fact symbolized by the boy in flight. Thracian
Maenads murder Orpheus in revenge for his rejection of
women.

99, 101 (above left and left) *Battle of the Sea Gods*,
ca. 1470
Copperplate engraving, two parts, each 34 x 44.5 cm
Staatliche Museen zu Berlin – Preußischer Kulturbesitz,
Kupferstichkabinett, Berlin

The battle is an allegory on the theme of *Invidia* (Envy),
who is standing top left as an old woman on a sea
monster. Neptune is turning away from the scene: he
does not want to see the bitter struggle between the sea
monsters, not even as a reflection in the mirror.
Apparently this scene was based on a classical description
of the competition between members of a family of
sculptors living on the island of Rhodes. Comparable
battle scenes can, however, be seen on classical reliefs that
were known through sketch-book drawings; Ludovico III
Gonzaga owned such a sketch-book.

as testimony to the success of Mantegna's engravings. In
addition to this, there is another drawing by Dürer for which
a missing work by Mantegna was presumably the
prototype. This is the *Death of Orpheus* (ill. 100). The
inscription on the tree reads "Orpheus, the first *puseran*

[defiler of boys]," which plays on the Italian word
buggerone (Venetian *buzerone*, and changed by Dürer to
puseran). This theme would have fitted in well with
Mantegna's moralistic series on "women's wiles," to which
Samson and Delilah (ill. 116) also belongs.

INTERMISSION IN ROME

102 *The Madonna of the Stonecutters,* 1488–1490
Distemper on wood, 29 x 21.5 cm
Galleria degli Uffizi, Florence

This view of the Madonna has the feeling of a fragment.
She is set dramatically against a rocky backdrop cut off by
the edge of the painting. Mary and Child are isolated
from what is happening in the rest of the picture and
appear to be turned in upon themselves, a reflection of
the rapt devotion of those who kneel before this image in
pious devotion.

In 1487, Pope Innocent VIII asked Francesco Gonzaga to send his court artist to decorate a chapel in the Vatican. At the same time the Pope also called other artists such as Pinturicchio (ca. 1454–1513) to Rome to decorate his apartments. Francesco Gonzaga was flattered by this request and had hopes of diplomatic preferment from this link. Mantegna left Mantua with a letter of recommendation dated 10 June 1488, in spite of the poor terms of the agreement, by which he was only to be reimbursed his costs in Rome and receive no fees – Francesco feared that Mantegna could be tempted away from him if the rewards were greater.

Early sources report that the chapel was relatively small. The main frescoes consisted of a series of scenes from the life of John the Baptist. In addition to this there were paintings of, for example, the birth of Christ, the adoration of the Magi, figures of saints and evangelists, and also a portrait of the Pope who had commissioned the work. The sacristy of the chapel was decorated with *trompe-l'œil* objects relating to the celebration of the Mass, as well as an illusionistic view of the landscape. The chapel was torn down by Pope Pius VI in 1780. During the 18th century, the period of Rococo and Neoclassicism, Mantegna was no longer respected outside his native area. This destruction of these frescoes was a heavy loss, particularly as Mantegna had painted the chapel without assistance, and would certainly have done all he could to impress both his fellow artists and the art connoisseurs in Rome.

In September 1490, Mantegna returned to Mantua. Though there had been no financial gain, he now held the new title of Count Palatine, presumably bestowed on him by the pope. However that may be, at the beginning of the 1490s Mantegna signed a few works with the title "Comes palatinus". According to Vasari, *The Madonna of the Stonecutters* (ill. 102) was painted in Rome. Mary, outlined against a bizarre jagged rock, is sitting on a rocky plateau that has been identified as Golgotha; the effect of this expressive backdrop, combined with other details in the picture, is to hint at Christ's future suffering. To the right a cavern can be seen: this can be interpreted as Christ's tomb. In front of this cavern, illuminated by a beam of light on this otherwise dark side, stone masons are working on a

pillar, a gravestone, and a sarcophagus, the symbols of Christ's passion. On the other side of Mary, everyday scenes can be observed in a valley. This contrast was seen as the symbol of redemption: unfettered everyday life is sunlit now that Christ has taken Original Sin upon Himself.

The newly acquired title "Comes palatinus" was added to the signature in the painting *Christ the Redeemer* (ill. 103), which, according to the inscription, was a gift from Mantegna to an unknown recipient on 5 January 1493, the eve of the Feast of the Epiphany. Perhaps it was intended for the niece of the Marquise Barbara, Francesca of Brandenburg, who had married Count Boso da Correggio in 1477; or for Boso's cousin Niccolò II, both friends of the Gonzaga. This head of Christ is a new interpretation of a famous painting by Jan van Eyck that was known in Italy from several copies. The book and the frame bear further inscriptions: one demands that the viewer should kneel in penitence and submission, while another quotes St Luke's words of hope, "Have no fear."

Christ on the Tomb Supported by Two Angels (Pietà) (ill. 104) shows Christ as a classical idealization, presenting him in an abstract setting without narrative links to the biblical story. The landscape here is highly evocative: to the left the sky is bright over Jerusalem, to the right it is pale over Golgotha. The clearly proportioned body of Christ rises from the detailed background brightly lit and with an almost silvery shimmer.

Descent into Limbo (ill. 105) possibly also dates from this period, around 1492. The composition seems crowded, largely because the upper and left-hand edges have been cut. From 1466 onwards, Mantegna painted several versions of this theme, the earliest of which was intended for Ludovico III Gonzaga. However, for the most part, these works are now available, if at all, only as drawings or engravings. A variation on this theme by Giovanni Bellini, painted 1475–1480, has survived (Bristol Museum and Art Gallery, England), and takes the same approach as Mantegna's studies. With Mantegna, Christ does not beat on the doors of Hell, as recounted in the biblical story. On the contrary, he steps right up to Hell's gates and frees the righteous, triumphing over death and the Devil. In Byzantine art,

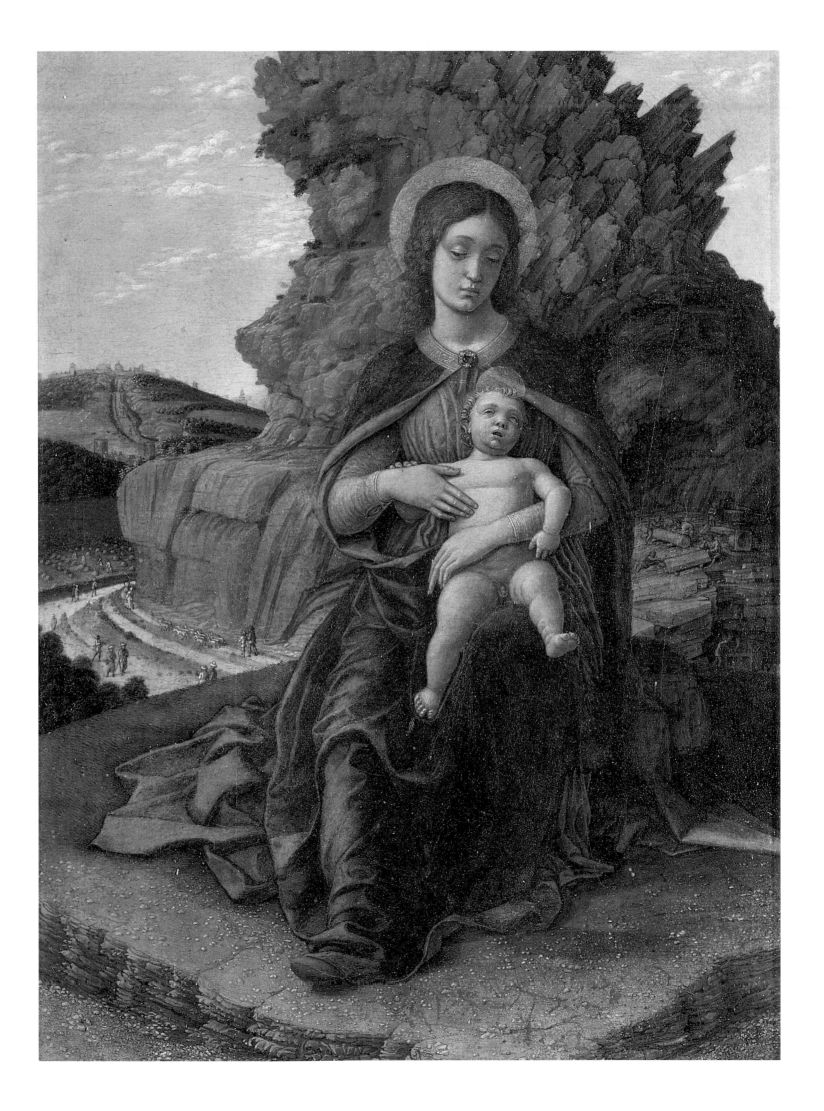

MOMORDILE VOS MET IPSOS ANTE EFFIGEM VVLTVS MEI

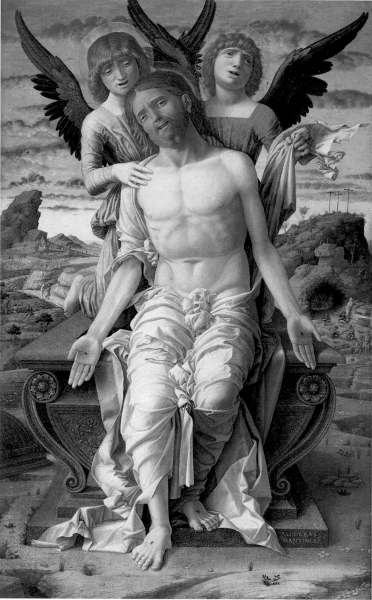

103 (above left) *Christ The Redeemer,* 1493
Distemper on canvas, 53 x 43 cm
Congragzione di Carità, Correggio

The motif is close-fitting so that Christ's head now comes very near to the frame. Though He appears as a living being, He seems remote and unapproachable. This is one of the few works of the later period for which we have a date, and which therefore provides a reference point for other works.

the descent into Limbo was a reference to the Resurrection.

Christ, who amazingly is seen from behind, bends towards one of the patriarchs emerging from the depths of Hell and whose cloak, caught by the wind, surrounds him like a halo. Pained, but full of hope, he turns his face and hands towards Christ. The emotional tension of the scene culminates in dialogue between these two figures. Guided by classical examples, Alberti recommended in his treatise "De Pictura" that strong emotion should not be directly depicted and that the figures should be shrouded, so that the extremes of feeling could be created in the viewer's imagination – the imagination not being limited to the representational or to propriety. The painter was to provide a stimulus to the imagination without making his work ridiculous with grotesque expressions of emotion. On another plane, the figure of Christ also provides a focus the viewer can identify with. His physical posture emphasizes the line of vision into the painting and leads directly to the patriarchs emerging from the depths.

104 (opposite) *Christ on the Tomb Supported by Two Angels (Pietà)*, 1490–1500
Distemper on wood, 78 x 48 cm
Statens Museum for Kunst, Copenhagen

This devotional painting, intended for a private apartment, is ascribed to Mantegna's Roman period. In this *imago pietatis*, Christ displays His wounds as a reminder that He died for us on the Cross. The finely worked sarcophagus on which Christ is leaning is a clear demonstration of Mantegna's skill. He was in fact commissioned to design the tomb of Barbara of Brandenburg, who died in 1481, but this project was never executed.

105 (below) *Descent into Limbo,* ca. 1492
Distemper on wood, 38.6 x 42 cm
The Barbara Piasecka Johnson Collection, Princeton, New Jersey

The story of Christ's descent into Limbo does not appear in the Bible, but in the apocryphal Gospel of Nicodemus, and also in the "Legenda Aurea" of Jacobus da Voragine. Limbo is a neutral zone of Hell where the souls of the Old Testament patriarchs and prophets reside. They are not damned, but cannot ascend into heaven until the coming of Christ. Thus, to the left in Mantegna's painting we have the first human couple, Adam and Eve, the two who, through Original Sin, begin the story of Christ's Passion.

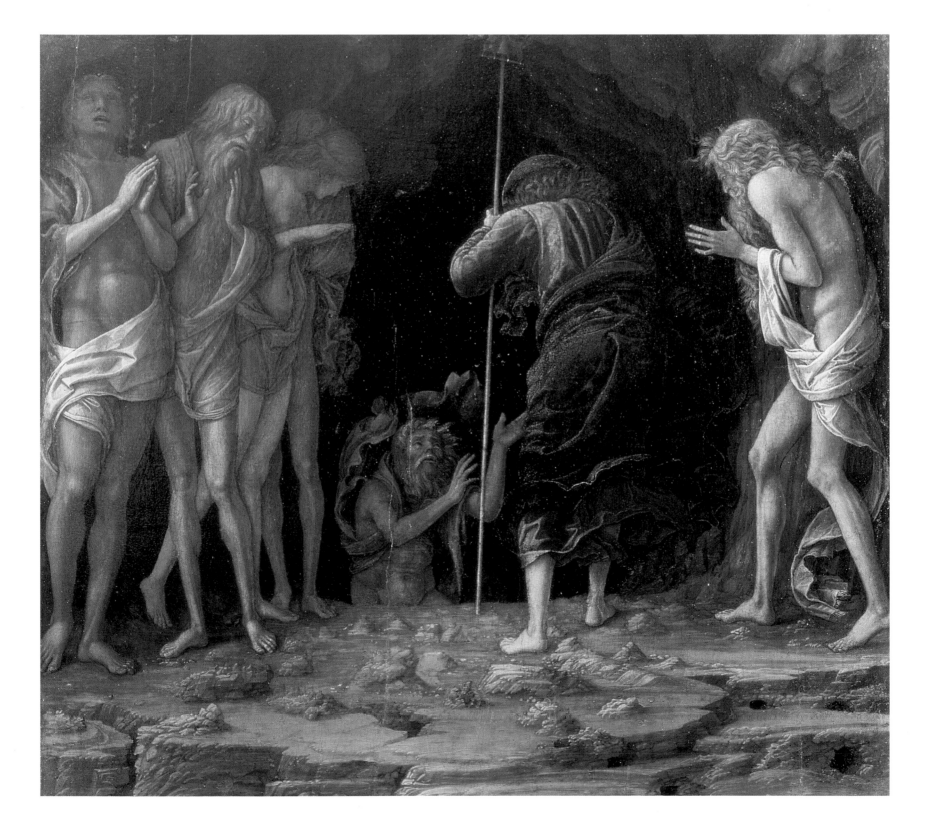

106 Titian
Portrait of Isabella d'Este (Isabella in Black), 1534–1536
Oil on canvas, 102 x 64 cm
Kunsthistorisches Museum, Vienna

The Venetian artist Titian painted this portrait when
Isabella was sixty years old. As a model, he used a painting
by Francia (ca.1450–1517/18), who had in turn copied
an earlier painting. Isabella wrote to her agent in Venice,
"We are so pleased at the portrait by Titian that we doubt
that we were of such beauty as it portrays at the age at
which it shows us." The portrait combines a youthful
appearance with the regal, composed demeanor of a
mature, self-confident woman.

Isabella d'Este's birth on 17 March 1474 in Ferrara was
celebrated just as lavishly as if a successor to the throne had
been brought into the world. Presumably this unusual joy
at the birth of a girl was based on the fact that this was the
first legitimate offspring from the d'Este family for a very
long time. Isabella remained a favorite with the family and
as a child was noted for her intelligence and charm.

At this time, the upbringing of women was again coming
under scrutiny, though naturally only in higher social circles.
Women were no longer seen simply as the bearers of the
next generation, who had to remain quietly in the
background. On the contrary, women were supposed to
possess social skills and attainments, such as an ability to
play music, and to receive a humanist education that
would enable them to conduct an informed conversation
at court. Isabella was commended and extolled by her
contemporaries. In his sonnets, Niccolò da Correggio
(1459–1508) praised her as the "prima donna del mondo"
(the first lady of the world), just like a queen. She was also
a leading figure in fashion. Thus the portrait by the great
Venetian artist Titian (1488–1576) shows her as a young
woman in an imaginative costume (ill. 106), whose majestic
radiance reflects an awareness of her uniqueness and the
successes she achieved during the course of her life.

Isabella was betrothed to Francesco Gonzaga as a six-
year-old, and in February 1490, at the age of sixteen, she
came to Mantua as the new Marquise. She immediately set
about creating her private apartments in the ducal palace.
She attached particular importance to the *studiolo*, a room
dedicated to the study of philosophy and art, and the so-
called *grotta*, which was to house her extensive collection
of *objets d'art*. These architectural requirements, unusual
for the mistress of a household, were modelled on
antecedents in the palace of the Duke of Urbino, and at the
palace of Isabella's uncle, Lionello d'Este's, at Belfiore.
Isabella could not be seen to direct extensive building work
as this would have overstepped the social norms for her sex.
But even outside her own sphere, she used all the means
available to her and became an art collector and patron on
a grand scale. For half a century she was one of the major
patrons of the new age. She collected paintings, sculptures,
bronzes, small articles such as cameos and medallions, and
prestigious rare and expensive antiquities. Her agents were
active throughout Europe, and on several occasions she
must have been in competition with male art collectors,
therefore also her father, Ercole d'Este, when trying to
obtain one work or another.

Besides fine editions of the Bible and illuminated religious
works, the library of her *studiolo* contained mainly the
works of classical authors such as Aristotle (384–322 BC),

Cicero (106–43 BC), Seneca (4 BC–AD 65), Catullus (ca.
84–54 BC), and Plutarch (AD 46–125). Alongside a good
many novels on chivalry were to be found Dante
(1265–1321), Petrarch (1304–1374), Lorenzo d'Medici
and contemporary authors like Niccolò da Correggio and
Jacopo Sannazaro (1457–1530), who had dedicated books
to Isabella. A special place was occupied by the poet Battista
Spagnoli (1448–1516), the "new Virgil of Mantua," and
also by Baldassare Castiglione (1478–1529), who had
outlined the ideal, universally cultivated Renaissance man
in his famous work on court life "Il cortegiano" (The
Courtier), published in 1528.

Inspiration for the *concetti* of the painters came
from Ovid's (43 BC–AD 18) "Metamorphoses", Petrarch's
"Trionfi" and Philostratos' (ca. AD 165–245) "Eikones".
Suggestively erotic images – for example Jupiter's amorous
adventures, which Titian and Correggio (ca. 1489–1534)
had painted for the *studioli* of Isabella's brother Alfonso in
Ferrara and for her son Federico – were not suitable for a
lady: the main theme in Isabella's *studiolo* was the struggle
between earthly and divine love. She had entered into
the discussions on the relevant books with enormous
enthusiasm. Isabella wanted the most famous painters of
her time to decorate her study. She must have had a certain
amount of difficulty getting them, and it was only through
dogged persistence that she got her way.

Isabella had a very clear idea both of the subject and of
the composition of the paintings she wanted, requirements
some artists found very restrictive. The French art historian
André Castel noted in his book on Leonardo da Vinci:
"Leonardo was able to politely deflect 'exploitative' patrons
like Isabella d'Este. (Giovanni Bellini escaped her attentions
by saying he was sick, but Perugino, Costa and others were
in her service and as such painted their worst pictures)." This
statement reflects something of the resentment felt for this
strong woman, even today. On the other hand, it must be
admitted that the paintings executed for Isabella's study are
somewhat static and lifeless, most probably because of the
detailed instructions to which they were painted.

Mantegna was commissioned to execute two paintings
for Isabella's *studiolo*, paintings that were hung in 1497 and
1502. One is *Parnassus* (ill. 107) and the other is a variation
on the subject of *The Triumph of Virtue* (ill. 109). From
Mantegna's works, Isabella laid down guidelines for
paintings which were to follow. After plain threats from
Isabella, Perugino (1448–1523) delivered the *Struggle of
Chastity against Lust* in 1505. In 1506, Lorenzo Costa
supplied the eulogistic *Coronation of Isabella* and over the
next few years he completed the painting of *The History of
the Cosmos* begun by Mantegna.

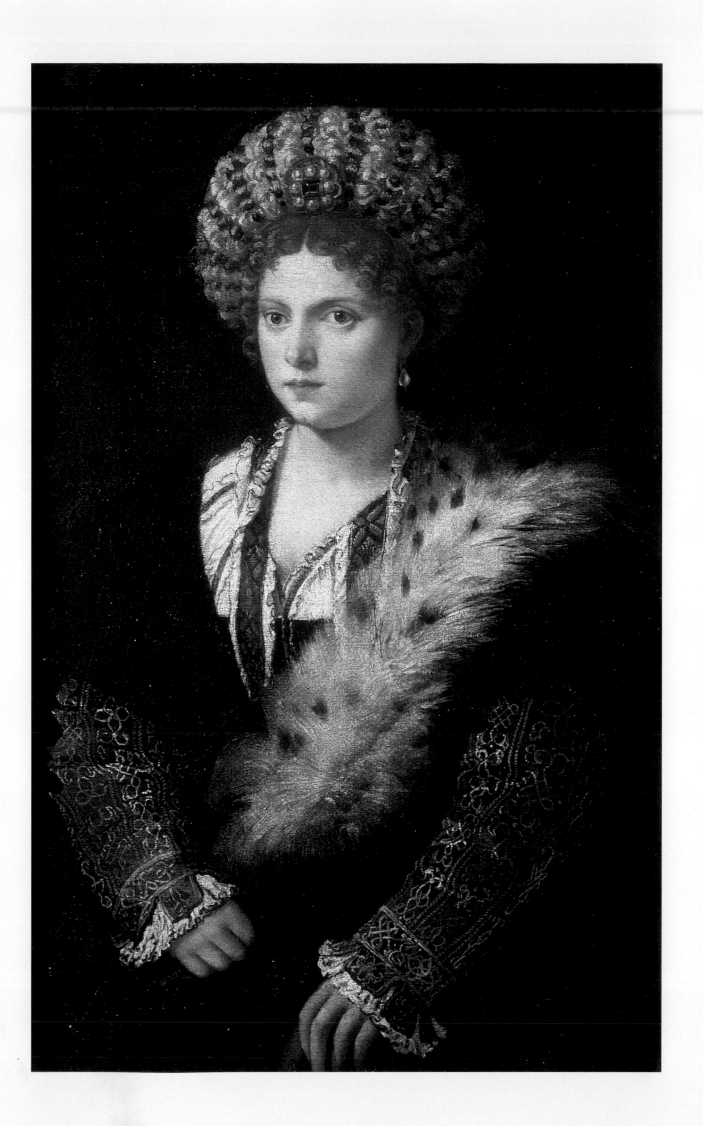

MANTEGNA'S LATE WORKS

The title of this painting goes back to the 17th century. The scene in fact takes place in the Helicon Mountains, with Parnassus, the mountain sacred to Apollo and the Muses, visible in the background. The divine lovers Mars and Venus, standing on an elevation in the center of the painting, may represent the union of the houses of d'Este and Gonzaga: the successful military commander Francesco Gonzaga in the role of the god of war and Isabella as the goddess of love – the d'Este family tree was descended, it was believed, from the Trojans, whose patron was Venus.

After the sixty-year-old Mantegna had returned from Rome to Mantua, he made a point of obtaining a recommendation to the recently married Isabella d'Este, who came to the court in 1490 as Francesco's wife. The frescoes in the Camera degli Sposi had been completed for Ludovico III Gonzaga in the year of Isabella's birth. Now, two generations of rulers later, the young countess wanted a *studiolo* in the palace, and to have this decorated to her taste, with complicated mythological themes. Parnassus, the seat of Apollo and the Muses, was a favorite subject for Renaissance painting. Isabella's impulse in selecting this theme was influenced by the Tempietto delle Muse (small temple of the Muses) situated directly beneath the Christian chapel in Federico da Montefeltre's palace in Urbino. Mantegna's small painting for Isabella d'Este's *studiolo* portrays the divine couple, Mars and Venus, standing on a rock arch (ill. 107). At Mars' feet a small putto, most probably Eros, is directing his blowpipe at Venus' husband, the furiously gesticulating Vulcan, who stands before his smithy fire in a cavern to the left. In the foreground, below Mars and Venus, the nine Muses are dancing to the sound of the cithara played by Apollo, who is sitting on the far left.

According to the court poet Battista Spagnoli, the "new Virgil of Mantua," Apollo was the sole ruler of Parnassus. But the division of the heavenly mountain into two peaks, seen at the right-hand edge of the picture, is also a reference to Apollo's antithesis, Dionysis. In front of these peaks, Mercury, the Gods' messenger and the guardian of Parnassus, is leaning against Pegasus, the flying horse (ill. 108). Mercury's staff, with snakes winding round it, symbolizes the principle of conflict amidst peaceful concord, thus drawing attention to the contrasting couple of Mars (god of war) and Venus (goddess of love), from whom harmony is born. The Dionysian impetus for the scene is repressed in the main, but becomes clear through the blowpipe directed at Vulcan's genitals, and in the finger gestures of the two Muses on the right. According to teaching on Platonic love, the union between Vulcan and Venus produced Eros, the god of sexual love, and the union between Venus and Mars produced Anteros, the heavenly love that leads to divine understanding. As

the emphasis here is placed on the latter union, the rule of *convenienza*, regarding decorum in a woman's apartments, was preserved.

Mantegna's second work for Isabella's *studiolo* is more puzzling, even though it bears several inscriptions. There is as much uncertainty about who thought out the content for *The Triumph of Virtue* (ill. 109), as there is about who developed the ideas represented in *Parnassus*. Paride da Ceresara, a humanist active at court, may have been responsible. However, Isabella could also have taken the relevant passages from Spagnoli's poetry and developed ideas for the paintings from these.

From the left, Minerva, undisputedly the personification of virtue, storms into the garden with its topiary arcades. She is looking up to the heavens, where the three cardinal virtues of Justice, Fortitude and Moderation are floating down surrounded by a halo of clouds. Confronted by this attack, the vices are fleeing towards a swamp. To the left, a woman in rags embodying *Inercia* (Sloth) is leading the mutilated figure of *Otium* (Idleness) with a cord. To the right we see the crowned figure of *Ignorancia* (Ignorance) being carried away by *Avaricia* (Avarice) and *Ingratitudo* (Ingratitude).

In the center of the painting, Venus is balanced on the back of a centaur (ill. 110). This is a sensuous Venus, doubling as the voluptuous *Luxuria*, queen of the vices, who leads us to lust and laziness. Her pose is a warning of the inconstancy of *Fortuna* (Fortune). Minerva's spear is broken, though this is not necessarily a sign of failure since it could also indicate that she has already engaged the enemy. Perhaps she is still capable of driving the seductive vices to flight through her moral determination, and to rescue the virtues, the font of the arts and sciences, from their prison in the rocks on the right. But *Fortuna Luxuria* seems indifferent. She goes along with what is happening, as constant change is a feature of her nature: she distributes her gifts here today, there tomorrow. Never taken, never troubled, she always manages to escape.

When Mantegna had completed *The Triumph of Caesar*, he was commissioned to paint two large altarpieces. The first was *The Madonna of Victory* (ill. 111), which was for a church in Mantua dedicated to

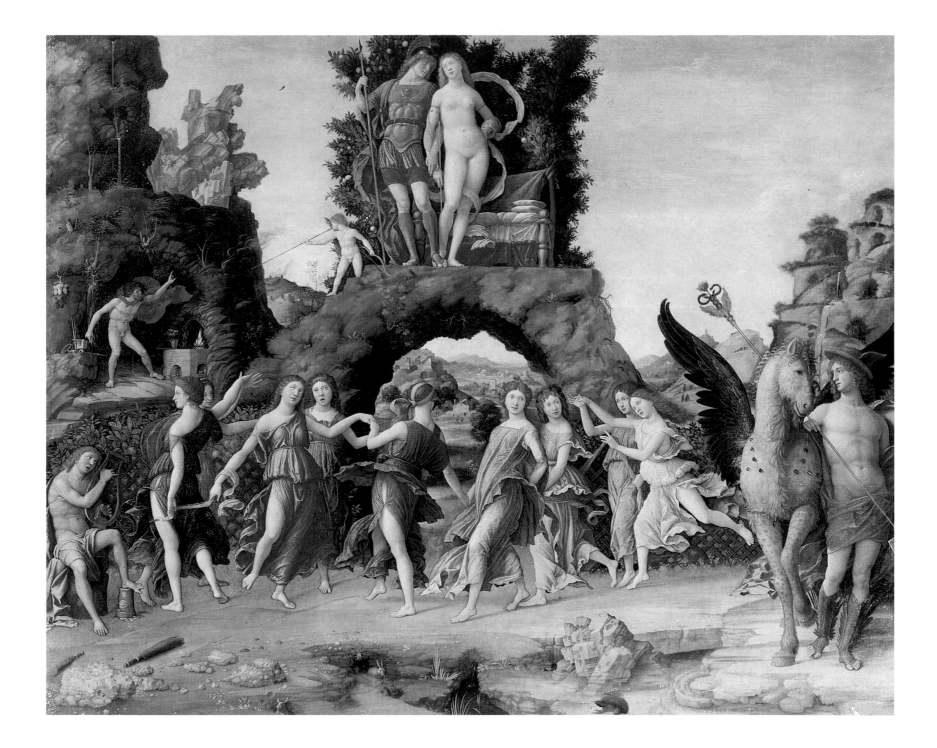

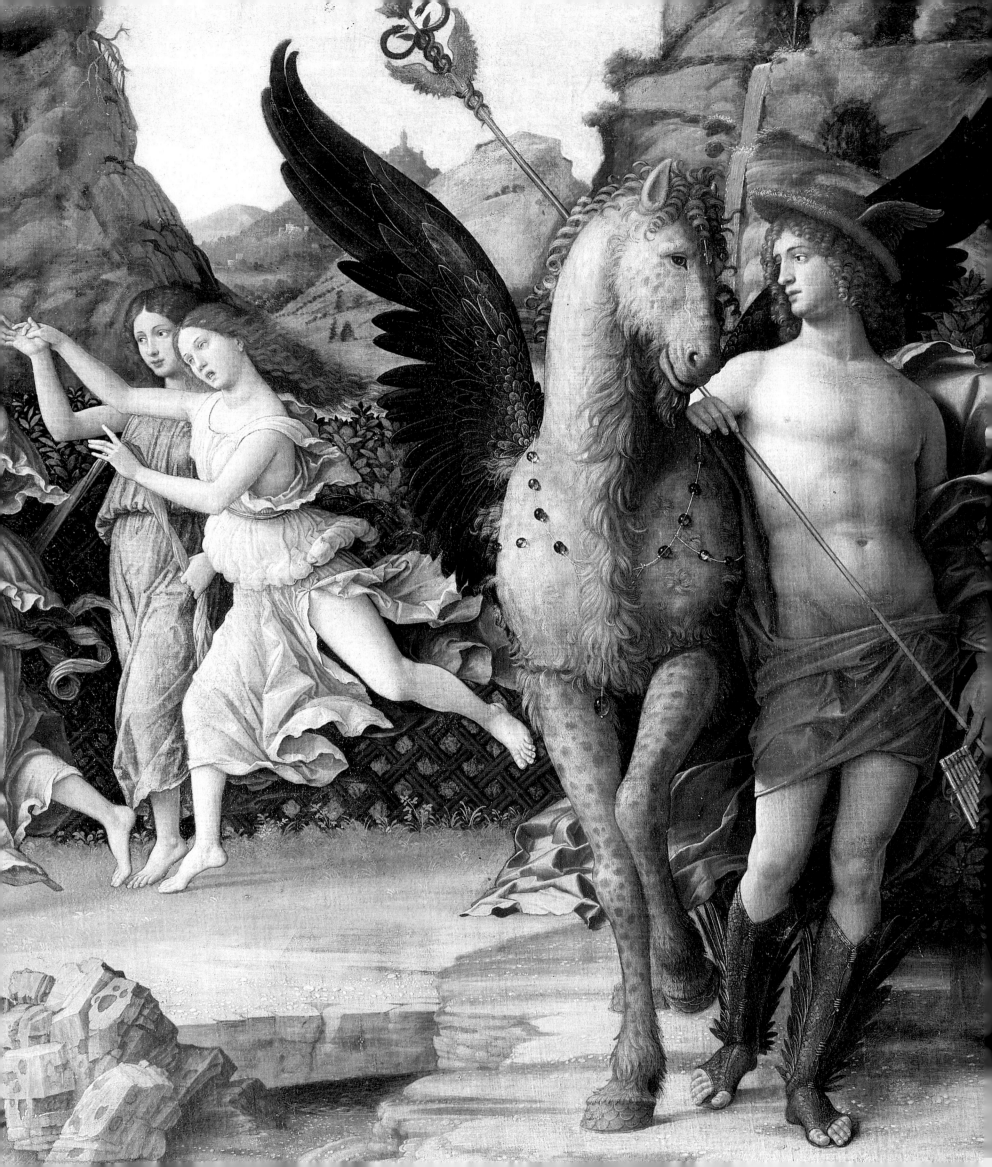

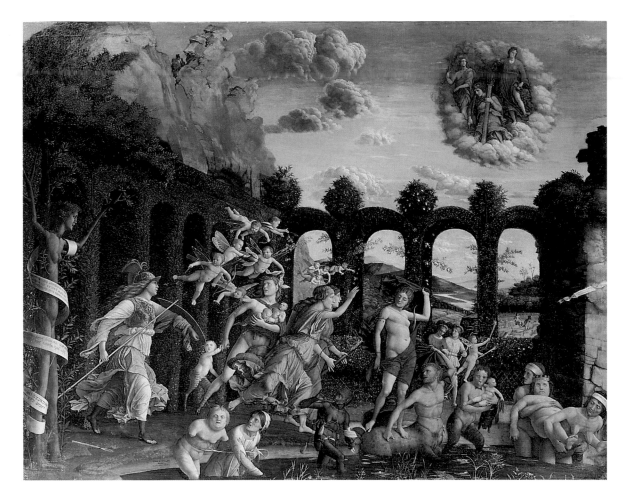

109 (right) *The Triumph of Virtue,* 1502
Distemper on canvas, 160 x 192 cm
Musée du Louvre, Paris

To the left, a scroll explaining the picture's theme is
entwined round Daphne, who is turning into a tree. It
contains the following entreaty in Latin, Greek, and
Hebrew: AGITE PELLITE SEDIBUS NOSTRIS
FOEDA HAEC VICIORUM MONSTRA VIRTUTUM
COELITUS AD NOS REDEUNTIUM DIVAE
COMITES ("Come thou divine companions of the
Virtues, returned to us from heaven and drive these
monstrous vices from our realm").

108 (opposite) *Parnassus* (detail ill. 107), 1497

Mercury, the patron of virtue, the god who endows the
eloquent with their swift-winged words and inventors and
sages with their creative thoughts, is in conversation with
Pegasus, the Muses' winged horse who symbolizes *Virtus,*
or Purity. Pegasus has lifted his hoof which, when it
struck the ground, created Hippocrene, the spring of the
Muses in the Helicon Mountains in Boetia. It appears in
the center foreground of the painting.

the Virgin Mary. The painting was supposed to mark
Francesco Gonzaga's victory at Fornovo on 6 July 1495,
and his miraculous escape from death. As the general of
an Italian army unit during this bloody battle, Francesco
had defeated the French troops of King Charles VIII.
The Marquis then styled himself the liberator of Italy,
though in fact the enemy troops had not been finally
defeated. He chose the Virgin to be his special patron
and had several churches built in her name throughout
his lands.

During his absence from Mantua, while his brother
Sigismondo dealt with the affairs of state, a remarkable
event had occurred. A Jewish householder removed an
image of the Madonna that had decorated the front of
his house. Jews were given sanctuary in Mantua and
were protected by the Gonzaga, though they had to pay
a high price for this privilege. The removal of a Christian
image from a public space was not acceptable and this
incident gave the populace a welcome opportunity to
attack the owner of the house. This led to an official
demand from the Gonzaga that the house owner should
restore the image – otherwise he, and not the image,
would hang outside his house. Naturally, he gave in
to the threats, though it was now too late to prevent
further consequences. Soon the whole affair was further
intensified when two men from the city, considered to
be god-fearing individuals, independently had visions in
which, at this very spot, they saw the church dedicated
to Mary that had previously stood there. It was not long
before the house of the Jew occupying supposed

hallowed ground had been torn down and the chapel of
Santa Maria della Vittoria built. Mantegna was also
believed to be responsible for the design of this simple
building. It was consecrated on 6 July 1496, the
anniversary of the victory of Fornovo.

To start off the festivities planned for this day by
Francesco and Isabella, the painting *The Madonna of
Victory* was placed on a richly decorated stand in front
of the church of *San Sebastiano.* Costumed men
grouped themselves around the painting and placed the
image of Mary within a living tableau: secured by
scaffolding, God the Father hovered overhead, flanked
to left and right by a prophet and three singing angels,
and the twelve Apostles stood in front. Here the
interplay of the different levels of reality, involving
artistic representation, earthly mortality and divine
presence, was graphically demonstrated. Then the
painting was carried in a procession to the chapel of
Santa Maria della Vittoria, where, after a banquet and a
Mass, it was installed over the high altar.

Contrary to Sigismondo's wishes, Mantegna's picture
does not show any other members of the family apart
from Francesco. Mary is enthroned in the center. Her
robe is protectively spread by Saints Michael and George
over Francesco Gonzaga, kneeling on the left, and the
infant John the Baptist standing to the right on the base
of the throne. Through his gesture and the inscription
on his cross-like staff, the infant John is pointing to
Jesus. His mother Elizabeth is kneeling beside him. In
the background the heads of the patron saints of

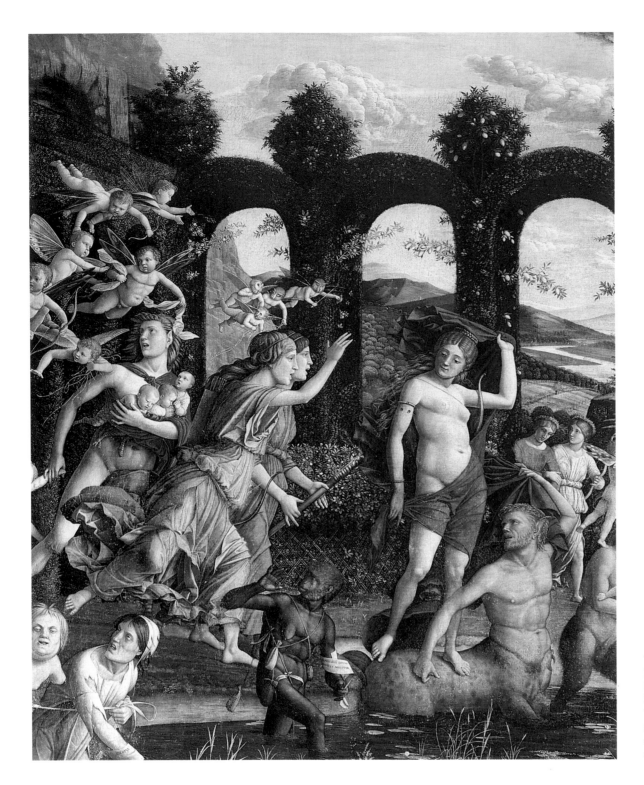

110 *The Triumph of Virtue* (detail ill. 109), 1502

The figure of Venus, armed with a bow, is standing on the back of a centaur, whose body unites the eternal conflict between reason and animal passions. Near them is an ape-like hermaphrodite with one female and one male breast. This figure, carrying four bags containing the seeds of evil, is, according to the scroll around his-her left arm, the embodiment of "undying hatred, deceit, and malevolence."

Mantua, Andrew and Longinus, are recognizable. They are both closely connected with the cult of the Holy Blood, the most important relic in the city (a drop of Christ's blood). This relic was kept in the church of St Andrew, specially built for the many pilgrims who came to see it from plans by Alberti. Longinus, the centurion who had pierced the side of Christ with his lance, was said to have brought this relic to Mantua.

The position of St Elizabeth, to the right of the throne, is unique. In fact, in a votive painting of this type, this place would normally have been occupied by the wife of the male patron, symmetrically opposite him. Elizabeth was the chosen patron of Isabella, as the Italian name Isabella translates into Elizabeth. In this way, the Marquise could be represented indirectly. But then it is unusual that Francesco was not similarly represented by St Francis, although this perhaps would have made the painting too cryptic. Francesco wanted to give lasting expression to his success. Mary and the Child Jesus and the two saints beside her are turning to Francesco alone, as is Elizabeth. The armed saints underline the message of the painting as a tribute to victory that alludes to the triumph of both body and soul.

More crucial to this painting's content, however, is a reference to the sad story of how the church in which the painting hangs came to be built. A panel in the base of the throne reproduces the moment when Original Sin came

111 (opposite) *The Madonna of Victory*, 1496
Distemper on canvas, 280 x 166 cm
Musée du Louvre, Paris

By the end of the 15th century, large single paintings were being used as altarpieces, a form that reached its apogee in the works of Titian and Paolo Veronese (ca. 1528–1588). The stiffly hierarchical composition of the traditional *Sacra Conversazione* was also discarded. Mantegna's Mary is turning slightly away from the central axis, which runs from the Tree of Knowledge on the throne pedestal up through the Christ Child to the branch of coral hanging on a chain. Mary and the idealized, over life-size figures of the saints Michael and George form a majestic group.

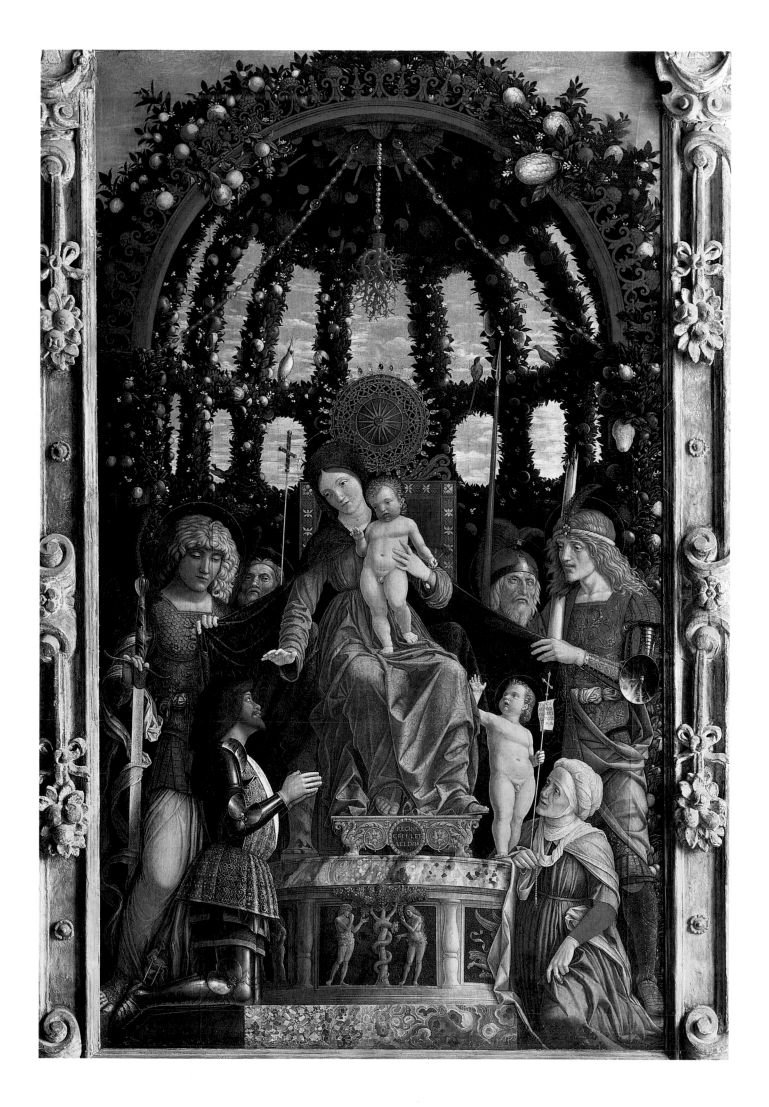

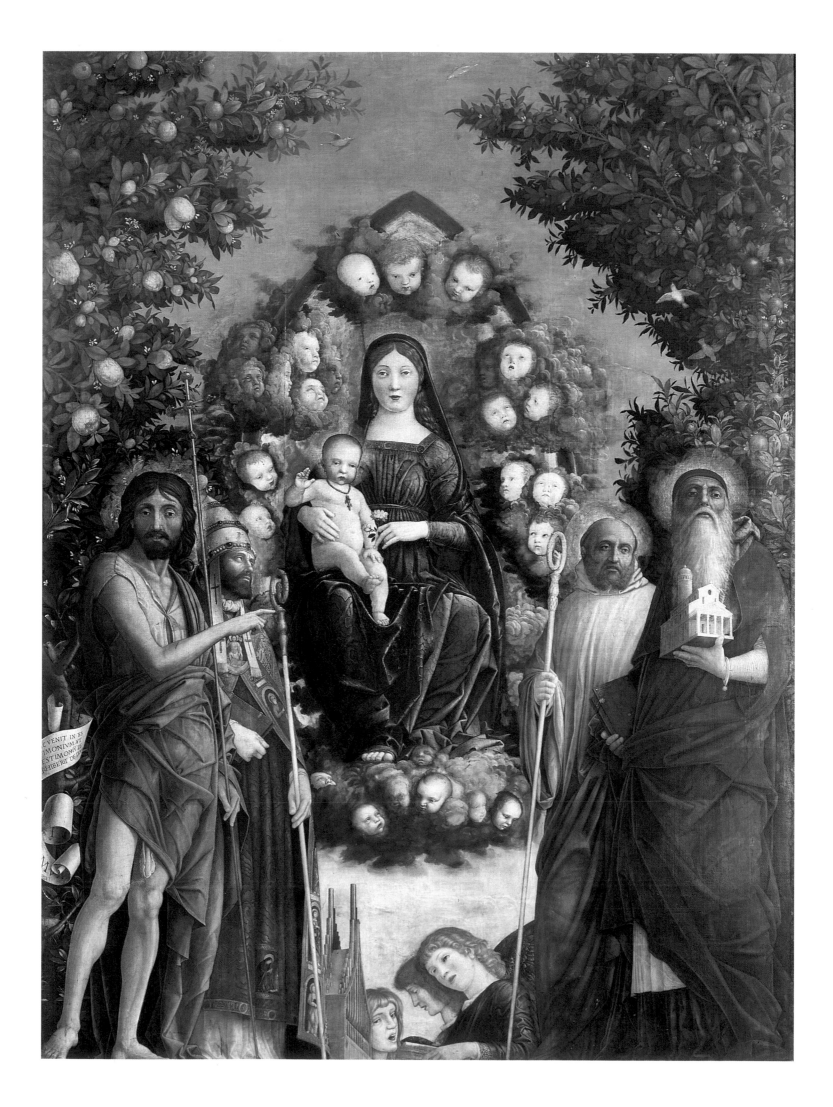

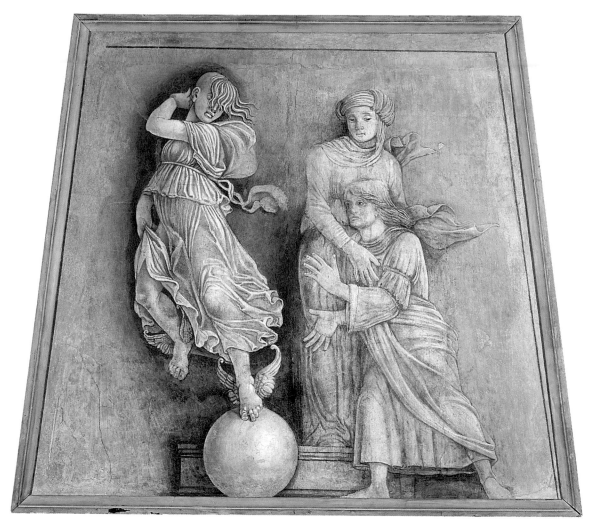

113 (right) *Occasio and Poenitentia*, ca. 1500
Fresco transferred to canvas, 168 x 146 cm
Palazzo Ducale, Mantua

Balancing precariously on a ball with one of her winged feet is *Occasio* (the personification of Transience). Her hair is blowing into her face, blinding her. If the occasion passes ungrasped, *Poenitentia* (the symbol of Regret), remains behind. But *Vera Eruditio* (True Learning), on the other hand, is standing on a solid base. The wisdom that can be achieved through True Learning protects those who have acquired it from the need to be subject to fickle fortune.

112 (opposite) *Trivulzio Madonna*, 1494–1497
Distemper on canvas, 287 x 214 cm
Castello Sforzesco, Civico Museo d'Arte Antica, Milan

At the lower edge of this painting an angel is playing the organ, accompanied by two singing companions. The emblem of the church of Santa Maria Organo includes an image of an organ, since the monks assumed that the name of their church was derived from the musical instrument, though it was probably taken from the nearby Porta Organa. The saints, the organ, and the floating Mary represent elements of a composition that has strong local links.

into the world. Eve was the mother of the first race of mankind, and it was through the mothers Mary and Elizabeth that a new era in human history was introduced. John represented the sacrament of baptism, an essential ritual that separated Christians from Jews. Christ was the Redeemer, marking the end of the old way and the beginning of the new. Thus this grouping of figures symbolizes the victory of Christianity over Judaism: the picture links the propaganda against the Jews with a triumph (military and spiritual) over the enemy.

Right up to the 18th century, the day of the annual harvest festival procession to the chapel of Santa Maria della Vittoria was 2 July, the day of the Visitation, the meeting of Elizabeth and Mary before their sons were born. Mantegna's *dolcezza*, the softness of his figures, their festive setting beneath a richly decorated pergola, and the harmonious use of the scintillating range of colors betray nothing of the bellicose background to the painting. Proclaimed Queen of Heaven by the medallion on her footstool, Mary is the center of a majestic group that includes the monumental and idealized figures of St Michael and St George. They embody the harmony of heavenly beauty and the "cultivated religious sensibilities of the high Renaissance," as the art historian Ronald Lightbown observed. The role of art was now to imitate the perfection of the divine.

The second large altarpiece Mantegna painted after he had completed *The Triumph of Caesar* was the *Trivulzio Madonna* (ill. 112) for the Olivetan monks of the monastery of Santa Maria Organo, in Verona. The Olivetan monks are a reformed order of white Benedictines, which is why the founder of the order, St Benedict, is shown on the right-hand side of the painting. Standing next to him, St Jerome is holding a model of a church: the monks had ordered this painting for their newly renovated and extended church. To the left, Gregory the Great can be seen, and at his side stands John the Baptist, who is pointing to the center of the painting, directing our gaze to the Madonna and Child. Holding the Christ Child on her lap, Mary is hovering in a mandorla of angels, a suitable motif, as the church is dedicated to the Assumption of the Virgin. No ground or floor is depicted, and the location of the event is unclear. The Virgin is seen directly from the front, though the saints are seen from below, an apparent disregard for the rules of perspective that in fact heightens the visionary nature of this luminous apparition from another plane of reality.

From 1490 onwards, Mantegna produced a series of illusionistic works representing sculptural reliefs in marble or bronze. These are in *grisaille*, light and dark tones of a single color creating figures that stand against a background simulating boldly patterned marble. In

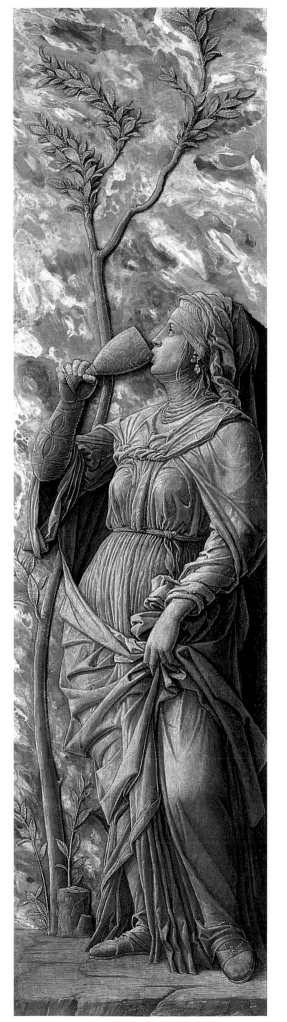

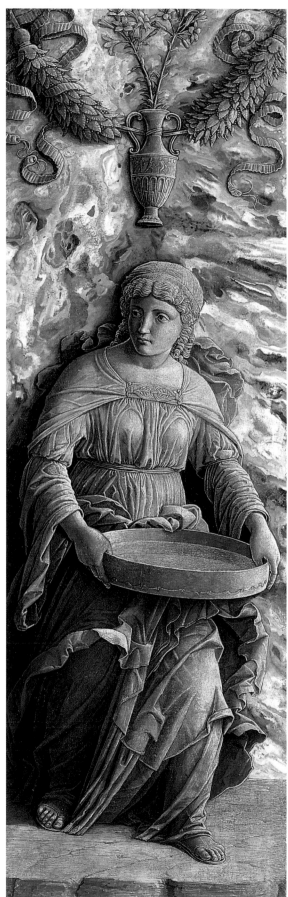

114 (far left) *Sophonisba*, after 1490
Distemper on wood, originally 72.5 x 23 cm (right side cut)
The National Gallery, London

Sophonisba, the daughter of the Carthaginian statesman Hasdrubal (3rd century BC), was for reasons of state married to various men one after the other. When the Roman leader Scipio demanded that Sophonisba be handed over after her husband had been taken prisoner, she drank a cup of poison rather than be taken by the enemy.

115 (left) *Tuccia*, after 1490
Distemper on wood, 72.5 x 23 cm
The National Gallery, London

Tuccia, a Vestal Virgin accused of incest, proved her innocence by a feat that was proverbially impossible. After appealing to her goddess for help, she carried water home from the river Tiber in a sieve, and so was rehabilitated through a divine pronouncement. The *chiaroscuro* tones suggest a classical relief, although Mantegna painted this *grisaille* without a specific model.

116 (opposite) *Samson and Delilah,* 1495–1506
Distemper on canvas, 47 x 37 cm
The National Gallery, London

Samson is the heroic figure with superhuman strength whose story is told in the Old Testament Book of Judges. His wife Delilah was to find the secret of his strength. After he told her that the secret lay in his hair, Delilah cut his hair off and the Philistines were able to capture Samson and blind him. The grapevine entwined round the tree is a symbol of Samson's drunken stupor.

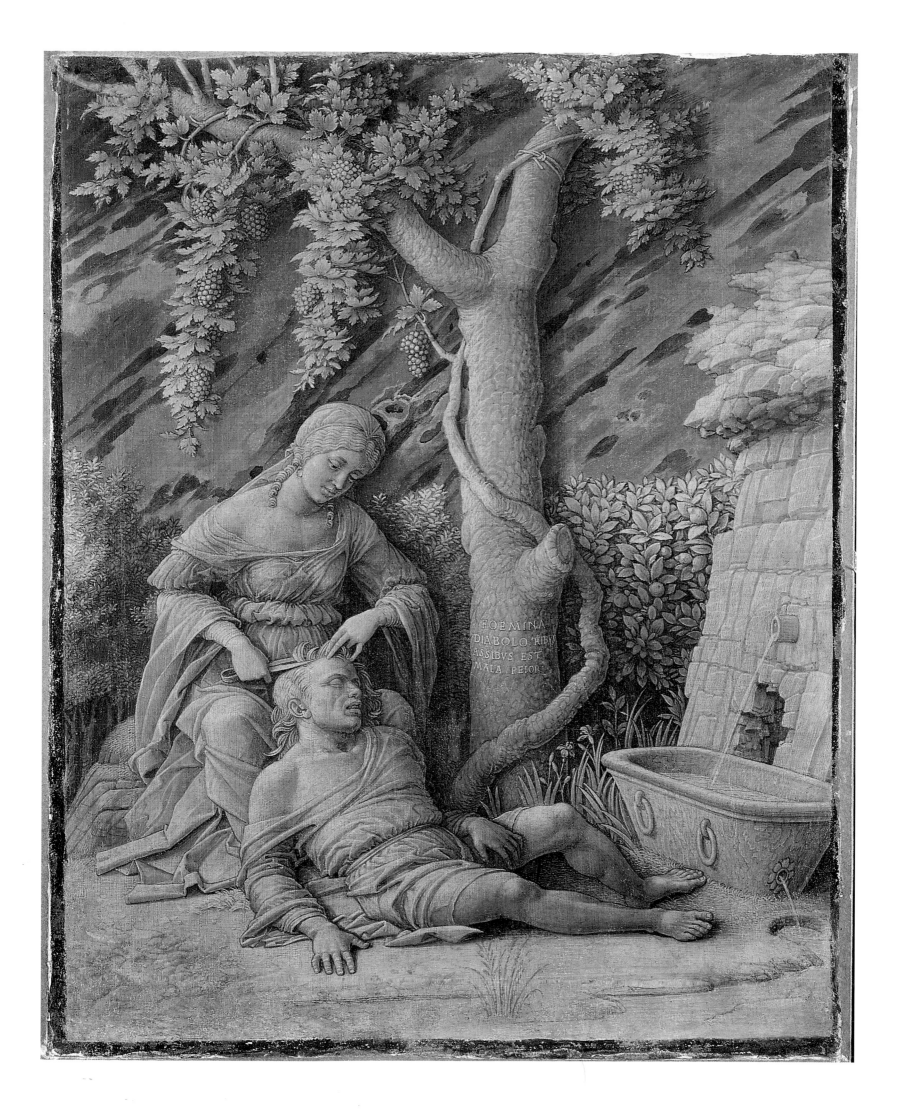

ANDREAS MANTINIA · MCCCCLXXXXI · FEB

During the Renaissance, the great biblical figures were
also counted among the heroes and heroines of antiquity.
Judith, the pious and beautiful widow from the besieged
town of Bethulia, an outpost of Jerusalem, saved the city
by outwitting Holofernes, Nebuchadnezzar's military
commander. Having charmed him and made him drunk,
she cut off his head. The leaderless Assyrians fled when
they saw the bloody head hanging on the city walls the
next morning.

Among Mantegna's works there are several representations
of Judith that, without exception, show a comparatively
peaceful scene in which Judith is placing the severed head
in a bag. During the Baroque, in contrast, the dramatic
central moment of the action was preferred, as Judith,
often with great effort, decapitates Holofernes. The dates
suggested for this work range from 1464 to 1495.

119 *Introduction of the Cult of Cybele to Rome,* 1505/06
Distemper on Canvas, 73 x 268 cm
The National Gallery, London

From the left the priests in their flowing robes are
approaching with a bust of Cybele. A young follower falls
on his knees in reverence, his position in the center of the
picture emphasizing the unusually wide format of this
work. Behind him, Scipio leads out the group of Romans
who have been awaiting the arrival of this image of the
goddess, which has been brought from Asia Minor. The
family of the patron of the picture, Francesco Cornaro,
had elected Cornelius Scipio as their legendary ancestor.

Italy, pictures like this, which appear to be carved in
stone, were first seen in the bases of Giotto's frescoes in
the Arena Chapel in Padua, where he illustrated the
seven Virtues and seven Vices. Mantegna certainly knew
these frescoes. It was Flemish painters, however, who
provided a new stimulus for this type of painting in
15th-century Italy. Vasari described how *grisaille* was
used in Italy for palace facades, stage sets, and ephemeral
structures for festivals and triumphal processions.
Mantegna had already used this technique for details in
his early painting *The Circumcision of Christ* (ill. 49) and
for the ceiling in the Camera degli Sposi (ill. 63). At the
end of the 15th century, grisaille work was in great
demand, and Mantegna painted a number of pictures
in this technique. The demand for such works was
linked to the limited availability of classical art treasures,
which meant that people were willing to accept bronzes,
sculptures, reliefs, medallions and other objects made in
the classical style. In consequence, even the *marmi finti*,
imitations of marble reliefs, found a market. Mantegna's

workshop became a center for these works. Since there
was a scarcity of sculptors with the relevant skills in
Mantua, mock classical reliefs were particularly well
represented here. Both the rivalry between painting and
sculpture, and the concept of the blending of various
levels of reality, meant that Mantegna and his students
were here given an opportunity to display their
virtuosity.

Such monochrome paintings found a place in small
galleries or studies. For example, two of these hung over
the door of Isabella's *studiolo*, though both have been
lost. Today, we have precise information about only one,
Occasio and Poenitenta (ill. 113): this is a fresco by one
of Mantegna's students and was later heavily restored. It
was intended for the canopy over a hearth in the Biondi
Palace in Mantua. The theme had been handed down
in a description of the sculpture *Occasio and Poenitentia*
by Phidias – a renowned sculptor of ancient Greece – by
the 4th century BC poet Ausonius.

Other paintings in this style follow the traditional

medieval cult of the hero, which was continued during the Renaissance with both biblical and mythological subjects. Two of Mantegna's female figures, *Sophonisba* (ill. 114) and *Tuccia* (ill. 115), representing two heroines of purity and constancy, presumably formed part of a larger series. *Samson and Delilah* (ill. 116) is a small masterpiece from a series illustrating the theme of "women's wiles." This was a series of stories that had been re-told in images since antiquity, stories that supposedly illustrated women's cunning. The inscription carved in the tree trunk warns that women are more wicked than even the Devil.

The *Introduction of the Cult of Cybele to Rome* (ill. 119) was one of a series of four long, narrow paintings ordered from Mantegna by Francesco Cornaro at the beginning of 1505, with the approval of the Gonzaga. Mantegna was able to complete only this one painting before his death. However, sketches for the others still exist and the rest of the series was completed on this basis, in Venice; among these is *Scipio's Abstinence* by Giovanni

Bellini (now in Washington). We have already come across the bust of the goddess Cybele in the *Triumphs of Caesar* (ills. 90, 96). At the end of the second Punic War, a Sibylline oracle predicted that a Roman victory would be hastened if they brought this foreign goddess to Rome. So in 204 BC, the Roman Senate decided that as the most distinguished of all the Romans, the still youthful patrician Publius Cornelius Scipio (235–183 BC) should receive the goddess and give her shelter in his house until a temple had been built. On the right of the painting a private house is depicted, on the steps of which a musician in oriental dress is standing, playing a pipe and a drum. A band attached to his ruff bears the letters *SPQR*, the Latin abbreviation for the Roman senate. This symbolizes official acceptance of the cult of this goddess, originally from Mount Ida, near Troy in Phrygia in Asia Minor. The trumpet of a second musician is projecting from the entrance to the house, a compositional device indicating that the action is continuing beyond the picture frame. This implies that

the picture frame does not mark the boundary of the fictive space.

At the center of this picture, which has an unusually wide format, flowing movement and statuesque dignity are closely juxtaposed. A young man, a eunuch in the service of the goddess, falls to his knees, thereby bringing the rapidly approaching procession to a halt. The Romans are standing in unperturbed expectation. The gathering of Roman notables contrasts with the vital foreign cult that they have formally decided to adopt. Over Scipio's head the color and form of the background are starting to break up: on the side of the Phrygian followers of the goddess it is glowing like fire, and on the side of the Romans it seems to be set in a blistered yellowish gray. The strong differentiation between light and shade, and the sweep of light across the foreground, shining on the clothes, create a life-like impression. Because the figures stand out boldly in this way, the events unfold as if on a stage parallel to the painting and do not have the appearance of a rigid relief.

Between 1490 and 1506, the year he died, Mantegna painted several more devotional paintings in which the main figures are represented as reliefs standing out against a mostly dark background (ills. 120–124, 126). Inspired by reliefs on classical tombs, these figures are shown partially hidden behind stone balustrades or a frame. The most impressive of the paintings from Mantegna's final years include the *Ecce Homo* in the Musée Jacquemart-André in Paris (ill. 124), and the *St Sebastian* (ill. 125) in the Ca' d'Oro in Venice. On Mantegna's death, the *St Sebastian*, still in his house, was given to Bishop Ludovico Gonzaga by Mantegna's sons. At the beginning of 1506, the plague was rife in Mantua, and this saint was called on for protection, since his martyred body symbolized a triumph over pain and death. Mantegna again employs the painted frame he used in earlier paintings, but here it takes the form of a stone niche. Now more than mere details project into the viewer's space. The saint is stepping out of the niche onto the ground, though this is not shown in the painting. St Sebastian is climbing out of the frame like a sculpture that has come to life. Painting imitated sculpture through the use of *grisaille*, and now painting seems to be bringing sculpture back to life. The fact that this link was to some degree given a real setting has already been demonstrated by the "living tableau"

120 *Virgin and Child with Saints,* ca. 1500
Distemper on wood, 61.5 x 87.5 cm
Galleria Sabauda, Turin

In this picture the strong contrasts of light and dark sharply differentiate the figures; in addition, the skin of Mary and Jesus seems to glow from within. Among the saints can be seen St John as a child shown close to Jesus, as always, and St Catherine of Alexandria with the wheel which broke while she was being martyred. When private patron knew who was being represented, the saints' attributes were not always included.

121 (opposite) *Holy Family with the Infant St John the Baptist,* 1495–1505
Distemper on canvas, 75.5 x 61.5 cm
Staatliche Kunstsammlungen, Gemäldegalerie Alte Meister, Dresden

The striking face of the man on the left may possibly combine the patron's features and the representation of St Joseph, who is shown here, contrary to traditional iconography, with no beard. The young St John is addressing us directly and directing our gaze to Christ. The softly modelled faces of Mary and the two boys contrast with the two realistically portrayed old people.

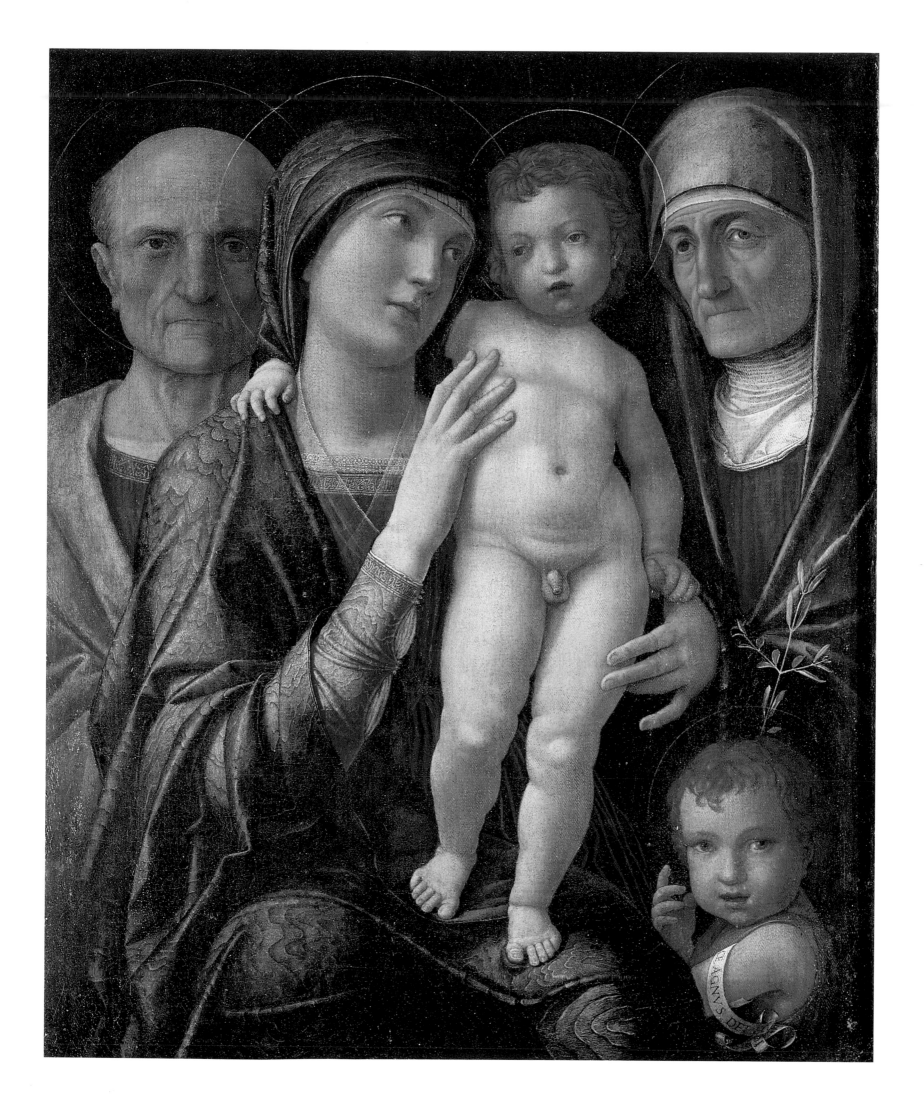

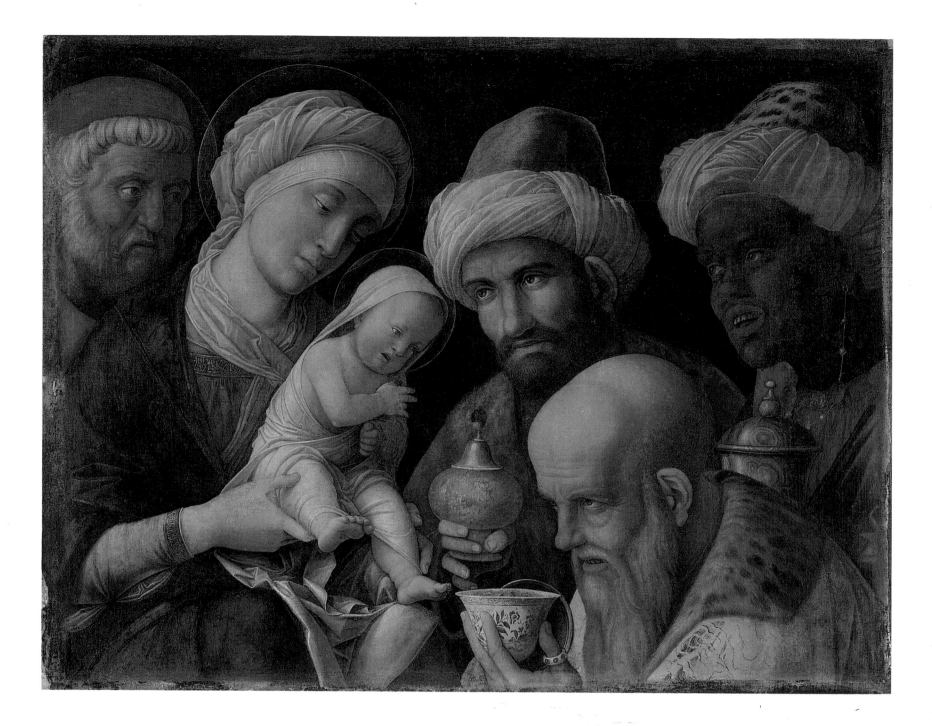

performed during the festivities for the *Madonna of Victory* (ill. 111).

To illustrate the saint's return from death all the more clearly, Mantegna broke with tradition and portrayed a St Sebastian who is not bound to a pillar or a tree. In addition, the figure is altogether more animated than ever before – his hair is windblown, his loincloth is falling away in crumpled folds. This decorative treatment of material moving independently was first seen in the initial scene of the *Triumphs of Caesar* (ill. 89). The link between the picture's fictive space and the viewer's real space is far more convincing in this *St Sebastian* than, for example, in the paintings for the altarpiece for San Zeno (ill. 33).

In the last two years of his life, Mantegna painted his own funerary chapel of Sant' Andrea, the largest church in Mantua. He had it decorated with *trompe-l'œil* monochrome frescoes showing the four Evangelists, and

a pergola with garlands of fruit and leaves in the cupola. Other paintings also intended for this space are rather modest (ills. 126, 127). They are still in the chapel to this day, with a bronze bust of himself (ill. 128) he designed for his tomb. At court, Mantegna had had several commissions to design sculptures, and after 1490, at the behest of Isabella d'Este, he created a now lost statue of Virgil, Mantua's most famous son, which was to stand in the city's main square. However, apart from the busts, none of the statues still extant can be proved to be his.

A multi-talented artist, Mantegna was a prime example of the *uomo universale*, the Renaissance man with an all-round education. His works were sought by the royal houses of France, Germany, and Spain. His innovations in painting reached artists' workshops throughout Europe through engravings, and masters as different as Dürer (1471–1528), Rubens (1577–1640)

122 *Adoration of the Magi*, 1497–1500
Oil and distemper on canvas, 54.5 x 71 cm
J. Paul Getty Museum, Malibu

This is one of the most frequently copied of Mantegna's works. The straightforward composition is similar to that of *Presentation at the Temple* in Berlin (ill. 28). The posture of the figures is now more natural and more distinctive. The kings are holding fine containers of porcelain, jasper set in gold, and agate.

123 (opposite) *Christ the Redeemer*, ca. 1500
Canvas, 72.5 x 45 cm
Musée du Petit-Palais, Paris

The iconography of this painting is unusual, though used by Mantegna more than once (cf. ill. 59). Portraying the Child Christ as the ruler of the world, *Imperator Mundi*, was less current in Italy than in Germany; and showing the Madonna sewing is very unusual. By working with her hands, Mary is demonstrating that she is God's humble handmaiden. This portrayal was presumably not based on one of Mantegna's own designs.

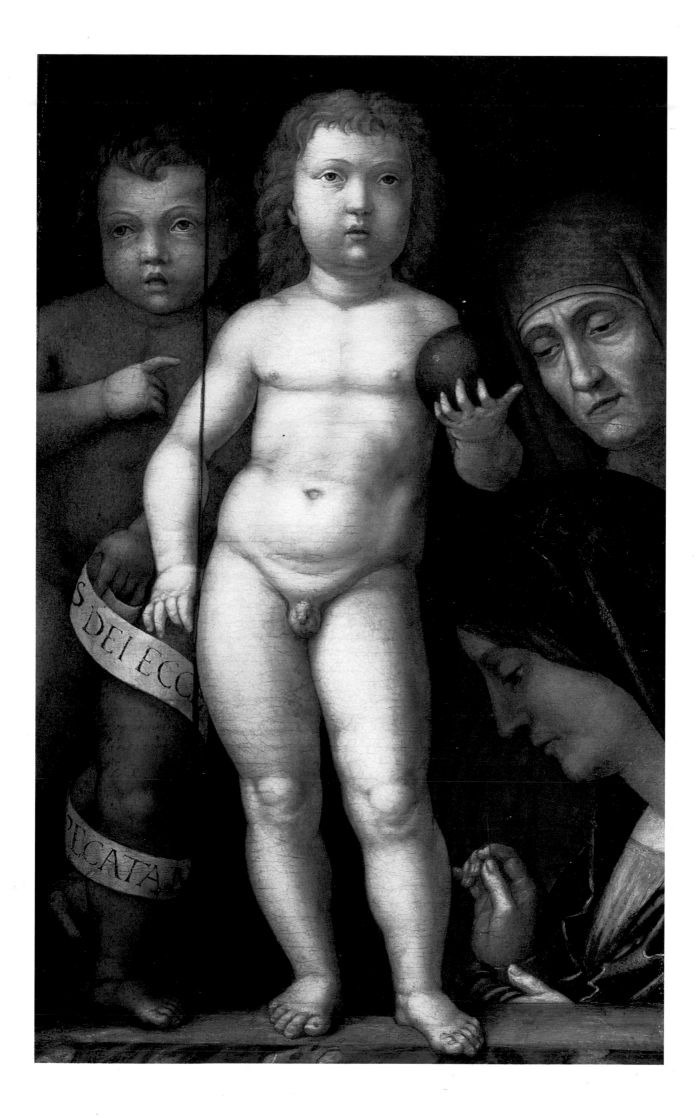

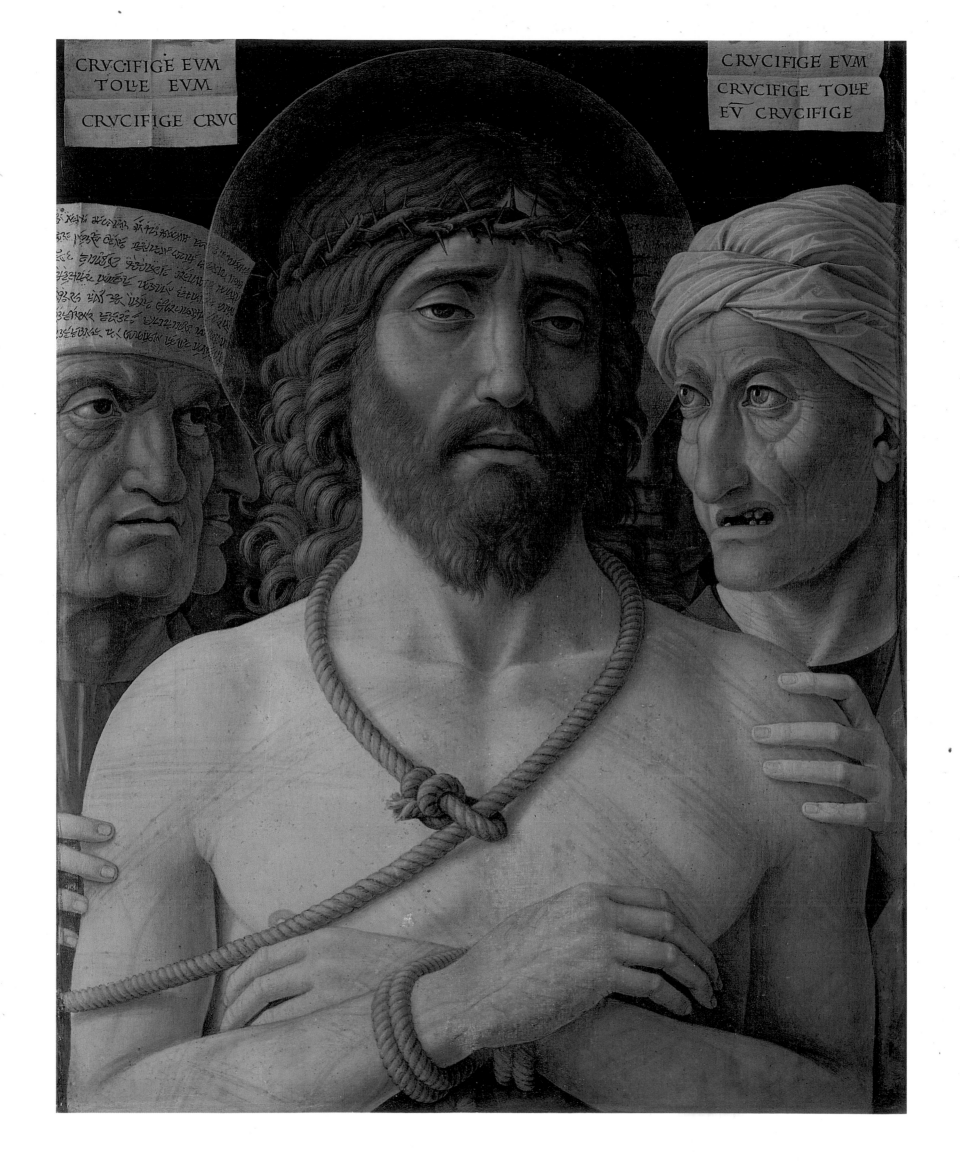

CRVCIFIGE EVM
TOLE EVM
CRVCIFIGE CRVC

CRVCIFIGE EVM
CRVCIFIGE TOLE
EV CRVCIFIGE

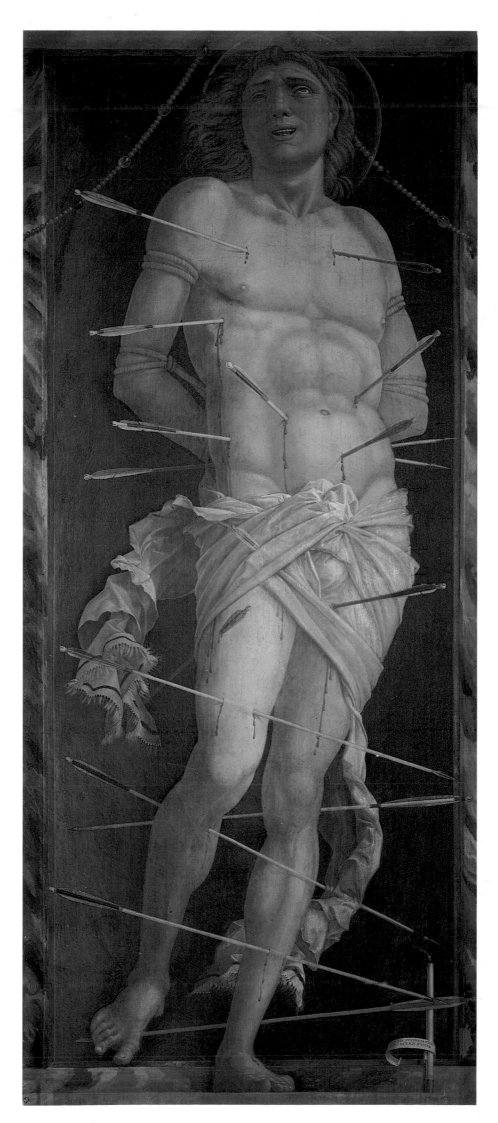

124 (opposite) *Ecce Homo*, ca. 1500
Distemper on canvas, 54 x 42 cm
Musée Jacquemart-André, Paris

The portrayal of the flagellated Christ combines the
timeless devotional image with a historic reference to a
real event. The figure of Christ is displayed covered in
weals from the flagellation, and with the crown of thorns
on his head. The words "What a man is this!" can be read.
Of the two men holding him, one is wearing a paper
headband with an inscription in pseudo-Hebrew. Two
other figures are barely visible in the background. The
unfolded sheet of paper in the top corner bears the
proclamation of the crucifixion.

125 (right) *St Sebastian*, ca. 1506
Distemper on canvas, 210 x 91 cm
Galleria della Ca' d'Oro, Venice

The parchment wrapped around the candle carries the
inscription: NIL NISI DIVINUM STABILE EST:
CAETERA FUMUS ("Nothing is eternal but God, all
else is smoke"). Thus the painting becomes a
representation of *vanitas* (vanity) and warns of the
transitory nature of earthly values. If this picture was
executed in the year of Mantegna's death, it is perhaps a
resigned comment from his last days, as at that time he
was plagued by financial problems and ill health.

126 (above) *The Holy Family and the Family of John the Baptist,* ca. 1504–1506
Casein (?) on canvas, 40 x 169 cm
Sant'Andrea, Cappella di Giovanni Battista, Mantua

This painting hangs to this day in Mantegna's funerary chapel. Since the chapel is dedicated to John the Baptist, his family is portrayed opposite the Holy Family. The child St John crosses his arms over his chest, showing his reverence. The lighting stresses the mothers and their children, and Joseph and Zachariah disappear into the shadows. The unusually broad format of the painting suggests that it was originally meant to be placed above the altar.

127 (left) *Baptism of Christ,* ca. 1506
Canvas, 228 x 175 cm
Sant'Andrea, Cappella di Giovanni Battista, Mantua

During the sacrament of baptism, John, the precursor and herald of Christ, recognizes him as "the Lamb of God." Over Jesus' head flies a dove, the iconographic symbol of the Holy Spirit. The painting is to a great extent the work of Mantegna's workshop and of his son Francesco.

128 *Self-Portrait of Mantegna,* ca. 1504–1506
Bronze, height 47 cm
Sant'Andrea, Cappella di Giovanni Battista, Mantua

The bust is a very natural portrait of Mantegna with his head encircled by a laurel wreath, following the tradition of the portraits of Roman patricians. The bronze cast was created by a medallion maker after a clay model made by Mantegna himself.

and, much later, Degas (1834–1917), copied his works. With bold and original conceptions of spatial design, as demonstrated in the Camera degli Sposi, he provided the stimulus for the profuse and illusionistic symbolism of Mannerist and Baroque art. His representations of nature correct in every detail, together with his keen feeling for the classical world, demonstrate that he was a widely cultivated humanist whose works were governed by a constant challenge to the boundary between art and life. Even in his own day he was considered one of the Great Masters, his reputation extending far beyond Mantua.

CHRONOLOGY

1430/31 Birth of Andrea Mantegna, the son of a joiner, probably in Isola di Carturo, between Vicenza and Padua.

1435 Leon Battista Alberti completes the "De Pictura", his influential book on painting, manuscript copies of which, in Italian translation as well as Latin, circulated until it was first printed in 1540.

ca. 1442 Mantegna arrives in the workshop of Francesco Squarcione in Padua.

1443–1450 Donatello works on the statues and reliefs for the main altar of the Santo, the church of St Anthony in Padua.

ca. 1445 The printing press with movable letters is developed, and ca. 1455 the first Gutenberg Bible is printed.

1447/48 The first altar solely by Mantegna: for Santa Sofia in Padua.

1447–1453 Donatello's equestrian statue of Gattamelata, erected on the piazza before the church of the Eremitani in Padua.

1448–1457 Mantegna works on the frescoes for the Ovetari Chapel in the church of the Eremitani in Padua.

1453/54 Mantegna marries Nicolosia, the daughter of the painter Jacopo Bellini from Venice.
The Turks conquer Constantinople on 29 May 1453, sealing the fate of the Eastern Empire.

ca. 1457–1460 Mantegna's polyptych for the church of San Zeno in Verona.

1459/60 At the Church Council in Mantua, Pope Pius II canvases for a campaign against the Turks.
Mantegna enters the service of the Gonzagas in Mantua.

ca. 1465–1474 Mantegna's frescoes in the Camera degli Sposi in the ducal palace in Mantua.

1477/78 *Primavera* painted by Botticelli (1445–1510) for the Villa Castello in Florence.

1484–1495 Mantegna paints the *Triumphs of Caesar* for Francesco Gonzaga.

1488–1490 Mantegna spends time in Rome in the service of Pope Innocent VIII.

1490 Marriage of Isabella d'Este of Ferrara to Francesco Gonzaga in Mantua.

1492 Columbus lands in the West Indies: the discovery of America.

1494 Charles VIII of France marches into Italy to take Naples. The Medici banished from Florence; the highly influential sermons of Savonarola attacking the wealth of the Catholic Church and calling for repentance. Dürer's copies of engravings by Mantegna.

1495–1497 Leonardo's *Last Supper* in the refectory of Santa Maria delle Grazie in Milan.

1496 Mantegna's *The Madonna of Victory* for Francesco Gonzaga in Mantua.

1498 Savonarola declared a heretic by the Pope and burned to death on the Piazza Signoria in Florence. Michelangelo (1475–1564) sculpts the marble *Pietà* for St Peter's in Rome.

1499–1502 The Florentine Amerigo Vespucci sails along the West Indian coastline. His reports spread the news of the new continent and give it his name.

1501–1504 Michaelangelo's sculpts *David* for the Republic of Florence.

1506 Dürer paints *The Feast of the Rose Garlands* for the church of San Bartholomeo in Venice.
Discovery of the *Laocoön* classical sculpture group in Rome.
Mantegna dies on 13 September.

1507 Copernicus proposes the theory that the Sun is the center of the universe.

GLOSSARY

aerial perspective, a way of suggesting the far distance in a landscape by using paler colors (sometimes tinged with blue), less pronounced tones, and vaguer forms.

all' antica (It. "from the antique"), (of an art work) based on or influenced by classical Greek or Roman art.

allegory (Gk. *allegorein*, "say differently"), a work of art which represents some abstract quality or idea, either by means of a single figure (personification) or by grouping objects and figures together. Renaissance allegories make frequent allusions both to both Greek and Roman legends and literature, and also to the wealth of Christian **allegorical** stories and symbols developed during the Middle Ages.

altarpiece, a picture or sculpture that stands on or is set up behind an altar. Many altarpieces were very simple (a single panel painting), though some were huge and complex works, a few combining both painting and sculpture within a carved framework. From the 14th to 16th century, the altarpiece was one of the most important commissions in European art; it was through the altarpiece that some of the most decisive developments in painting and sculpture came about.

apse (Lat. *absis*, "arch, vault"), a semicircular projection, roofed with a half-dome, at the east end of a church behind the altar. Smaller subsidiary apses may be found around the choir or transepts. Also known as an exedra.

arcade (Lat. *arcus*, "arch"), a series of arches supported by columns, piers or pillars. In a **blind arcade** the arches are built into a wall.

Arcadian, relating to Arcadia (a mountainous area of Greece), in Greek and Roman literature, a place were a contented life of rural simplicity is lived, an earthly paradise peopled by shepherds.

architectonic (Gk. *arkhitektonikos*, "architectural"), relating to structure, design, or organization.

attribute (Lat. *attributum*, "added"), a symbolic object which is conventionally used to identify a particular person, usually a saint. In the case of martyrs, it is usually the nature of their martyrdom.

Bacchus, in Greek and Roman mythology, the god of wine and fertility. Bacchic (or **bacchanalian**) rites were often orgiastic.

baldachin, or **baldacchino** (It. "brocade"), originally a textile canopy supported on poles and carried dignitaries and relics. Later, an architectural canopy of stone or wood set over a high altar or bishop's throne.

balustrade, a rail supported by a row of small posts or open-work panels.

Baroque (Port. *barocco*, "an irregular pearl or stone"), the period in art history from about 1600 to about 1750. In this sense the term covers a wide range of styles and artists. In painting and sculpture there were three main forms of Baroque: (1) sumptuous display, a style associated with the Catholic Counter Reformation and the absolutist courts of Europe (Bernini, Rubens); (2) dramatic realism (Caravaggio); and (3) everyday realism, a development seen in particular in Holland (Rembrandt, Vermeer). In architecture, there was an emphasis on expressiveness and grandeur, achieved through scale, the dramatic use of light and shadow, and increasingly elaborate decoration. In a more limited sense the term Baroque often refers to the first of these categories.

Byzantine art, the art of the Byzantine Empire, which had its capital in Constantinople (Byzantium), from the 5th century to the fall of Constantinople to the Turks in 1453. Based largely on Roman and Greek art, Byzantine art also absorbed a wide of influences, notable from Syria and Egypt. Byzantine art was essentially a spiritual and religious art, its forms highly stylized, hieratic and unchanging (central images were thought to derive from original portraits). It also served to glorify the emperor. Among its most distinctive products were icons, mosaics, manuscript illuminations, and work in precious metals. The strong influence of the Byzantine style on medieval Italian painting can be seen in the works of Cimabue, Duccio, and Giotto.

caisson (Fr. *casson*, "a chest, box"), in architecture, a sunken panel in a ceiling or vault.

candelabra, sing. **candelabrum** (It. *candela*, "candle"), a large, usually decorated, candlestick, usually with several branches or arms.

capital (Lat. *capitellum*, "little head"), the head or crowning feature of a column or pillar. Structurally, capitals broaden the area of a column so that it can more easily bear the weight of the arch or entablature it supports.

caryatid (Gk. "priestess"), a carved female figure used in architecture as a column to support an entablature.

castello (It.), "castle", palace.

chiaroscuro (It. "light dark"), in painting, the modelling of form (the creation of a sense of three-dimensionality in objects) through the use of light and shade. The introduction of oil paints in the 15th century, replacing tempera, encouraged the development of chiaroscuro, for oil paint allowed a far greater range and control of tone. The term chiaroscuro is used in particular for the dramatic

contrasts of light and dark introduced by Caravaggio. When the contrast of light and dark is strong, chiaroscuro becomes an important element of composition.

cithara (Gk.), an ancient musical instrument, resembling a lyre, on which strings were plucked. They were often used to accompany a singer or someone reciting poetry.

classical, relating to the culture of ancient Greece and Rome (**classical Antiquity**). The classical world played a profoundly important role in the Renaissance, with Italian scholars, writers, and artists seeing their own period as the rebirth (the "renaissance") of classical values after the Middle Ages. The classical world was considered the golden age for the arts, literature, philosophy, and politics. Concepts of the classical, however, changed greatly from one period to the next. Roman literature provided the starting point in the 14th century, scholars patiently finding, editing and translating a wide range of texts. In the 15th century Greek literature, philosophy and art — together with the close study of the remains of Roman buildings and sculptures — expanded the concept of the classical and ensured it remained a vital source of ideas and inspiration.

coffering, a ornamental system of deep panels recessed into a vault, arch or ceiling. Coffered ceilings, occasionally made of wood, were frequently used in Renaissance palaces.

concetto, pl *concetti* (It. "concept"), in Renaissance art theory, the intellectual or narrative program behind a work; a work's underlying theme. *Concetti* were often taken from the literature and mythology of Ancient Greece and Rome, as well as from the Bible.

condottiere, pl. **condottieri** (It. "leader"), in Italy from the 14th to the 16th century, a leader of mercenary soldiers.

contrapposto (It. "placed opposite"), an asymmetrical pose in which the one part of the body is counter-balanced by another about the body's central axis. Ancient Greek sculptures developed contrapposto by creating figures who stand with their weight on one leg, the movement of the hips to one side being balanced by a counter movement of the torso. Contrapposto was revived during the Renaissance and frequently used by Mannerist artists, who developed a greater range of contrapposto poses.

copperplate engraving, a method of printing using a copper plate into which a design has been cut by a sharp instrument such as a burin; an engraving produced in this way. Invented in south west Germany during the 1430s, the process is the second oldest graphic art after woodcut. In German art it was developed in particular by Schongauer and Dürer, and in Italian art by Pollaiuolo and Mantegna.

corbel, in architecture, a bracket of stone, brick or wood that projects from a wall to support an arch, large cornice or other feature. They are often ornamented.

di sotto in sù (It. "up from under"), perspective in which people and objects are seen from below and shown with extreme foreshortening.

distemper (Lat. *distemperare*, "to mix, dilute"), a technique of painting in which pigments are diluted with water and bound with a glue. It was usually used for painting wall decorations and frescoes, though a few artists, notably Andrea Mantegna (1430/31–1506), also used it on canvas.

Ecce Homo (Lat. "Behold the Man!"), the words of Pontius Pilate in the Gospel of St John (19, 5) when he presents Jesus to the crowds. Hence, in art, a depiction of Jesus, bound and flogged, wearing a crown of thorns and a scarlet robe.

festoni (It. "festoons), architectural ornaments consisting of fruit, leaves, and flowers suspended in a loop; a swag.

Franciscans, a Roman Catholic order of mendicant friars founded by St. Francis of Assisi (given papal approval in 1223). Committed to charitable and missionary work, they stressed the veneration of the Holy Virgin, a fact that was highly significant in the development of images of the Madonna in Italian art. In time the absolute poverty of the early Franciscans gave way to a far more relaxed view of property and wealth, and the Franciscans became some of the most important patrons of art in the early Renaissance.

fresco (It. "fresh"), wall painting technique in which pigments are applied to wet (fresh) plaster (*intonaco*). Painting in this way is known as painting *a fresco*. The pigments bind with the drying plaster to form a very durable image. Only a small area can be painted in a day, and these areas (known as *giornata*), drying to a slightly different tint, can in time be seen. Small amounts of retouching and detail work could be carried out on the dry plaster, a technique known as *a secco* fresco.

grisaille (Fr. *gris*, "gray"), a painting done entirely in one color, usually gray. Grisaille paintings were often intended to imitate sculptures.

humanism, an intellectual movement that began in Italy in the 14th century. Based on the rediscovery of the classical world, it replaced the medieval view of humanity as fundamentally sinful and weak with a new and confident emphasis on humanity's innate moral dignity and intellectual and creative potential.

A new attitude to the world rather than a set of specific ideas, humanism was reflected in literature and the arts, in scholarship and philosophy, and in the birth of modern science.

iconography (Gk. "description of images"), the systematic study and identification of the subject-matter and symbolism of art works, as opposed to their style; the set of symbolic forms on which a given work is based. Originally, the study and identification of classical portraits. Renaissance art drew heavily on two **iconographical** traditions: Christianity, and ancient Greek and Roman art, thought and literature.

imago pietatis (Lat. "image of pity"), a religious image that is meant to inspire strong feelings of pity, tenderness, or love; specifically, an image of Christ on His tomb, the marks of the Passion clearly visible.

Legenda Aurea (Lat. "golden legend"), a collection of saints' legends, published in Latin in the 13th century by the Dominican Jacobus da Voragine, Archbishop of Genoa. These were particularly important as a source for Christian art from the Middle Ages onwards.

loggia (It.), a gallery or room open on one or more sides, its roof supported by columns. Loggias in Italian Renaissance buildings were generally on the upper levels. Renaissance loggias were also separate structure, often standing in markets and town squares, that could be used for public ceremonies.

lunette (Fr. "little moon"), in architecture, a semicircular space, such as that over a door or window or in a vaulted roof, that may contain a window, painting or sculptural decoration.

magna mater (Lat. "great mother") a mother goddess, especially when seen as the guardian deity of a city or state. Specifically, the goddess Cybele, who was adopted by the Romans in 204 BC.

mandorla (It. "almond"), an almond-shaped radiance surrounding a holy person, often seen in images of the Resurrection of Christ or the Assumption of the Virgin.

marmi finti (It. "pretend marble"), a painted imitation of marble. Usually a decorative feature (on simulated architectural features) it was sometimes used in paintings, particularly by the artist Andrea Mantegna (1430/31–1506).

medallion, in architecture, a large ornamental plaque or disc set into a wall.

monochrome (Gk. *monokhromatos*, "one color"), painted in a single color; a painting executed in a single color.